THE **DIGITAL NEGATIVE**

Raw Image Processing in Lightroom, Camera Raw, and Photoshop

JEFF **SCHEWE**

Peachpit Press

THE DIGITAL NEGATIVE
RAW IMAGE PROCESSING IN LIGHTROOM, CAMERA RAW, AND PHOTOSHOP
Jeff Schewe

PEACHPIT PRESS

www.peachpit.com

To report errors, please send a note to: errata@peachpit.com
Peachpit Press is a division of Pearson Education.
Copyright © 2013 by Jeff Schewe

Acquisitions Editor: Rebecca Gulick
Production Editor: Lisa Brazieal
Development and Copy Editor: Elizabeth Kuball
Compositor: Kim Scott/Bumpy Design
Proofreader: Patricia Pane
Indexer: Emily Glossbrenner
Cover and Interior Designer: Mimi Heft

ISBN-13: 978-0-321-83957-2
ISBN-10: 0-321-83957-9

9 8 7 6 5 4 3 2

Printed and bound in the United States of America

Dedicated to the lasting memory and substantial contributions of Bruce Fraser.
Thanks, Bruce, from all of us.

TABLE OF CONTENTS

Introduction xi

■ CHAPTER 3
FUNDAMENTALS OF LIGHTROOM AND CAMERA RAW 65

DEPLOYING PHOTOSHOP TO PERFECT YOUR DIGITAL NEGATIVES 203

CREATING AN EFFICIENT WORKFLOW 253

INTRODUCTION

The Digital Negative is about raw image processing of digital camera captures. It details what makes for a really good digital negative and how to harness the massive power of Lightroom and Camera Raw to extract the best-possible raw rendering of that digital negative. It's also about when and how to deploy Photoshop to take your rendered digital negatives further using the power of Photoshop to perfect the images that need and deserve the attention.

I drill down on the Lightroom Develop module and the Camera Raw plug-in extensively—that's the meat of this book. While *parametric image editing* (editing the parameters instead of the image pixels in Lightroom and Camera Raw) has advanced considerably since Camera Raw was first introduced, there is still a use for that venerable old lady named Photoshop.

I wrote this book because there didn't seem to be an optimal source of information that suitably covered the main topic without being relegated to covering everything about a single application. The world doesn't need yet another Lightroom or Photoshop book. What I thought was needed, though, was a book about the essence of raw image processing, regardless of the imaging application. I set out to write a book about cross-application integration that addressed the needs of photographers who want to optimize their images for the best-possible image quality.

I called the book *The Digital Negative* for a reason. In my formative years as a young photographer, I read a series of books by Ansel Adams that formed the genesis of my infatuation with and addiction to photography. Ansel's books—*The Camera*, *The Negative*, and *The Print*—had a huge impact and greatly helped advance my knowledge of photography. Time will tell if I can have even a minute fraction of the impact on others that his books had on me.

Who am I and why should I write this book? Well, I'm a graduate of Rochester Institute of Technology (RIT), with two degrees in photography. I was a commercial

advertising photographer in Chicago for over 25 years (yeah, I won a few awards). I was an early adopter of digital imaging—my first photo assignment that was manipulated on a computer was in 1984 (the year the first Macintosh computer shipped). No, I didn't do the digital imaging—a pioneering company called Digital Transparencies, Inc., in Houston, Texas, did it.

I started doing my own Photoshop digital imaging in 1992 using Photoshop 2.0. I was one of the first off-site Photoshop alpha testers (*alpha* meaning way before any sort of final coding is done and before it's really usable). I got to know and work with many of the Photoshop engineers because of this testing. When I mention names like Thomas Knoll (the co-author of Photoshop) or Mark Hamburg (the No. 2 Photoshop engineer and founding engineer of Lightroom), I do so not to drop names, but because these guys are friends of mine. I've worked with them a lot over the years. I want people to know their names and give them the respect they deserve.

I was significantly involved in the early development of both Camera Raw and Lightroom—not because Adobe was paying me tons of money (alpha testers work for free), but for the selfish motive of advancing and improving the tools I personally wanted to use.

I've also had the good fortune to meet a lot of the leading experts in the field, and I want to express my sincere appreciation of one dearly departed friend, Bruce Fraser, noted author and educator, for taking me under his wing. I had the singular honor of joining Bruce and some other friends in forming a company named Pixel Genius, which developed Photoshop plug-ins. I also fulfilled Bruce's wish that I take over and act as co-author of two of the books he authored, *Real World Camera Raw* and *Real World Image Sharpening*. I've also co-authored a book with another good friend and colleague, Martin Evening, titled *Photoshop for Photographers: The Ultimate Workshop*. So, now, with this new book, I'm a full-fledged author!

By way of disclosure, let me just say that I am not and never have been an employee of Adobe (even though, over the years, I've worked with Adobe on software development). I don't have any contracts or testimonials with any camera companies. In the book, I frequently mention specific cameras and lenses I used for image captures. I do so to provide a provenance of how and with what gear an image was captured, not to promote any specific camera. I used those cameras because, well, those are the cameras I bought and paid for (although I've been known for getting some really good deals). My opinions are my own, and anybody who knows me knows that no company could influence me. So, when I write something, you can be assured my motives are pure (even if my tone can be a bit, uh, verbally aggressive).

I owe a large debt of gratitude to many people, and since it's my book, I'll take the time to mention them. First, we all owe a huge debt of gratitude to two guys, John Knoll, and his brother, Thomas, who really started this whole digital image revolution

by co-authoring Photoshop. I also send sincere thanks to Mark Hamburg, for his willingness to put up with my quirky ways and sometimes actually listen to me when I told him what he should do. There are a ton of people at Adobe to thank: Russell Preston Brown for being a co-conspirator, Chris Cox for a lot of sneaky things he put into Photoshop, Russell Williams for striving for Photoshop excellence, and John Nack (and most recently Bryan Hughes) for being Photoshop product managers who really care about the end-user. On the Camera Raw team, special thanks go to Eric Chan, who will always listen and do the right thing (even if it's a pain), and the gone but not forgotten Zalman Stern (he didn't die—he just went to work for Facebook).

I also thank my good friends and partners at Pixel Genius—Martin Evening, Mac Holbert, Mike Keppel, Seth Resnick, and Andrew Rodney—and our gone but not forgotten members, Mike Skurski and Bruce Fraser. We all miss them and so does the industry. I'll also give a shout-out to the Pixel Mafia—you know who you are....

I want to thank the Peachpit "Dream Team" (that's what Bruce used to call them, and I wholeheartedly agree): Rebecca Gulick, who was the acquisitions and project editor (which means she had to put up with my foolishness and tardy submissions); my production editor, Lisa Brazieal, who conspired with me to allow me to do what I thought was best; and my development and copy editor, Elizabeth Kuball, who had the unenviable job of reading and rereading all my terrible writing and correcting me to make me sound like I have half a clue. Thanks also to the book compositor, Kim Scott of Bumpy Design, who did an excellent job of laying out the book and making my figures work. Thanks to my proofreader, Patricia Pane, for catching all the small stuff, and indexer, Emily Glossbrenner, for making stuff easy to find. Big thanks also go to Mimi Heft, for the cover and interior design excellence (and for putting up with my histrionics)—seriously, I never would've picked *that* image for the cover, but it really works!

I also owe a huge debt of gratitude and massive appreciation to my long-suffering wife, Rebecca (Becky), who is always the first person to read the drivel I write (and tell me how to make it sound intelligible, which always makes me look good to my copy editor). She stoically puts up with all my inattention and bad habits when I'm writing and seems to genuinely love me in spite of myself. Thanks also to my loving daughter, Erica, who suffers the loss of her dad while I'm under deadline. She gets back at me by being one my harshest critics, which, I think, makes us even.

My thanks also go to you, the reader, for taking the time to at least get this far. I hope you'll find this book beneficial in advancing your image-processing excellence. You can find additional information on the book's companion website at www.thedigitalnegativebook.com.

—Jeff Schewe, August 2012

A Twelve-spotted Skimmer dragonfly (Libellula pulchella) shot with a Panasonic Lumix DMC-GH2 camera with a 14–140mm lens. I didn't have to go far to shoot it, OZ Park in Chicago (about 3 blocks from my studio and on the way to Starbucks).

WHAT IS A DIGITAL NEGATIVE?

A digital negative is a raw capture from the sensor of the camera with little or no processing but with camera-generated metadata. Why do I call these files digital negatives? Well, it's what Thomas Knoll (the guy who wrote Camera Raw) calls them, and they are like an analog (film) negative in that, without some sort of processing or printing, they can't really be seen and evaluated. A film negative is an inverted version of an image and difficult to evaluate. Although a digital negative isn't inverted (and, thus, not really a negative in the technical sense), it doesn't look like anything really useful.

So, a digital negative is that initial raw file captured by your camera. It embodies the image as seen through the lens and captured by the sensor. It contains color information but isn't really a color image file—getting color requires processing. The metadata contains the information regarding exposure, white balance, and ISO which is used by Lightroom and Camera Raw to make the color image from the raw capture. Odds are, you've never really looked at a real raw file, so let's dissect a digital negative to see what it's made of.

DISSECTING A DIGITAL NEGATIVE

When you shoot in raw mode, the camera must process the raw capture to produce an image you can see on the camera's LCD. A raw file displayed on the LCD without processing would be pretty ugly. **Figure 1.1** shows four visual renderings of a digital negative. The first is a normal image processed from Camera Raw. The two grayscale versions and the ugly green-looking image are different representations of the specially processed raw image.

The actual raw file contains color information but not a color image… yet. Each *photosite* (the photosensitive part of a camera sensor) captures light photons and generates electrical charges that are transformed into a signal that can be stored as a digital file on media. **Figure 1.2** shows extreme close-ups of the flower's stamen in the center of the raw sensor dump shown in Figure 1.1. The first image shows the image processed normally from Camera Raw zoomed in to 3200 percent in Photoshop. The next image is the normalized undemosaiced version. The last image shows the actual individual red, green, green, and blue photosites blown up. Given that the camera this image was shot with (a Canon EOS 1Ds Mark III) has a pixel pitch of 6.4 μ (a micron equals 0.001 millimeter), the image you're seeing is about 2500 times life-size. Yes, photosites are really, really small!

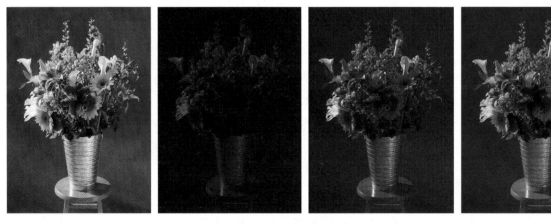

▲ IMAGE PROCESSED IN CAMERA RAW

▲ RAW SENSOR DATA DUMP

▲ RAW SENSOR DATA DUMP NORMALIZED FOR WHITES AND BLACKS

▲ RAW SENSOR DATA DEMOSAICED

FIGURE 1.1 The image on the left has been processed through Camera Raw with default settings. The next image has been processed using DNG_Validate using the option to neither demosaic nor normalize the tones. The next image is also undemosaiced but has been normalized so white and black tones in the capture are normal. The last image has had a simple (and primitive) demosaic processing.

GREEN RED

GREEN

BLUE

FIGURE 1.2 These images show just how small photosites actually are.

▲ RGB IMAGE PROCESSED THROUGH CAMERA RAW

▲ RAW SENSOR DATA DUMP NORMALIZED FOR WHITES AND BLACKS

▲ EXTREME CLOSE-UP OF THE ACTUAL PHOTOSITES

CAMERA SENSOR TYPES

There will always be a debate on the relative merits of charge-coupled device (CCD) sensors versus complementary metal-oxide semiconductor (CMOS) camera sensors. Their fundamental difference lies in the manner of manufacturing. CMOS sensors are made just like any other integrated circuit and can be produced for less money than CCD sensors. CCD and CMOS sensors also operate slightly differently:

- A CCD captures photons on the photosites, causing each photosite to accumulate an electric charge in proportion to the amount of light falling in that region. Once the photosite captures the charge, a control circuit causes each capacitor in the photosite to transfer the charge to the coupled transmission region. The controlling circuit converts the entire semiconductor contents of the array to a sequence of voltages, which is recorded to memory (or disk). This conversion is called the analog-to-digital converter.

- A CMOS is a broader class of integrated circuit used in a variety of microprocessors, static RAM, and other digital logic circuits. CMOS circuits use a combination of P-type and N-type metal-oxide-semiconductor field-effect transistors (MOSFETs) to implement logic gates in signal-processing equipment such as camera sensors. The MOSFET is used to amplify or switch electronic signals. When on but static, CMOS sensors generate less heat and consume and dissipate less power than CCD sensors do.

The CMOS type of sensor is typically found in consumer and professional DSLR cameras. One benefit of CMOS sensors is that they generate less heat and, therefore,

PROCESSING YOUR OWN DNG FILE DATA DUMPS

If you have a burning desire to try the DNG_Validate processing yourself, you can. But I'll warn you, it's kind of geeky! Download the free DNG Software Development Kit (SDK) from Adobe. Go to www.adobe.com and search for DNG Software Development Kit or go straight to www.adobe.com/support/downloads/dng/dng_sdk.html. There are separate versions of the DNG SDK for Mac and Windows.

On a Mac, launch Terminal (found in Applications/Utilities) and drag and drop the dng_validate file in the dng_sdk/targets/mac/release folder onto Terminal's window application. Then type in –1 s1 –2 s2 –3 s3 (be sure to type a space after each number, as shown here, including after the last number, 3). Then take a DNG file and drop it onto the Terminal window. It should automatically fill in the directory path of your DNG image. Then press Return. If you've properly entered the commands, you'll see dng_validate processing and get a "Validate complete" message. The processed files will end up in your user's root folder named s1.tiff, s2.tiff, and s3.tiff. The s1.tiff file will be the raw data dump, the s2.tiff file will be the normalized unde-mosaiced file, and the s3.tiff file will be the demosaiced green-looking version.

The log should look something like this:

OldMacPro:~ schewe$ /Users/schewe/Desktop/dng_sdk_1_3/dng_sdk/targets/mac/release/dng_validate –1 s1 –2 s2 –3 s3 /Users/schewe/Desktop/DNG-test/_MG_3181.dng

Validating "/Users/schewe/Desktop/DNG-test/_MG_3181.dng"...

*** Warning: IFD 0 Copyright has non-ASCII characters ***

Raw image read time: 0.411 sec

Linearization time: 0.045 sec

Interpolate time: 0.562 sec

Validation complete

Note that dng_validate will work only on a color filter array (CFA) Bayer array raw file that has been converted to DNG.

You'll notice in Figure 1.2 that the photosites seem rotated from the normal orientation of a Bayer array (see the nearby sidebar). That's because the image was shot as a vertical. The Bayer array is set up as red, green, green, and blue but is based on the orientation of the sensor in the camera that is mounted on the horizontal axis.

can shoot video or use live view (showing the image as seen by the sensor live on the camera LCD). Live view is very handy for critical framing and focusing. Another advantage is that CMOS sensors generally can use much higher ISO speeds with less perceptible noise than their CCD counterparts.

One downside of CMOS sensors is that most of them require a low-pass filter or aliasing filter in front of the sensor to mitigate stairstepping, aliasing errors, and moiré patterns. Moiré is a result of interference patterns created when the sensor grid interacts with a pattern in the subject. It's often seen when shooting textiles and fabrics or in manmade objects with repeating patterns found in architecture. Some DSLRs don't have strong aliasing filters, and a few (such as the Leica M9 or the Nikon D800E) have no filters. Because these filters reduce the color aliasing and moiré by blurring or softening the image, additional sharpening is needed to counteract the results of the inherent softness of images. Sensors without the filters will produce sharper images but at the risk of the undesirable artifacts.

CCD sensors are found in most low-end point-and-shoot cameras, as well as larger, more expensive medium-format digital camera backs. The advantage of CCDs in larger-format camera backs is that the photosites are larger and more efficient at capturing photons. CCDs generally don't have low-pass or aliasing filters, so the sensor produces sharper images—with the same risk of artifacts as CMOS without filters.

Between CCD and CMOS sensor designs, CMOS sensors have seen the most rapid development and progress and have the benefit of being easier and cheaper to produce. The Nikon D800E retails for about $3,300 and captures a respectable 36 MP on a CMOS sensor. The Phase One IQ180 camera back with a CCD sensor is 40 MP but costs about $22,000. The differences in the two systems really go way beyond the megapixel race and price. However, a D800E is certainly a viable option for lower-cost, higher-megapixel captures.

ATTRIBUTES OF A DIGITAL NEGATIVE

I've shown you what a digital negative looks like, but now I want to explain the attributes of a digital negative that are important to understand if you want to get really good at raw processing.

LINEAR CAPTURE

Put a quarter in your hand, and then add another quarter. Do two quarters feel twice as heavy as one? Not exactly. You perceive more heaviness, but your perception isn't exact. If you have a three-way lightbulb that has settings of 50 watts, 100 watts, and

THE BAYER ARRAY

The Bayer pattern array is a CFA with RGB tricolor filters on a grid of photosites that make up the camera sensor. It was named after the inventor, Bryce E. Bayer of Eastman Kodak. Bryce Bayer's patent in 1976 called the green photo sensors *luminance-sensitive elements* and the red and blue sensors *chrominance-sensitive elements*. He used twice as many green elements as red or blue to mimic the physiology of the human eye (which is also why the dng_validate simple demosaicing is so green in Figure 1.1). **Figure 1.3** shows the basis of a Bayer array.

As you can see, this sort of Bayer pattern image needs to be reconstructed to create a full color image from the incomplete Bayer pattern color sampling. This reconstruction is called *demosaicing*. It interpolates the CFA to estimate the relative color values needed to turn a photosite into an RGB pixel. Both Camera Raw and Lightroom have very exotic algorithms to do this. The downside to demosaicing is that interpolation is involved in achieving an RGB color image. This effectively reduces the actual pixel resolution of a raw capture. A capture from a 24 MP camera is reduced by a factor of about two-thirds to about 16 MP. But this is a minor issue as long as you're starting with a large enough sensor size for your intended use.

The Bayer filter is used almost universally in digital cameras. Alternatives include the CYGM filter (cyan, yellow, green, magenta) and the RGBE filter (red, green, blue, emerald), both of which require similar demosaicing. The Foveon X3 sensor (which layers red, green, and blue receptors vertically instead of using a mosaic) and arrangements of three separate charge-coupled devices (CCDs), tricolor linear arrays, don't need demosaicing.

Color co-site sampling is a system of photographic color sensing, in which four or more individual exposures are collected from the sensor and merged to form a single image. In a process known as micro-scanning, each subsequent exposure physically moves the sensor by exactly 1 pixel, in order to collect RGB data for each pixel. With color co-site sampling, color interpolation isn't necessary. Using this method, the whole sensor is shifted in pixel distances after the first acquisition, in order to obtain full color information from each filter color of the Bayer pattern. Hasselblad has the H4D-200MS that creates 200 MP captures with no demosaicing required. It isn't what I would call cheap at about $45,000 and, unfortunately it requires multiple exposures, so it won't work for situations where the camera can't be locked down or where the subject might move.

▲ DETAIL GRAPHIC OF THE STANDARD BAYER ARRAY OF RED, GREEN, GREEN, AND BLUE PHOTOSITES

▲ GRAPHIC SHOWING HOW MULTIPLE BAYER ARRAYS ARE COMBINED INTO A LARGER ARRAY

FIGURE 1.3 The standard Bayer array pattern.

150 watts, will you perceive that 100 watts is twice as bright as 50 or that 150 is three times as bright as 50? No, your mind registers more brightness, but it doesn't really quantify the result. Your eyes adapt to the changing light.

A camera sensor doesn't—it can't *perceive* changes in light; it simply counts the number of photons falling on the photosites and counts them in a linear manner. If a camera's sensor can capture 12 bits (2^{12}) of data per color, that means that each red, green, and blue channel will have 4096 discrete levels of tone between black and white. Level 2048 represents half the number of photons recorded at level 4096. At level 1024, the number of photons recorded would be half again. This is the meaning of linear capture: the levels correspond to the number of photons captured.

Linear capture has important implications for exposure. If a camera captures seven stops of dynamic range (which is fairly typical of today's lower-end DSLRs but low for newer, high-end cameras), half of the 4096 levels are devoted to the brightest stop, half of the remainder (1024 levels) are devoted to the next stop, half of the remainder (512 levels) are devoted to the next stop, and so on. The darkest stop, the extreme shadows, is represented by only 32 levels. **Figure 1.4** illustrates this concept.

Humans see light very differently. Although human vision can't be modeled exactly with a gamma curve, vision under common lighting conditions (not totally black or blindingly bright) follows an approximate gamma or power function. If images are linearly encoded in a gamma 1.0, they allocate too many bits to highlights

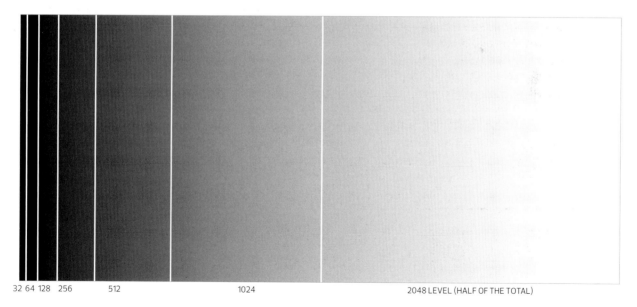

32 64 128 256 512 1024 2048 LEVEL (HALF OF THE TOTAL)

FIGURE 1.4 A linear gradient representing a linear capture.

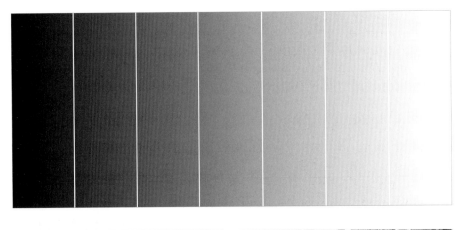

FIGURE 1.5 A gamma-encoded gradient.

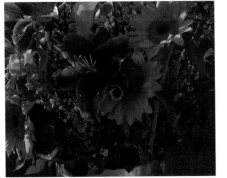

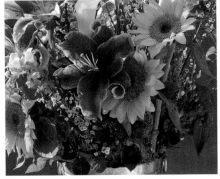

FIGURE 1.6 Comparing a raw linear capture to a processed image in Camera Raw.

▲ A LINEAR CAPTURE WITHOUT TONE MAPPING

▲ A LINEAR CAPTURE AS TONE MAPPED THROUGH CAMERA RAW AND PROCESSED OUT AS PROPHOTO RGB WITH A GAMMA OF 1.8

that human vision can't differentiate and too few bits to shadow values that human vision is sensitive to. **Figure 1.5** shows a graphic representation you would see if a linear gradient were transformed into a normal gamma.

The gammas of various color spaces in Camera Raw or Lightroom vary; ProPhoto RGB is a gamma 1.8 and Adobe RGB is a gamma 2.2. If you try to look at a linear image in Photoshop without applying a gamma correction, the image will appear dark and somewhat lacking in contrast (**Figure 1.6**).

One of the major tasks raw converters perform is converting the linear capture to a gamma-encoded space to make the captured levels more closely match the way our eyes see them. In practice, though, the tone mapping from linear capture to gamma-encoded space is considerably more complex than simply applying a

gamma correction. When editing raw images, you typically use a variety of image adjustments to tweak and modify the basic linear tone mapping, so the tone mapping from linear to gamma-encoded space is much more complex than can be represented by a simple gamma formula. If you want your images to survive this tone mapping without falling apart, good exposure is critical.

DIGITAL EXPOSURE

Back in the old film days when I shot 8x10 transparencies, I bracketed my exposures in 1/6 stop. I did this for two reasons: First, I charged clients by the sheet, so if I shot more film, I made more money. Second, in close evaluation, I could see the differences of 1/6 stop on a lightbox. These days, with digital cameras having much more sophisticated metering and digital negs capable of being finely adjusted in Camera Raw and Lightroom during post-capture processing, I'm afraid the art of exposing tends to fall by the wayside.

There are two main factors you need to keep in mind when you're determining the optimal exposure for a shot: the contrast range of the scene you're shooting and the dynamic range capable of being captured by your camera's sensor. If you're shooting outside on a sunny day in the early afternoon, the contrast range of a landscape image could easily far exceed the dynamic range of your sensor. When faced with that situation, you need to make an aesthetic decision regarding what's more important in your image—the highlights or the shadows—and then expose correctly for your preference.

To understand how to choose the correct exposure, you need to know the actual dynamic range of your sensor. There are two ways of determining that: testing or shooting experience. Rather than digress into talking about shooting step wedges and calculating your own sensor's dynamic range calculations, let me point you to a useful web site: DxOMark (www.dxomark.com). Started by DxO Labs (the same company that developed the DxO Optics Pro, a raw processing and optical correction software application), DxOMark has generously tested the dynamic range of most of the major models of digital cameras and camera backs. You can check the website to see, for example, that a Nikon D800 camera has a dynamic range of 14.4 EVs (exposure values, which means the same as f-stops). By comparison, DxOMark rates the Canon EOS 5D Mark III dynamic range at 11.7 EVs. Does that mean the Nikon has a better dynamic range than the Canon? Yes, but it doesn't tell the entire story. Other factors are at play, not the least of which is that photographers aren't in the habit of jumping from one system to another simply to gain 2.7 stops of dynamic range.

The other way you can determine what sort of dynamic range your camera's sensor has is by experience. You go out and shoot in a variety of lighting situations

NOTE The term *chimping* refers to when photographers take a photograph with a digital camera and immediately look down at the LCD of the camera and make the "ooh ooh ooh ooh" sound of an excited chimpanzee. There are several things wrong with chimping: First, you tend to fall in love with or hate what you just shot. Second, while you're looking down, the rest of the world keeps going around you, so you lose any chance to see or capture another shot. The worst aspect of chimping is that, in the presence of regular people, it makes you sound goofy. So, don't chimp if you can help it. (Of course, I chimp all the time, but do as I say, not as I do, okay?)

and see what works and what doesn't. I've even gone to the extent of using a hand-held spot meter and measuring the EV of highlights and shadows that I wanted to maintain textural detail. I then compared the resulting image with my experience of measuring the original scene. If you don't have a separate spot meter, your camera likely can be set to spot-meter mode, which you can use to evaluate the exposure range of the scene.

Of course, you'll find situations where no single exposure can capture the entire contrast range of some scenes—that's life. If you can shoot several (or more) different exposures by bracketing, you may be able to use post-processing techniques to turn that high-contrast scene into a high dynamic range (HDR) image that maintains the highlight and shadow detail you want in the final image.

The one "experience" that I've had that has made me realize just how much dynamic range there can be in a raw capture happened when I was shooting at Niagara Falls. I was shooting with a Canon EOS 1Ds Mark III (which according to DxOMark has about 12 stops of dynamic range). I was trying to shoot the river at the end of Horseshoe Falls and use an exposure time that would blur the water falling over the falls. The sun wasn't hitting the scene, so the overall scene contrast wasn't too high, but the light was pretty bright. I had the aperture set to f/22 (the lens's max) and tried a variety of slow shutter speeds going from about 1/20 second to about 1 second. I wasn't really paying much attention to the camera LCD at the moment I was shooting. When I took a pause and chimped my shots, I realized that my exposures were way off. I thought I had blown it. **Figure 1.7** shows what the image looked like on the back of the camera with the overexposure warning showing black (overexposed) over the majority of the image and the histogram showing just a sliver of levels at the extreme right side.

FIGURE 1.7 The camera LCD showing what appeared to be a severely overexposed and completely useless capture.

I could see some slight hint of texture there in the image when I returned from the shoot, but I didn't expect that there would be anything useful in the image. I originally processed the image in Lightroom 2 and tried playing around with the image by making extreme adjustments of the Blacks and the Tone Curve. Lo and behold, I actually got an image that was not only useful but also actually looked a lot like what I was hoping to achieve when I shot it. **Figure 1.8**, **Figure 1.9**, and **Figure 1.10** show the image in Camera Raw 7 with various settings.

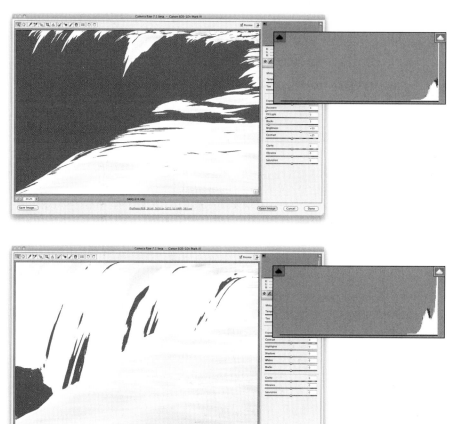

FIGURE 1.8 This is the same raw image shown in the camera LCD. The exposure was 1/2 second at f/11. The histogram shows only a tiny sliver of image data on the far right. It should be noted that Camera Raw's highlight clipping warning was turned on, so the large red area shows what Camera Raw thinks is clipped image data. This figure shows Camera Raw set to Process Version 2010, which was standard in Lightroom 2.

FIGURE 1.9 This figure shows the same image but in Process Version 2012 instead of Process Version 2010. You'll note that the clipping is showing a much smaller area and more textural detail is visible. Not enough, mind you, but it's a step in the right direction.

FIGURE 1.10 For this figure, I made only one primary adjustment: I clicked the Auto button in Camera Raw. You'll see that not only has the image been substantially tone mapped to make the river image "useful," but it actually looks pretty cool. Also, notice that there is no clipping showing in the image or histogram. If you look at the Basic panel subfigure, you'll see the image adjustments Camera Raw decided to make. I did add some Clarity, Vibrance, and Saturation to pump up the local contrast and the colors of the image.

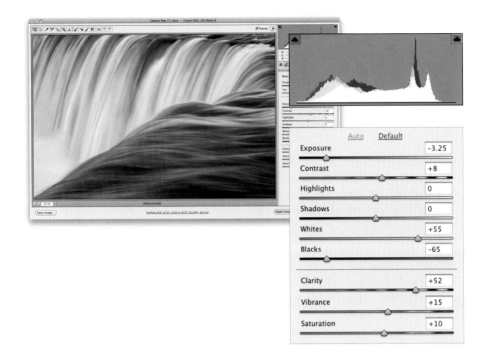

So, what did I learn from this experience? A bunch of stuff that's really useful:

- I needed to get a neutral density (ND) filter to throw in my camera bag for situations just like this. I now have a three-stop ND filter.

- It's *never* a good idea to try to judge an image's potential on the camera's LCD screen, because the camera's highlight warning ("blinkies") is very conservative.

- Camera Raw 7.x and Lightroom 4.x have new processing controls that can render even more image detail out of the tiniest places.

- A linear raw capture can contain a huge amount of data that might look clipped but is actually just "clumped" at the far right side of the histogram. This leads me to the next section.

ETTR

ETTR, short for "expose to the right," is a term I first read about on Michael Reichmann's website The Luminous Landscape (www.luminous-landscape.com). In 2003, Mike wrote an article called "Expose (to the) Right" (www.luminous-landscape.com/tutorials/expose-right.shtml), which recounted a conversation he had with Thomas Knoll about how to properly expose digital captures. Thomas suggested that if the

contrast range of the scene was less than the dynamic range of the sensor, you could get a better signal-to-noise ratio (SNR) if you intentionally overrode the camera's meter and moved the exposure to the right in the histogram.

I need to add some qualifications to the previous statements: They hold true *only* if the scene contrast is less than the dynamic range of the sensor. They also hold true only if the scene or subject doesn't have an arbitrary requirement of f-stop or shutter speed for optimal image capture. It doesn't make any sense to open up the lens if you lose the required depth of field needed for a sharp image. It also doesn't make sense to use a slower shutter speed at the risk of getting a fuzzy, blurred subject.

The concept of ETTR works only when you can increase the exposure (catch more photons) without sacrificing anything else in the image. What Mike (through Thomas) was *not* advocating was overexposing a shot arbitrarily. The advice was to use your knowledge of the dynamic range of your sensor and the scene contrast range to make an intelligent decision to override the camera's meter to better optimize your image capture. It's not about *overexposing* but about *properly* exposing a capture to maximize the SNR and improve your image quality. Does it really work? Yes, it does. And if you're interested in getting the best image quality, pay close attention to what I'll show you next.

I set up this shot using the camera's built-in ability to autobracket five exposures from –2 stops to +2 stops in one-stop increments. In the examples shown in **Figure 1.11**, I show only the –2 and +2 extremes and the middle normal exposure.

NOTE The SNR is a measure in science and engineering that compares the level of signal to the level of background noise. The higher the SNR, the better off you are in terms of image quality. I'll drill down on the whole question of noise later, but for now let me just say that if all other things are equal, capturing more photons will result in a better image.

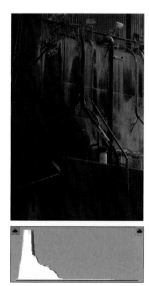

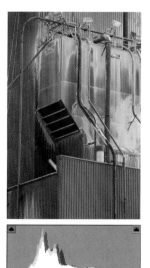

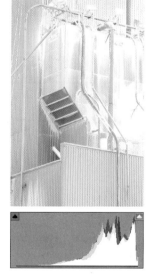

▲ −2 STOPS EXPOSURE COMPENSATION

▲ NORMAL EXPOSURE

▲ +2 STOPS EXPOSURE COMPENSATION

FIGURE 1.11 This is a series of bracketed exposures without any image adjustments. You can see the −2 exposure on the left looks dark with the image data on the left side of the histogram. The middle, normal exposure has a well–distributed histogram with none of the image data clipped. The +2 exposure has the image data in the histogram moved to the right and shows clipping.

It might look like the underexposed and overexposed images are lost causes, but they aren't. By adjusting the image in Camera Raw, I was able to bring up the underexposed image and tone down the overexposed image. All three exposures can look very similar with proper adjustments to the tone mapping. In **Figure 1.12**, you can see the results of the image adjustments.

I suppose this proves that underexposed and overexposed images can be adjusted to look good, but the real takeaway for this demonstration is that the actual image quality of all three images isn't equal. If you zoom in to the images and evaluate the noise, you'll see that capturing more photons really is better! **Figure 1.13** shows a close-up view of each adjusted exposure.

FIGURE 1.12 All three images have been adjusted so the tone and color are consistent. The images look very similar, as do the histograms. The primary tone adjustments to the normal exposure, which served as the basis for correcting the other exposures, were: Exposure +0.10, Whites +43, Blacks −26, and Contrast +14. These adjustments were done by eye to make the middle image look good. The biggest adjustment for the −2 stops image was an Exposure adjustment of +2.05 and for the +2 stops image an Exposure setting of −1.90. You'll see that the clipping in the +2 stops exposure has been eliminated.

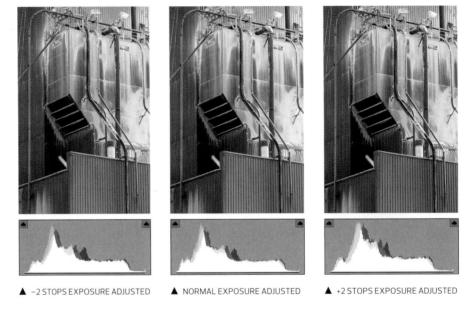

▲ −2 STOPS EXPOSURE ADJUSTED ▲ NORMAL EXPOSURE ADJUSTED ▲ +2 STOPS EXPOSURE ADJUSTED

FIGURE 1.13 The three exposures zoomed to 400 percent in Photoshop to show the differences in the noise levels of each exposure.

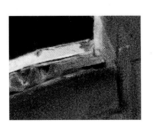

▲ −2 STOPS ZOOMED VIEW ▲ NORMAL EXPOSURE ZOOMED VIEW ▲ +2 STOPS ZOOMED VIEW

This example proves that you can improve the SNR by using the ETTR conceptual approach for scenes with contrast ranges within the dynamic range of the sensor. By capturing a higher exposure and catching more photons, the noise level is reduced and the image quality is improved.

SENSOR NOISE AND ISO SPEED

The topic of sensor noise is complicated because there are different types of noise caused by different factors. Actually, the term *noise* is a bit misleading—the term was coined in the old AM radio days and was used to describe the unwanted electrical fluctuations in signals received by radios that caused an audible noise or static. But if you think of noise as being visual static, you might better grasp what's going on in a sensor.

The two basic types of noise are random noise (which is actually more accurately defined as pseudo-random noise following a Poisson distribution) and pattern noise. Pattern noise often can be substantially reduced by computational methods. Random noise really can't be totally eliminated, although low-level blurring can reduce it. **Figure 1.14** shows the two types of noise.

The images in Figure 1.14 show some pretty egregious noise that was produced with an old Canon EOS 10D camera. I keep this poor thing around because it produces really good examples of really bad noise. (More modern sensors don't work near as well for producing examples!) The random noise was shot at ISO 3200 at a normal exposure. The pattern noise was shot at ISO 100 but using a 30-minute exposure (with the lens cap on), which is way too long for this particular sensor (but the pattern noise it produces is really great, if that's what you're looking for).

FIGURE 1.14 The two basic types of noise found in digital captures.

▲ RANDOM NOISE

▲ PATTERN NOISE

Although there are really only two types of noise, there are three main causes of sensor noise. It's useful to understand the distinctions:

- **Shot noise** (or photon noise) is a quantum effect of light and time. A photosite counts the stream of photons that strike it over a particular period of time, but the light from a scene doesn't arrive at the sensor in an even, regular stream. When you expose the sensor for a short period of time (in ratio to the total number of photons), the lack of regularity in the stream will create fluctuations in the photon count, causing random noise. The more photons that strike a sensor during exposure, the higher the signal-to-noise (SNR) ratio, and the less the amount of perceived noise. Sensors with larger pixels, like those found on full-frame DSLRs or medium-format digital camera backs, gather more photons per pixel (in other words, each pixel is more efficient) and, hence, produce images with less perceived shot noise. Since shot noise is a fundamental property of light, even images captured by a theoretically perfect sensor would still have some shot noise.

- **Read noise** (or readout noise) is a combination of noise components inherent in the sensor electronics that convert the stored sensor charge into digital data (zeros and ones). Read noise often contains random and fixed-pattern components. Fixed-pattern read noise is the more visually objectionable of the two, often showing up in images as horizontal or vertical lines or other easily seen patterns. Fortunately, most of the fixed-pattern noise can be eliminated through so-called black subtraction or black-frame subtraction methods. Some cameras actually perform this step in hardware prior to writing the raw file to the memory card.

- **Dark noise** (or thermal noise) is caused primarily by the heat energy in the sensor itself being converted into a digitized signal. Like read noise, dark noise tends to have random and fixed-pattern components. In some cases, the fixed pattern is related to the position of various electronics around the sensor and can lead to one part of the image being considerably noisier than other areas; this unpleasant effect can be reduced by the same black-frame subtraction methods used for patterned readout noise. Very high-end astronomical cameras and some medium-format backs use cooling systems to reduce or eliminate thermal noise.

In the two examples shown in Figure 1.14, the image showing the random noise is primarily shot noise. The shot noise of a particular sensor is consistent at both high and low ISOs (see the sidebar "ISO and sensor noise" for more information). The pattern-noise example has lots of different noise going on; it has the salt-and-pepper type of speckles (shown as color specks in a color sensor), it has vertical stripes showing pattern noise, and it shows thermal noise in the lower-right corner and along the bottom and right side. The thermal noise is because of the internal components of the camera heating up during the 30-minute exposure.

ISO AND SENSOR NOISE

Increasing a camera's ISO increases the amplification applied to the sensor's captured signal, thereby increasing perceptible shot noise, early-stage electronic read noise, and thermal noise. The amplifiers themselves also may contribute some noise of their own, thus adding to the total combined noise present in the final image. Consequently, increasing the ISO results in noisier-looking images, particularly in the shadow areas where the SNR ratio is lowest. Ironically, while the noise is amplified (and images appear noisier), the actual noise signature in a high-ISO capture is essentially the same as it is at a lower ISO—it's just made more visible by the amplification and, thus, considered objectionable. See **Figure 1.15** for base ISO and an amplified ISO 3200.

The better the sensor design and light-gathering efficiency, the better the noise signature of a given camera will be. Great strides have been made in recent years in the improvement of light-gathering efficiency by reducing the wasted space surrounding sensor photosites, as well as by developing light-gathering microlenses. Recent cameras have even claimed to offer "hyper ISOs" up to ISO 25,600 or more. However, these extended ISO settings aren't implemented through true analog hardware amplification as described earlier; instead, they're implemented through digital gains (equivalent to pushing the exposure control in post-processing by +1, +2, or more stops). Even so, the highest real ISO of many of these cameras (using hardware amplification) is 3200 or 6400, which is remarkable and still very usable in practice.

If this discussion of sensor noise made your eyes glaze over, here's the main takeaway: To a certain degree, sensor noise will always be there. The higher the ISO setting on the camera, the more perceptible the noise will be. With a given camera, the noise may become objectionable at some higher ISO settings and lead you toward wanting to do something to reduce the apparent noise. The manner of dealing with the various sensor noises usually breaks down into color noise and luminance noise reduction and will depend entirely on what application you're using. Camera Raw and Adobe Lightroom have separate noise controls for color and luminance. The current noise-reduction capabilities of Camera Raw and Lightroom have improved considerably, mitigating the need for third-party noise-reduction applications.

▲ PERCEPTIBLE NOISE AT ISO 100

▲ PERCEPTIBLE NOISE AT ISO 3200

FIGURE 1.15 The perceptible noise for the Canon 10D at ISO 100 and ISO 3200.

▲ NO COLOR NOISE REDUCTION

▲ COLOR NOISE REDUCTION AT SETTING +100

▲ COLOR AND LUMINANCE NOISE REDUCTION BOTH SET TO +100

FIGURE 1.16 Color and luminance noise reduction in Camera Raw.

It should be noted that I intentionally turned off the default Canon black subtraction calculations for a few reasons: First, I wanted to have a really good example of bad thermal noise. Second, a black subtraction requires a second exposure the same length as the primary exposure, and I didn't want to sit around waiting for that second 30-minute exposure!

Camera Raw and Lightroom both offer different noise-reduction algorithms for luminance-based noise and color-based noise. All CFA cameras suffer from color noise to a greater or lesser degree—it's an inevitable by-product of demosaicing. Color noise can raise its head anywhere. It's largely independent of ISO speed (although more obvious at higher ISOs) or exposure settings, and it can appear in highlights, shadows, or midtones. It does, however, vary from camera to camera. Most raw converters do a good job of eliminating color noise, so much so that many shooters use a "set and forget" approach, dialing in a default color noise-reduction setting for each camera.

Figure 1.16 shows color noise from a digital neg made at ISO 3200. The capture is from the same Canon EOS 10D to better show the color noise. Recent cameras exhibit better color noise reduction as part of the analog-to-digital conversion. Unless you have a compelling reason to change it, the Camera Raw and Lightroom default setting of 25 is suggested.

The main point to be made when considering high-ISO noise and noise-reduction techniques is at what point is noise relevant or irrelevant? Downsampling is a very effective noise-reduction technique!

Looking at an image at 100 percent to 400 percent zoom in Camera Raw or Lightroom doesn't give you a realistic (or particularly useful) view of your image's noise signature for print. Zooming out to 25 percent to 50 percent can give you a more realistic representation, albeit in much lower resolution than your printer can print. Some raw converters, particularly those from camera vendors, have a tendency to bury shadow noise simply by clipping shadows to black, but it's always worthwhile to address luminance noise in the raw converter when using Camera Raw or Lightroom.

COLORIMETRIC INTERPRETATION

When you shoot JPEG, you typically have a choice between capturing images in either sRGB or Adobe RGB (1998). Yet the vast majority of today's cameras can capture colors that lie well outside the gamut of either of these spaces, especially in the case of saturated yellows and cyans. When you shoot in sRGB or Adobe RGB, those colors get clipped forever, as if they never existed!

Raw converters vary in their ability to render images in different color spaces, but Camera Raw offers four possible color spaces and Lightroom offers three. **Figure 1.17** shows the color space settings in Camera Raw and Lightroom.

One of these color spaces, ProPhoto RGB, encompasses all the colors your cameras can capture and the vast majority of colors we can see. If you see serious color clipping on a conversion to ProPhoto RGB, you're probably capturing something other than visible light!

I'll talk a bit more about the use of various color spaces and the origins of ProPhoto RGB in Chapter 2, but here I'll concentrate on the size of the gamut contained in the various options in Camera Raw and Lightroom because it pertains directly to the processing of digital negs.

NOTE When you're shooting raw, the color setting you make on your camera has zero impact on the color space in which your camera captures. The color settings, in-camera impact what your image looks like on the camera's LCD and the EXIF preview, but the color setting on the camera is merely a metadata tag when shooting raw and doesn't alter the raw data in any way.

▲ COLOR SPACE SETTINGS IN CAMERA RAW'S WORKFLOW OPTIONS DIALOG BOX

FIGURE 1.17 Color space settings.

▲ COLOR SPACE SETTINGS IN LIGHTROOM'S EXTERNAL EDITING TAB OF THE PREFERENCES DIALOG BOX

NOTE The sRGB color space was developed by Hewlett-Packard and Microsoft in 1996 for use as a standard color space for displays, printers, and the Internet. An HP engineer named Michael Stokes, who later moved to Microsoft, spearheaded the color space. Microsoft settled on sRGB to be the default standard color space of Windows. Over the years, there has been a debate about what the s in sRGB referred to. I have a couple ideas: it may stand for "standard" RGB or "simple" RGB. Others (myself included) have thought it stood for "satanic" RGB or a somewhat less civil "s" word. But, for good or evil, sRGB has been adopted as the default color space of the Internet.

I could use a variety of metaphors to try to explain the differences in the gamut or total volume of colors that can be contained in a color space. I'll choose a metaphor you may be experienced with: volume. If sRGB (which is the smallest total volume of colors available in Camera Raw or Lightroom) is a pint, Adobe RGB is a quart and ProPhoto RGB is a gallon. If your camera can capture more than a quart but less than a gallon, and you want to keep all the colors your camera can capture, the only color space to use in Camera Raw or Lightroom is the gallon-size ProPhoto RGB color space.

If you artificially constrain your colors spaces to sRGB or Adobe RGB, you're clipping colors your camera can capture, colors that you can use when image processing, and some colors you could actually print. The only color space you can choose that contains all the colors your camera can capture in Camera Raw and Lightroom is ProPhoto RGB. There are other color spaces that could contain your camera's colors, but they aren't readily available in Adobe's raw processing applications.

There are several good reasons for maintaining the total colors your camera can capture for as long as you can when processing digital images:

■ If you render your digital negatives in ProPhoto RGB, you can take full advantage of the colors your camera can capture for later post-processing in Photoshop. These rendered RGB images in ProPhoto RGB become your RGB masters.

THE ACCIDENTAL COLOR SPACE

The Adobe RGB (1998) color space started life as a typo. Back in 1998, Photoshop 5 was released and the major new feature was color management. The concept was to have three kinds of color spaces: input color spaces, working color spaces, and output color spaces. It seemed simple enough, but way too many people's heads exploded. When Photoshop 5 was released, it contained a color working space that was mysteriously named SMPTE-240M. It seems a Photoshop engineer by the name of Mark Hamburg had been surfing the Internet to learn more about RGB color spaces. On the website of the Society of Motion Picture and Television Engineers (SMPTE) there was a "proposed" color space for the editing of HD video tentatively named SMPTE-240M. Mark copied the RGB color coordinates and gamma information, made an ICC profile, and named it SMPTE-240M. That color space shipped with Photoshop 5.0. The problem: it was merely a proposed RGB color space and hadn't actually been ratified by SMPTE. In addition, there seems to have been a slight typo on the specification of two of the RGB colors. That typo was corrected in a later proposal. SMPTE contacted Adobe and asked for a correction. However, the actual color space (typos included) was deemed to be "useful," so it was renamed Adobe RGB (1998) and shipped in the Photoshop 5.0.1 update.

- Time doesn't stand still, and new technologies are being developed that can take better advantage of wider color-space images. I use NEC wide-gamut displays for digital imaging that can display about 98 percent of the total colors in Adobe RGB (there are no displays that can contain all the colors in ProPhoto RGB, and there may never be), so if I limit my images to sRGB, I limit the total volume of colors in my images. I don't like that. Do you?

- Most important, in digital imaging, more precision is better. If your final output ends up being limited to a smaller total volume of color than you need, then you have to edit in a larger total volume of color to start with. A theorem called the Nyquist sampling theorem postulates that in order to end up with a certain degree of accuracy at the end of signal processing, you need to start off with at least two times the degree of accuracy you want to end up with. ProPhoto RGB is the largest by far of all the options in Adobe raw processors, and while I don't know for a fact if it's over two times the size of Adobe RGB or sRGB, I'm pretty sure it does approach the conditions needed.

Figure 1.18 shows an example image with a lot of various bright and saturated colors. I processed this same image in Camera Raw to three different color spaces—sRGB, Adobe RGB, and ProPhoto RGB—to demonstrate the impact of clipping color spaces.

FIGURE 1.18 Color spaces and the loss of colors due to color clipping. The gamut plots were done with a color space visualization tool called Color Think by Chromix (www.chromix.com) that plots color spaces in the L*a*b color space. The image colors are plotted as small square points both inside and outside the gamut plots of the respective color spaces.

◀ THE ORIGINAL IMAGE PROCESSED FROM CAMERA RAW TO PROPHOTO RGB

▲ THE IMAGE PLOTTED INTO SRGB COLOR SPACE

▲ THE IMAGE PLOTTED INTO ADOBE RGB COLOR SPACE

▲ THE IMAGE PLOTTED INTO PROPHOTO RGB COLOR SPACE

Neither sRGB nor Adobe RGB color spaces can contain all the colors in the original image. The result of either shooting (in JPEG) or processing the original image into either of those two color spaces is the loss of color fidelity and accuracy. The colors that appear outside the color space gamut cease to exist. Only ProPhoto RGB can contain and, therefore, make use of those colors when processed.

METADATA

I'll keep this short, but I feel the need for a basic explanation of the role of metadata in digital negs. There are basically three types of *metadata* (data about data) that can be contained in a digital negative.

The first type of metadata is the metadata embedded by the camera itself. The specification is called Exchangeable image file format (Exif). The Japan Electronic Industries Development Association (JEIDA) created the Exif standard. JEIDA and the Camera & Imaging Product Association (CIPA), which succeeds the Japan Camera Industry Association jointly, formulated the most recent version, version 2.3. The Exif metadata schema defines how certain tags are embedded in the raw file at the time of capture. Some of the basics, such as date, time, and camera settings, are obvious. But other tags can be embedded, such as image descriptions, copyright information, and a thumbnail for viewing. The Exif structure borrowed many TIFF standards. There are also standard tags for location and GPS coordinates. Exif tags can be either publically defined metadata or private makers' notes that are undocumented. The Exif metadata is what you see in the image File Info; it's used by both Camera Raw and Lightroom when setting defaults for file handling.

The second type of metadata, the IPTC Information Interchange Model (IIM) metadata, is not embedded in the raw file but can be added later. This schema was developed by the International Press Telecommunications Council (IPTC) to expedite the international exchange of news among newspapers and news agencies. Although IIM was intended for use with all types of news items—including simple text articles—a subset found broad worldwide acceptance as the standard embedded metadata used by news and commercial photographers. Information such as the name of the photographer, copyright information, and a caption or other description can be embedded either manually or automatically.

The third type of metadata was developed by Adobe and is called the Extensible Metadata Platform (XMP). XMP defines a metadata model that can be used with any defined set of metadata items. XMP also defines particular schemas for basic properties useful for recording the history of a resource as it passes through multiple processing steps, from being photographed, scanned, or authored as text, through photo-editing steps (such as Camera Raw or Lightroom adjustment parameters), to

NOTE While the camera embeds the Exif metadata directly in the camera's raw file, due to the undocumented nature of those raw files, it isn't considered prudent for third parties to do so. As a result, IPTC and Adobe's XMP metadata are stored in text-based sidecar files that must (hopefully) travel with the raw file. Other file formats such as TIFF and JPEG can have IPTC and XMP metadata safely added to the files. Digital Negative Format (DNG), which is Adobe's documented raw file format, also can have metadata safely written into the file.

FIGURE 1.19 Various metadata schemata contained in a digital negative file.

the assembly into a final image. XMP allows each software program or device along the way to add its own information to a digital resource, which can then be retained in the final digital file.

There are lots of other metadata standards in general use, but these three are the ones of primary interest to photographers. **Figure 1.19** shows the File Info for a digital negative from within Bridge.

BIT DEPTH

Back in the "Linear capture" section of this chapter, I made reference to the bit depth of raw capture files. If you got to this point without your brains turning to mush, congratulations! But if you kind of glossed over that section without really understanding it, let me give you just a bit (pun intended) of information to help you out.

Bit depth is the number of bits used to describe the information and number of discrete levels in a digital capture. It's usually expressed as a certain number of bits per channel. So, a DSLR can usually capture between 12 and 14 bits per channel, which equates to between 2^{12} to 2^{14} or 4096 to 16,384 levels per channel. Some cameras can exceed this; for example, the Nikon D800 has a dynamic range of 14.4 stops, so clearly it's capturing more than 14 bits of information per channel. Many medium-format digital backs claim 16-bit captures (although in reality it's really only 14+ bits, depending on what you consider usable bits versus noise).

When you shoot raw, you have, by definition, captured everything the camera can deliver, so you have much greater freedom in shaping the overall tone and contrast for the image. You also produce a file that can withstand a great deal more editing in Photoshop than an 8-bit/channel image can.

NOTE What is a bit? A bit (short for binary digit) is a basic unit of binary information in computing where the information exists or is stored in one of two states: a 0 or a 1. A byte is 8 bits, a kilobit is 1024 bits, and so on. When used to indicate bit depth of digital images, it's standard to refer to the per-channel bit depth. So, an 8-bit JPEG would have three channels of 8 bits for a total bit depth of 24 bits. A 16-bit RGB image would have three channels for a total of 48 bits.

Edits in Photoshop are destructive—when you use tools such as Levels, Curves, Hue/Saturation, or Color Balance, you change the actual pixel values, creating the potential for either or both of two problems:

- **Posterization:** This can occur when you stretch a tonal range. Where the levels were formerly adjacent, they're now stretched apart, so instead of a gradation from, for example, level 100 through 101, 102, 103, 104, to 105, the new values may look more like 98, 101, 103, 105, and 107. On its own, such an edit is unlikely to produce visible posterization—it usually takes a gap of four or five levels before you see a visible jump instead of a smooth gradation—but subsequent edits can widen the gaps, inducing posterization.

- **Detail loss:** This can occur when you compress a tonal range. Where the levels were formerly different, they're now compressed into the same value, so the differences, which represent potential detail, are tossed irrevocably into the bit bucket, never to return.

Some vendors try to equate bit depth with dynamic range. This is largely a marketing ploy because although there is a relationship between bit depth and dynamic range, it's an indirect one. The dynamic range of a digital capture can't really exceed the total number of bits in the original raw capture.

Dynamic range in digital cameras is an analog limitation of the sensor. The brightest scene information the camera can capture is limited by the capacity of the sensor element. At some point, the element can no longer accept any more photons—a condition called *saturation*—and any photons arriving after saturation aren't counted. The subjective aspect is the exact point at which the noise inherent in the system overwhelms the very weak signal generated by the small number of photons that hit the sensor. The subjectivity lies in the fact that some people can tolerate more noise in their photographs than others.

One way to think of the difference between bit depth and dynamic range is to imagine a staircase: The dynamic range is the height of the staircase. The bit depth is the number of steps in the staircase. If you want your staircase to be reasonably easy to climb, or if you want to preserve the illusion of a continuous gradation of tone in your images, you need more steps in a taller staircase than you do in a shorter one, and you need more bits to describe a wider dynamic range than a narrower one. But more bits, or a larger number of smaller steps, won't increase the dynamic range, or the height of the staircase.

The bottom line is, more bits are better when you're doing image processing. If the final output needs 8 bits/channel, then you'd better be doing the image processing in a greater bit depth than what you need to end up with.

RAW VERSUS JPEG

Yeah, I know, the odds are pretty good that if you bought this book, I don't need to evangelize the benefits of shooting raw instead of JPEG. But if you have friends who like to argue this issue with you, let me give you some ammunition.

The raw capture gets everything your camera's sensor can see. A JPEG is also a raw capture (all sensors always capture all the data the sensors see), but the resulting image has been modified or processed by the camera's analog-to-digital conversion and the camera has "baked in" some critical attributes such as bit depth, color space, tone mapping, and white balance. If the raw capture is the cookie dough, then a JPEG is a baked cookie. Personally, I really, *really* like cookie dough.

When I say that JPEG images from cameras are "baked," I mean it (although one could argue that they may be only half-baked). Each camera manufacturer has defined a certain "look" it wants to present to photographers who may buy its cameras. There is nothing particularly accurate or absolute in these looks—they're just a certain pre-set the camera manufacturers have settled on. The analog-to-digital converter takes the raw image captured by the sensor, makes certain assumptions, and processes the raw image data to arrive at a given rendering. Most camera companies have resorted to the more contrasty and saturated look many photographers associated with film—the cameras are designed to make film-like images. The problem is that once the image is baked the manufacturer's way, it becomes more difficult to bake it your way because large chunks of your image data have been baked away in someone else's ovens! **Figure 1.20** shows the impact of taking a continuous tone image and saving it as a JPEG. I'll admit, this is a worst-case scenario to demonstrate the "badness" of the JPEG process, but it's accurate.

▲ 8-BIT CONTINUOUS TONE COLOR IMAGE BEFORE JPEG COMPRESSION

▲ THE RESULT OF COMPRESSING A JPEG AT LEVEL 1

FIGURE 1.20 This shows the result of taking an 8-bit RGB image and saving it with a level-1 JPEG compression.

JPEG (which stands for the Joint Photographic Experts Group) is a method of (usually) lossy compression for digital photographic images. Compression isn't a bad thing in and of itself—we couldn't have fast-loading images on the Internet without some sort of compression. But this sort of compression as the starting point for a photograph that's intended to undergo additional image processing is less good. JPEG compression tries to maintain the luminance data while compressing the heck out of the color data. The thought here is that color compression is less harmful (lossy) than the luminance data, which is true. However, as you can see in Figure 1.20, the loss of color gradations can be detrimental. If what you start with is an 8-bit RGB image, and you compress it as a JPEG, the resulting JPEG image no longer has all its bits!

The real problem with JPEG images from digital captures is that going from the original raw file with a linear gamma, the gamma encoding is baked in the file. So, if you understand how much headroom a raw capture can contain, that headroom is lost when compressed to JPEG. In the case of the image shown in Figure 1.8, you would get a totally useless image had that capture been a JPEG. I'll admit that's an extreme case, so let me present you with another example with a shot done using a Canon EOS 1Ds Mark III set to record both raw and JPEG files at the same time. One image is written as a raw file, and the other has gone through the camera's JPEG compression. It's the same shot, just two different renderings (**Figure 1.21**).

It's a tough shot to meter. The background is very bright and the bird is in deep shadow. But as I've shown (and will show throughout the rest of this book) there's a lot of potential using post-processing in Camera Raw or Lightroom. For **Figure 1.22**, both images were loaded into Camera Raw for adjustments. All the image adjustments for both the JPEG and raw files are the same. First, I processed the raw file to get it the way I wanted; then I synced the settings to the JPEG image.

FIGURE 1.21 Comparing the original JPEG and raw file from the camera.

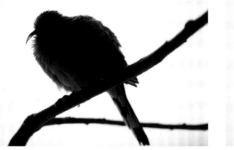

▲ THE ORIGINAL JPEG CAMERA FILE

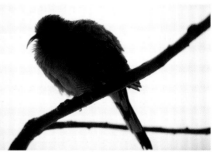

▲ THE ORIGINAL RAW CAMERA FILE

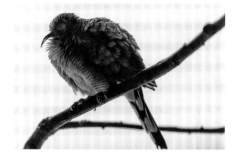

FIGURE 1.22 Comparing the adjusted JPEG and raw images.

▲ THE ADJUSTED JPEG IMAGE ▲ THE ADJUSTED RAW IMAGE

A couple things jump out at you when you compare the adjustments to the JPEG and the raw image. The first is that the JPEG has lost a lot of highlight detail in the background. That's to be expected because the original JPEG lost a ton of editing headroom in the highlights. Tougher to see in the book reproduction is that the shadows of the bird didn't respond very well to the Shadows adjustment used to lighten the body of the bird. The color and tone gradations aren't as smooth, and the shadow areas look blocked up. Yes, I'll admit that when I shot the image, I could have done a bit of ETTR to lighten the whole image, but that wouldn't have done much good for the JPEG; I'm already suffering a loss of highlight detail as it is.

The main point I'm trying to get across (and the ammunition you need for debates over JPEG versus raw) is that JPEG captures lock you in and reduce flexibility. If you're like me, you want maximum flexibility when processing your digital images, right?

PHOTOGRAPHIC ASPECTS OF A DIGITAL NEGATIVE

So far in this chapter, I've concentrated on the technical aspects of a digital negative file. However, I now want to talk about the photographic aspects of the digital neg. Regardless of how skilled and talented you are at processing raw files, there's not much you can do to alter fundamental flaws in photographic technique. The old saying GIGO (garbage in, garbage out) holds true when it comes to the image quality of the original capture. Yes, post-processing can fix a lot of ills, but you're better off if you're working on a healthy image to start with.

TIP If you really want to maximize image quality, you may want to lock down your camera on a quality tripod. It's a pain, believe me. I've dragged my tripods all over the world, and nothing is more frustrating than bringing a tripod and not using it. But if you don't bring it, you certainly won't be able to use it.

SHUTTER SPEED

The brief moment of time a camera's shutter is open is the essential capture. Selecting a shutter speed that is appropriate for the shooting conditions is critical.

You need to understand the relationship between lens focal length and shutter speed for stopping either camera shake or subject motion. Another element you need to consider is the ISO factor. If you can get a sharper capture by increasing the ISO, do it. **Figure 1.23** shows two shots of a dragonfly; one is sharp and the other isn't.

I shot both images with a Panasonic Lumix GH2 camera with a 14–140mm lens with image stabilization (IS). After I captured the first shot, I chimped the image on the LCD while zoomed in. I could clearly see motion blur, which ruined the image. I adjusted the ISO to 320 and the shutter speed to 1/400 second and shot again.

Even though the lens had IS, that didn't really help because I was at the longest 140mm focal length (a 280mm equivalent for 35mm film), so 1/200 second was not

FIGURE 1.23 Comparing the results of increasing ISO to be able to use a faster shutter speed.

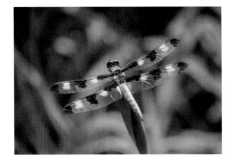

▲ HANDHELD SHOT AT 1/200 SECOND AT ISO 160

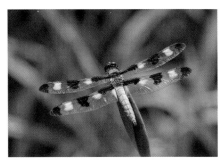

▲ HANDHELD SHOT AT 1/400 SECOND AT ISO 320

▲ DETAIL OF THE 1/200 SECOND SHOT AT 100 PERCENT ZOOM IN PHOTOSHOP

▲ DETAIL OF THE 1/400 SECOND SHOT AT 100 PERCENT ZOOM IN PHOTOSHOP

fast enough. And although there is a bit more noise in the higher-ISO capture, it was easy to reduce it in Lightroom by adjusting the luminance noise reduction. The improvement in the image sharpness was helped by the faster shutter speed and not hurt by the higher ISO.

Yes, use a tripod if you can. But if you can't, you're better off using a higher ISO than a lower ISO. Dealing with noise is much easier than trying to fix camera shake or motion blur caused by a too-slow shutter speed.

LENS APERTURE

The f-stop you use will impact the sharpness of your digital neg. When capturing a scene, the smaller the aperture, the greater the depth of field (DOF). DOF is the distance between the closest and farthest object in a scene that appears reasonably sharp. Many factors impact the overall DOF, such as focal length and distance from the subject, as well as the sensor format you're using (smaller sensors exhibit greater apparent DOF than larger sensors).

So, you might think DOF problems can be solved by simply stopping down the lens (using a smaller f-stop), right? Yes, but there are consequences to using an aperture that's too small. You encounter a problem called *lens diffraction,* which actually makes your image softer. The diffraction occurs because of the lens iris—light is bent around the edge of the iris and spreads, causing the image to lose sharpness (**Figure 1.24**).

Both images were captured by a 100mm macro lens. The image shot at f/8 is clearly sharper with better detail than the image captured at f/32.

Most lenses have a sweet spot where a given aperture provides an optimal image-forming capability. This optimal aperture is usually found when the lens is stopped down two to four stops from wide open. As a result, a fast lens with a very

▲ IMAGE SHOT AT F/8

▲ IMAGE SHOT AT F/32

FIGURE 1.24 Comparing the impact of lens diffraction.

wide aperture, such as f/1.4, will perform better at an aperture between f/2.8 and f/5.6. Stopping down the lens to f/8 or f/11 probably won't degrade performance, but stopping way down to f/22 or f/32 will, because of lens diffraction. So, choose your aperture wisely.

By the way, there are focus-blending techniques you can use to blend multiple shots to achieve optimal DOF with excellent image sharpness. I cover these techniques in Chapter 5.

LENS ABERRATIONS

When lenses are designed for photographic use, many factors come into play, such as the quality and type of glass used, the number of individual lens elements and lens groups, and the angle of view of the lens. An extreme wide-angle lens has different problems a lens designer must deal with than a telephoto lens has. A zoom lens adds enormous complexities.

If you had an unlimited budget, a lens designer could design out almost all the various problems or aberrations in the image projected on the sensor. But such a lens would be very expensive and likely huge, so designers have to make compromises. As a result of those compromises, some amount of lens aberrations must

TESTING YOUR NEW LENS

When you get a new lens, test it out to make sure you got a good copy of the lens and that it performs as expected. I start by taking the lens out for "technical" shooting as opposed to trying to get good shots. I shoot with the lens wide open and then at each aperture the lens has. The aim here is to check the image quality the lens offers, not make a great photograph. I generally put the camera on a tripod so camera shake doesn't interfere with the lens test. I also shoot the lens at infinity and at the closest focus. I shoot brick walls to check distortion. And I test the autofocus accuracy of the lens to make sure it doesn't front or back focus. (Some cameras allow you to calibrate the autofocus and adjust for differences.)

If the lens can't pull good focus, doesn't look sharp at any aperture, and you're disappointed, return the lens for an exchange and test the replacement lens. I've been known to return two or three lenses before I was satisfied.

If you've had a lens for a while and you're finding that you no longer get the sort of quality you got when you first bought it, send the lens in for factory service. I often test a lens just before the warranty is due to expire and, if necessary, have the lens repaired.

be tolerated. Some of those image-quality issues can be dealt with after the fact by image processing; others can't. Lens aberrations fall into two general categories: monochromatic (affecting all colors of light) and chromatic (affecting different colors of light differently).

Monochromatic lens aberrations

Putting a cheap lens on a really great, high-resolution camera is a crying shame. A quality prime (fixed focal length) lens will generally give better image quality than even the best zoom lenses. But not all primes or zooms are equally good or bad. Individual copies of even expensive lenses can vary in their performance, so you should test any new lens you buy to determine whether it's a good or a bad one—and don't be shy about returning a lens for a replacement (which is easier to do sooner rather than later).

The lens quality is based on how well various lens defects or aberrations are handled by the designer and manufacturing tolerances. The following aberrations are all *monochromatic,* meaning they impact lens performance even for a single color of light. The three lens aberrations that directly impact image sharpness are spherical aberration, astigmatism, and curvature of field:

- **Spherical aberration** is the inability of all light rays to focus at the same point. Rays at the edge of the lens (called *marginal rays*) come to focus closer to the lens than do rays that are parallel to the axis or center (called *paraxial rays*). This causes the focus to drift as you stop down the lens. Some lenses use aspheric elements to better correct spherical aberration at wide apertures.

- **Astigmatism** is the inability of the lens to bring to focus both vertical and horizontal lines on the same plane. It will appear that lines of equal density (darkness) are less dense horizontally or vertically. Stopping down the lens can improve astigmatism.

- **Curvature of field** results from the image plane being formed as a curved surface, not a flat one. As a result, when the center of the image is in focus, the edges are not, and vice versa. Stopping down the lens may improve the overall sharpness, but it won't fix the field curvature.

Spherical aberration affects the whole image, while astigmatism and curvature of field affect mostly the edges and corners.

The better the lens design is at dealing with these aberrations, the better your image quality will be, but there's not a lot you can do in post-processing to correct them. Again, the better the lens, the better your digital negative will be with regards to image quality.

FIGURE 1.25 Comparing uncorrected and corrected curvilinear distortion.

▲ A BRICK WALL WITH UNCORRECTED BARREL (CONVEX) DISTORTION

▲ A BRICK WALL CORRECTED BY USING THE ENABLE PROFILE CORRECTIONS OPTION IN THE LENS CORRECTION PANEL

There is another lens aberration common to zoom lenses and some cheaper prime lenses called *curvilinear distortion* (also called *barrel* or *pincushion distortion,* depending on whether the distortion is convex or concave). Fortunately, Camera Raw and Lightroom can correct this distortion in the Lens Correction panel. **Figure 1.25** shows an example of uncorrected and corrected curvilinear distortion.

One of the downsides of correcting for this distortion is that you must sacrifice part of the outer portions of the image to correct the distortion. The other problem is that the correction uses a degree of image interpolation to make the corrections, which can have a slightly negative impact on the image quality.

Chromatic lens aberrations

Chromatic aberrations involve the way a lens performs with different colors of light. There are two types of chromatic lens aberrations:

- **Lateral chromatic aberration** is the lateral displacement of color images at the focal plane. This type of aberration is caused by different sizes of images produced by different colors, even though the image is all on the same plane. This chromatic aberration produces color fringing of red or blue, and it isn't improved by stopping down.

- **Longitudinal chromatic aberration** is the inability of a lens to focus all wavelengths (colors) of light at the same plane on the lens axis and is often seen as a color fringe. Shorter wavelengths come to focus in front of the focal plane; longer wavelengths, behind. This defect is not improved by stopping down the lens. This aberration is normally noticeable only in cheaper long telephoto lenses and is reduced by the use of exotic glass elements, referred to as LD (low dispersion), ED (extra-low dispersion), AD (anomalous dispersion), and Fluorite.

Fortunately, both Camera Raw and Lightroom can address these issues (**Figure 1.26**).

FIGURE 1.26 Comparing uncorrected and corrected chromatic aberrations.

▲ LATERAL AND LONGITUDINAL CHROMATIC ABERRATIONS UNCORRECTED

▲ LATERAL CHROMATIC ABERRATION CORRECTED, SHOWING A MILD LONGITUDINAL CHROMATIC ABERRATION UNCORRECTED

▲ LATERAL AND LONGITUDINAL CHROMATIC ABERRATION CORRECTED

SENSOR RESOLUTION

One thing you have to understand about capture resolution is that all Camera Raw and Lightroom care about is the pixel resolution of the original capture. A digital capture has no pixels per inch (PPI) until you decide on the image dimension of the final reproduction. So, as far as raw processing is concerned, you really need to know only how many pixels wide and tall the capture may be. To get this point across, let's compare a shot done by two different cameras: an Apple iPhone 4 with an 8 MP camera, which retails for as little as $199, and a Phase One IQ180 80 MP camera back, which retails for over $40,000. Which one do you think is "better"? **Figure 1.27** shows adjusted images from each camera.

FIGURE 1.27 Comparing camera A to camera B.

▲ CAMERA A

▲ CAMERA B

FIGURE 1.28 Comparing the iPhone and IQ180 captures.

▲ THE IPHONE CAPTURE SIZED TO MATCH THE IQ180 CAPTURE

▲ THE IQ180 CAPTURE AT A 100 PERCENT ZOOM IN PHOTOSHOP

You probably thought it would be easy to figure out which camera produced which photograph, right? Well, I wanted it to be just a little more difficult to make that determination. I brought both the JPEG from the iPhone and the raw capture from the IQ180 back into Camera Raw and did a little work on each to match the overall tone and color. Given that the size of the image reproduced in the book isn't huge, I'm not surprised that I was able to adjust each image to be very close. That was the point of the exercise: to show that the resolution of the original capture is really dependent on the final image size of the reproduction. If all you need is a small image for a book or website, it's pretty silly to buy a $40,000 camera to create it. The real story of high-resolution, high-image quality sensors needs to be told when the image is reproduced large. Check out **Figure 1.28** and see if you can figure out which is which.

Once you zoom in to the captures, it's pretty easy to tell the iPhone from the IQ180. The IQ180 capture was set to a 100 percent zoom in Photoshop. The iPhone image had to be set to a zoom of 320 percent to appear the same size. Clearly, the resolution of the IQ180 is vastly superior if you want to make a really large print. The iPhone capture was 2448x3264 pixels and could make a reasonable print of 6.8x9 inches at 360 PPI. The IQ180 capture was 7760x10,328 pixels and would make a reasonable print of 21.5x28.7 inches at 360 PPI.

To be honest, when I set up this shot, I was really surprised at the image quality of the iPhone 8 MP capture. It was a lot better than I was expecting from a cameraphone.

By the way, if you're still trying to figure out which camera produced which image in Figure 1.27, camera A was the IQ180 and camera B was the iPhone.

I shot this image of a rusty, old truck on a photographic trip to the Palouse region of Washington State during harvest season. It was shot on a Phase One 645DF camera with a Phase One IQ 180 medium-format camera back and a 120mm macro lens.

ADOBE RAW IMAGE PROCESSING: AN OVERVIEW

Photoshop has been around for over 20 years, but all the Adobe applications for raw image processing of digital negatives are just youngsters. There are two distinctly divergent approaches to raw image processing: Lightroom and the Camera Raw plug-in with Bridge and Photoshop. Although Lightroom and Camera Raw share the same underlying processing pipeline, each is unique with regard to its origins and purposes. To fully comprehend their differences and similarities, it helps to understand how and why they were developed.

By the way, other worthy third-party raw image-processing applications are out there. I even use one—Capture One from Phase One—when I'm tethering to my Phase One camera. But my preference is to use the applications from Adobe covered in this chapter.

THE GENESIS OF CAMERA RAW

Shortly after the release of Photoshop 7 in the spring of 2002, Adobe faced a difficult situation: its user base started buying digital cameras that could produce raw files that Photoshop couldn't open. Sure, the cameras came with software that could process the digital negatives, but that software was cumbersome, slow, and not very well designed.

In early June 2002, I produced a seminar called Digital Imaging For Photographers (DIFP) in New York City. During the panel discussion, well-known New York shooters on the panel and in the audience were complaining about the camera software and asking why they couldn't open raw files directly into Photoshop. Adobe, as one of the sponsors, had sent a representative to the seminar. John Nack, a new Photoshop product manager, got an earful from the crowd. The takeaway for John and Adobe was that not being able to process raw files in Photoshop was a big problem and should be addressed.

Ironically, that same week Thomas Knoll, who, along with his brother John, originally wrote Photoshop, bought a Canon EOS D60 camera to take on a family vacation to Italy. FedEx delivered it the day the Knolls were due to leave. Thomas packed the camera with some lenses and the camera software CD and left for the airport. During the long flight over to Italy, Thomas played with the camera, installed the Canon software on his laptop, and tried processing some raw captures of, as he tells it, his daughter's ear. What Thomas discovered was the same thing photographers were complaining about at the DIFP seminar: not being able to process raw files in Photoshop was a big problem and should be addressed. So, while sightseeing in Italy, Thomas worked at decoding the proprietary raw file format to figure out a way of opening them in Photoshop. That was the week Camera Raw was born.

When Thomas returned home, he was prepared when Adobe started talking about the need for processing raw files into Photoshop. Later that summer, I rode my motorcycle over to Tom's house to lend him my Canon D30 so he could decode those raw files as well. There was a lot of discussion at Adobe about how to deal with the release of Camera Raw to the user base. Some people thought it should wait until the next version of Photoshop (the first Creative Suite version, which wasn't due to ship until October 2003). Others thought that was too long to wait and pushed to have it released as a download purchase for use in Photoshop 7. That group (of which I was a member) won. Camera Raw 1.0 (**Figure 2.1**) was released February 19, 2003, at Photoshop World in Los Angeles. The price was $99. It was (and still is) simply an import plug-in for Photoshop with some pretty nifty bells and whistles that gave digital photographers an easy and fast way of opening raw images into Photoshop.

FIGURE 2.1 Camera Raw 1 installed in Photoshop 7. Notice that the user interface (UI) is rather primitive, with a single set of adjustment controls and only three tools: a Zoom tool, a Hand tool, and a White Balance tool.

THE GENESIS OF LIGHTROOM

The second engineer hired to work on Photoshop was a fellow by the name of Mark Hamburg. He interviewed at Adobe in February 1990, the same month that Photoshop 1 shipped, but he didn't start working at Adobe until later that year.

Mark was (and still is) a brilliant engineer. He advanced Photoshop over a period of more than a decade. He was the senior engineer and eventually was given the title Photoshop Architect. However, once Photoshop 7 shipped in April 2002, Mark left the Photoshop team. He worked on some developmental sandbox projects while in Adobe's Digital Media Lab. One of the projects was an application he called PixelToy (**Figure 2.2**), which used the ability to paint from history to adjust a photographic image. Mark had developed the History feature of Photoshop and wanted to play with the concept for image adjustments. He kidded me about calling it "Schewe Paint" because he and I had worked together when he was developing the History feature in Photoshop. He was inspired by my history blending technique in Photoshop.

FIGURE 2.2 One of the initial versions of PixelToy from the fall of 2002.

In the fall of 2002, Mark sent me a copy of PixelToy to play with. We exchanged emails back and forth while he developed additional versions with more features. However, there was one big shortcoming of PixelToy: it could really only work on one image at a time. I pointed that out to Mark, saying that Photoshop's original concept also was limited by that shortcoming. Yes, you could open multiple images at the same time, but you could really only work on one image at a time. That was fine for Photoshop because at the time (before digital cameras) photographers still shot film. And although they may have shot a ton of film, only a few select images would be scanned for retouching.

However, with the advance and adoption of digital cameras, photographers were faced with a ton of digital captures instead of only a few scans. It was clear that yet another application that could deal with editing only single images wasn't a good solution for the new market of digital photographers.

Mark listened and started to design a new approach to image editing. He determined that what was needed was some sort of image database that could store the image-editing parameters without having to actually edit the pixels.

In early December 2002, Mark said that he and his team would like to come to my studio to brainstorm this new approach. Mark and his team (Project Lead

Andrei Herasimchuk and UI Designer Sandy Alves) came to Chicago. Mark also invited Thomas Knoll to attend, which he did, helping to push the concept of having Lightroom be the back end for Camera Raw. We all met at my studio and hashed out the concept for what direction this new application would take. The code name Mark selected was Shadowland (a musical reference to KD Lang's 1988 album). The first version of Shadowland I saw (**Figure 2.3**) was in the middle of 2003. It would take until January 2006 to finally release the public beta version of what was then renamed Lightroom (**Figure 2.4**).

To really understand how and why Lightroom was designed and developed, you have to understand that Lightroom was Mark's Photoshop. Yes, he built upon Thomas's Camera Raw processing, but Mark added a lot to the process. He worked on the HSL, B&W, and Split Tone panels. Mark also developed the Parametric Curves functionality in the Tone Curve panel. Thomas was impressed enough that he added them to the Camera Raw processing pipeline. That adoption by Thomas was important, because it meant that the Lightroom and Camera Raw processing pipelines could be tied together.

FIGURE 2.3 The very early UI of Shadowland.

FIGURE 2.4 The evolution of the UI for the public beta of what had, by then, been renamed Lightroom.

NOTE Lightroom was not Adobe's response to Apple's Aperture. The initial development of both applications started at about the same time, in early 2003. Apple released Aperture in October 2005, just a few months before the public beta of Lightroom. So, Lightroom and Aperture are just two concurrent solutions to the same basic problem of workflow.

Many people wonder why Lightroom looks and behaves so differently from Photoshop. Well, that's easy to answer: given a choice between adopting a Photoshop way of doing something and doing something completely different, Mark was predisposed to doing something completely different in an attempt to improve on the Photoshop approach. As time has shown, that's a Lightroom strength, not a weakness. In fact, Photoshop actually has been more influenced by Lightroom than the other way around. A look at the new UI colors in Photoshop CS6 is an example of that influence.

Lightroom 1.0 shipped on February 19, 2007. Does that date ring a bell? It should. February 19 is a pretty important date in the history of digital imaging. That day in February also marked the day that Camera Raw (2003) and Photoshop (1990) shipped.

THE BRIDGE, CAMERA RAW, AND PHOTOSHOP SYSTEM

Bridge, Photoshop, and Camera Raw act as a suite of two integrated applications and a plug-in for viewing and processing digital files. Bridge is the front end, with Camera Raw being the image-processing component for opening images into Photoshop.

BRIDGE

Bridge (**Figure 2.5**) was introduced with the first version of Adobe's Creative Suite. As the name implies, it acts as a bridge between various applications in the suite. For the purposes of photographers, Bridge is usually the first place to start.

FIGURE 2.5 A standard configuration of Bridge with the Folders and Filter panels on the left and the Preview and Metadata panels on the right. The main Content panel in the center has the Grid Lock option turned on. Grid Lock is available under the View menu of Bridge.

TIP If you make a change to an image in Lightroom, that change is stored only in the catalog, unless you save the settings to the file. If you make a change to an image using Camera Raw, Lightroom won't know about that change. Lightroom will show a small badge indicating that settings have been changed outside Lightroom. Clicking that badge will bring up a dialog box indicating that the settings have been changed and giving you two options: Import Settings from Disk or Overwrite Settings. If you want the image settings to reflect a change from Camera Raw, select the Import Settings from Disk option. If you want to ignore the Camera Raw changes and keep the Lightroom settings, select the Overwrite Settings option.

Unlike Lightroom, which is driven by a database, Bridge is a file browser. You point it at a volume or folder, and it shows you the files. Bridge parses the files, creates thumbnails, and displays embedded metadata. Bridge stores those thumbnails and metadata in a cache for later use, but Bridge itself doesn't remember the files. If a folder is removed or a volume is unmounted, Bridge forgets about the files. It's kind of like short-term memory.

The thumbnails and previews Bridge creates for digital negatives use Camera Raw for rendering, depending on how the thumbnail options are set. If you have the options set to Prefer Embedded, Bridge will simply extract the embedded EXIF JPEG previews. This method is faster, but it isn't really accurate. I have my thumbnail option set to Always High Quality (**Figure 2.6**).

FIGURE 2.6 The drop-down menu at the top right of the main Bridge window. When viewing digital negatives, I always want Bridge to use Camera Raw to generate accurate thumbnails and previews.

I'm often asked if I use Bridge or Lightroom. My answer is yes. Okay, truth be told, I use both all the time but for different tasks. I use Bridge to have a quick look at a particular folder or when working on a project involving files that aren't just images. Because I use InDesign and Illustrator for design or publishing projects, I find Bridge indispensable. Bridge can help manage all sorts of file types besides Camera Raw files, so it's really useful. However, every digital capture I shoot still ends up getting imported into Lightroom. Since Lightroom and Camera Raw talk the same parametric language, there's really no disadvantage to using both (as long as you understand how to move the Camera Raw image settings back and forth).

CAMERA RAW

Adobe Camera Raw (ACR) is simply a raw file format import plug-in for Photoshop. But over the years and versions, Camera Raw has really become much more. Used not only for Bridge and Photoshop, the Camera Raw processing pipeline is also the backbone for Lightroom.

Camera Raw has the interesting property that it can be hosted either by Bridge (**Figure 2.7**) or Photoshop (or even both at the same time). The key to knowing which application is actually hosting Camera Raw is in the buttons at the bottom of the ACR window (**Figure 2.8**). When ACR is hosted by Photoshop, the highlighted button is Open Image. When it's hosted by Bridge, the highlighted button is Done.

FIGURE 2.7 Camera Raw opened while being hosted by Bridge in the ACR Filmstrip mode, showing multiple images in the column on the left.

▲ CAMERA RAW HOSTED IN PHOTOSHOP

▲ CAMERA RAW HOSTED IN BRIDGE

FIGURE 2.8 The Camera Raw host decoder.

You might ask why you would want to have Bridge host Camera Raw. In the field, while you're making initial selection edits and basic image adjustments, you can launch just Bridge without also having to launch Photoshop. You can pop the image into Camera Raw, make some adjustments, and simply click Done. Another reason for opening Camera Raw hosted by Bridge is that you can rank, label, and make image adjustments of multiple images in Camera Raw while handing off the images to Photoshop for processing by clicking Save Image.

The role of Camera Raw's default settings in generating Bridge's thumbnails and previews is pretty simple: a digital negative without some basic rendering isn't very pretty or useful. Unless you tell it to do otherwise, Camera Raw uses the default settings for your camera that are hardwired into Camera Raw to render thumbnails and previews for images that Bridge hasn't seen before.

The Default Image Settings section of the Camera Raw Preferences dialog box (**Figure 2.9**) allows you to control how the defaults are applied. Camera Raw can have different defaults based on the camera serial number or the image ISO. Saving a default based on the camera serial number can be useful if you have multiple bodies

> **NOTE** ACR is not limited to just raw digital negatives; it also can open JPEGs and TIFFs (without layers). For the purposes of this book, however, I limit the discussion to digital negatives.

FIGURE 2.9 Camera Raw's Default Image Settings dialog box.

of the same camera model whose color or tone are slightly different. Since Camera Raw's default regarding noise reduction is off, you can make basic noise-reduction settings for commonly shot ISOs and have those settings automatically applied when Bridge first looks at those images.

The Camera Raw defaults aren't sacred. They're neither objectively correct nor particularly accurate; instead, they're just an arbitrary initial interpretation of the raw image data. What the default settings show is a normalized view of the digital negative as determined by the Camera Raw engineers.

A common complaint by some photographers is that the default settings in Camera Raw don't exactly match the look they've fallen in love with on the LCD of the camera or the processing done by the camera maker's proprietary raw processing. Well, since Camera Raw doesn't use the camera maker's processing, the thumbnails and previews will never match the camera LCD *exactly*. But with the introduction of DNG profiles, users of Camera Raw can modify the defaults to better match the color and tone rendering of digital negatives. You can make your own Camera Raw defaults mimic the camera's "look" very accurately.

TIP By the way, if you use both Camera Raw and Lightroom, they both share the same Camera Raw Default settings, which can be pretty useful but also a bit confusing. If you change the defaults in Lightroom, Camera Raw will apply those same defaults.

PHOTOSHOP

What can I say about Photoshop that hasn't already been written? Not a lot. If you do a search on Amazon for "Photoshop books," you'll get over 7,000 results. There's a ton of Photoshop info out there! Heck, I've even co-authored a Photoshop book with my good friend and colleague Martin Evening called *Adobe Photoshop CS5 for Photographers: The Ultimate Workshop* (Focal Press).

However, for the purposes of this book, I think it's important to understand the relationship between *parametric editing* (adjusting the parameters of an image) in Camera Raw and *pixel-level editing* in Photoshop. Bridge and Camera Raw work together to provide a more efficient workflow for masses of images. But Photoshop provides far greater power and precision in taking images that extra step toward perfection.

Figure 2.10 shows an image that had been selected in Bridge and processed in Camera Raw, finally opened in Photoshop. At this point, you can throw the full power and functionality of Photoshop into perfecting your image. I offer an in-depth look at the power of Photoshop in Chapter 5, but suffice it to say that Photoshop is where you can make accurate masks, do substantial retouching, and make multi-image composites.

The combination of Bridge, Camera Raw, and Photoshop can make for an efficient raw image-processing workflow. The two applications and the Camera Raw plug-in work together to provide end-to-end image processing. If you shoot relatively few captures for a given project and don't need immediate access to your entire image library on a regular basis, the combination of Bridge, Camera Raw, and Photoshop is a dandy solution. However, if you shoot a lot and have a large image library, the better solution is Lightroom.

FIGURE 2.10 An image opened in Photoshop with the new Lightroom–like UI color scheme.

THE LIGHTROOM WAY

As I pointed out in "The Genesis of Lightroom" earlier in this chapter, Lightroom is the un-Photoshop. The UI design is based on a single window interface (SWI), which means that the design is intended to present task-based functionality that is accessed via switching modules. The modular approach is clearly more restrictive than Photoshop's panel-based approach, which allows tearing off panels to have free-floating palettes. I realize this drives some people nuts, and I'm sympathetic to a degree. But this is the way Mark Hamburg envisioned working in Lightroom. **Figure 2.11** shows Lightroom pointing to the same folder of images previously shown in Bridge (refer to Figure 2.5).

Unlike in Bridge, you can't browse an arbitrary folder of images in Lightroom without first importing the folder into Lightroom. I'll describe the import process in Chapter 6, but for now just realize that the concept of importing is fundamental

FIGURE 2.11 The main Library module of Lightroom.

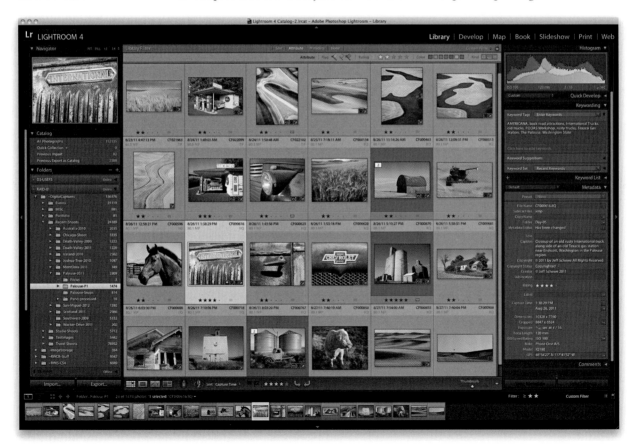

to the database of the Lightroom catalog. The act of importing creates thumbnails and previews and reads image metadata just like Bridge, but each image creates a database record of the image and stores all the metadata as data fields in the record. So, everything Lightroom knows about the image becomes a permanent record in the catalog. This is a good thing (mostly).

One downside of this approach is that if a user makes any Finder-level changes to the name or organization of the files on the disk, Lightroom won't know any changes have occurred and you'll end up with a mess in the catalog. The reason I called this section "The Lightroom Way" is that there's a right way and a wrong way to use Lightroom. The right way is to do everything—such as renaming or moving files or folders—directly inside Lightroom, not in the Finder.

The advantage of the Lightroom way is that within the image catalog, Lightroom knows everything that has been done to images (such as parametric image edits and keywording) and allows you to do very fast searches and filtering of a massive number of images.

Figure 2.12 shows the folder structure I've created and imported into Lightroom. You'll notice I have a total count of 136,376 image files in my ~DigitalCaptures enclosing folder. The Catalog panel shows that the total number of images in this catalog is

▲ MY LIGHTROOM CATALOG PANEL SHOWING THE TOTAL NUMBER OF IMAGE RECORDS IN THE CATALOG

◀ MY LIGHTROOM FOLDERS PANEL HIERARCHY SHOWING IMAGE COUNTS PER FOLDER

FIGURE 2.12 The Folders panel as organized on disk.

TIP By default, Lightroom will try to store imported images in the User/Pictures folder (Mac) or User\My Pictures folder (Windows). Since I maintain a large external RAID array for image storage, that's where I import images. You'll also note that I use a tilde (~) to force the enclosing folder to the top of the root–level folder hierarchy. This works fine for Mac, but for Windows I would need to use a hyphen (–) or underscore (_).

152,135 images. You might wonder why there is a 15,759-count difference between my main digital captures folder and the total count of the catalog files. Well, for the purposes of organization, I sometimes have multiple copies of the same original files. You'll note that two folders (~RWCR-Stuff and ~RWIS-CS4) account for the majority of the count differences. These two folders contain original and rendered files I've put together for the purposes of writing some of my books. Instead of using the Lightroom way of creating collections or using keywords for organization, I prefer to actually have real folders of images so I can copy folders back and forth to my laptop for demos and fieldwork.

Just as Bridge uses Camera Raw for digital negative image adjustments, Lightroom relies upon the Develop module in Lightroom for parametric image adjustments.

The basic tools and image adjustments are pretty much the same with generally only subtle UI and usability differences. **Figure 2.13** shows the basic Develop module and a detailed view of the Basic and Tone Curve panels. I'll highlight the differences

FIGURE 2.13 The Develop module of Lightroom.

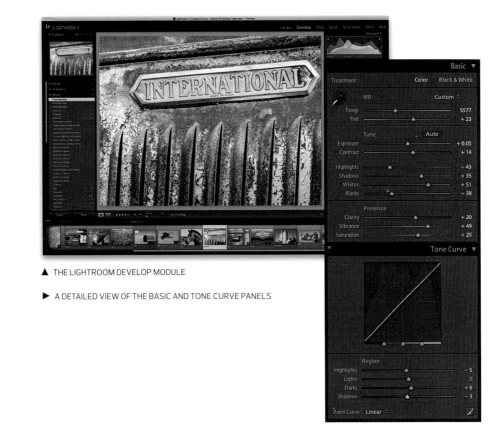

▲ THE LIGHTROOM DEVELOP MODULE

▶ A DETAILED VIEW OF THE BASIC AND TONE CURVE PANELS

in later chapters, but there is one main usability issue I want to point out here: unlike the single-panel limitation found in Camera Raw, Lightroom allows direct access to multiple panels at the same time. The two panels I'm showing in Figure 2.13 point to a difference in usability and, as a result, a benefit to using the Develop module instead of Camera Raw. It's not at all unusual to bounce back and forth between various panels when refining the image adjustments, so Lightroom's ability to have multiple panels open at once is a benefit.

This book isn't intended to drill down on each and every feature in Lightroom, but let me suggest my own go-to book for looking up anything you need to know about Lightroom: *The Adobe Photoshop Lightroom 4 Book: The Complete Guide for Photographers* (Adobe Press), written by my good friend and colleague Martin Evening. I personally don't use *everything* in Lightroom, so when I need to know how a certain feature or function works, Martin's book is where I turn.

LIGHTROOM AND THE PARETO PRINCIPLE

The original intent and design of Lightroom was to adhere to the Pareto principle (also called the 80–20 rule), in which 80 percent of the land in Italy was owned by 20 percent of the people. Vilfredo Pareto was an Italian economist and Lightroom has nothing to do with population and wealth, but there is a corollary: Lightroom is designed to accomplish 80 percent of what a photographer needs to do with images, leaving only a relative few (20 percent) that require the special attention of Photoshop. As Lightroom has progressed, version by version, I would argue the ratio is now more like 90–10 or, for some photographers, 95–5 or more.

Ironically, this does come down to a question of economics, in a way. If you can accomplish the vast majority of your digital image processing requirements inside Lightroom, you'll need Photoshop for only a select few images that deserve special investment of time and effort. That's the core principle that Mark Hamburg envisioned (and I helped encourage) when Lightroom was started.

Does Lightroom replace the need for Photoshop? For some people it may. But I would argue the need for Photoshop has been diminished not eliminated. Odds are, Lightroom will never get the deep power and flexibility of Photoshop pixel–editing glory. But clearly, the more time you can save dealing with a ton of images, the more time you can spend perfecting in Photoshop those images that deserve it.

THE RELATIONSHIP OF CAMERA RAW AND LIGHTROOM VERSIONS

Since Lightroom uses the Camera Raw processing pipeline, it's important to understand how Lightroom and Camera Raw in Photoshop interrelate. When you want to open an image from Lightroom into Photoshop, there are two distinct behaviors involved:

■ When the versions of Lightroom and Camera Raw match, Lightroom uses a script called Bridge Talk to send the original digital negative directly to Camera Raw for rendering. So, if you have Lightroom 4.1 and Camera Raw 7.1, the versions are in sync and Lightroom sends the image to Photoshop without having to do anything else. When you have the image open in Photoshop, you can Save or Save As, Photoshop passes along to Lightroom where the image file is saved, and the rendered image is added back into the Lightroom catalog.

■ When the version of Lightroom and the version of Camera Raw are out of sync, by default, Lightroom must do the image rendering, save the file (in the same folder as the original), add that file with -edit at the end of the filename, and send the rendered file to Photoshop for imaging. This behavior is not the optimized integration between Lightroom and Photoshop (or another third-party pixel-editing application). **Figure 2.14** shows the warning that Lightroom displays when Lightroom and Camera Raw are out of sync.

Some people may speculate that this is an evil plot by Adobe to encourage (read: force) upgrading Photoshop and Lightroom in tandem. It's really not. There are technical limitations between the Lightroom and Photoshop software development kits (SDKs) that limit the communication between the two applications. As long as you choose the option to render using Lightroom, virtually any recent version of Photoshop or even Photoshop Elements can perform imaging on files from Lightroom.

FIGURE 2.14 The Lightroom warning dialog box for Camera Raw compatibility.

Lr

This version of Lightroom may require the Photoshop Camera Raw plug-in version 7.0 for full compatibility.

Please update the Camera Raw plug-in using the update tool available in the Photoshop help menu.

☐ Don't show again (Cancel) (Render using Lightroom) (Open Anyway)

COLOR MANAGEMENT BETWEEN LIGHTROOM, CAMERA RAW, AND PHOTOSHOP

Color management can be a confusing and frustrating subject, but I'll make it really simple: pick an editing space to work in, and stick with it. That's what I've done. Years ago, my late friend and partner Bruce Fraser advocated working in the largest color space possible and a bit depth of 16 bits/channel when working on RGB images. Bruce had done a bit of consulting for Kodak and had tested an editing space Kodak called Reference Output Medium Metric (ROMM) RGB. That's a geeky mouthful, so Kodak renamed it ProPhoto RGB, which is a lot better, don't you think?

Without getting into ICC profile graphs and charts, let me make this simple: ProPhoto RGB is the only editing space in Adobe raw-processing applications large enough to contain all the color information your camera can capture and all the colors today's higher-end printers can print. ProPhoto RGB made an impression on Thomas Knoll when he developed Camera Raw, and he incorporated the color chromaticity values of ProPhoto RGB while changing the gamma from 1.8 to a linear gamma of 1. The reason for the change of gamma was to be able to preserve the linear tone mapping of a raw capture in the internal processing pipeline of Camera Raw.

Yes, some pundits claim that ProPhoto RGB is "too big" and that about 13 percent of the colors are imaginary colors that don't exist in the visible color spectrum. It's said that this overly large color space sacrifices the size of the color gamut at the expense of color accuracy and is wasted on these "unnecessary colors." I've been using ROMM RGB and then ProPhoto RGB for a decade and I haven't seen any issues I can attribute to color inaccuracy. I *have* seen real benefits by not clipping the color my cameras can capture. The one limitation I do recognize is that the color coordinates for ProPhoto RGB are so far apart that you do need to keep your processed image in a high bit depth. (See the sidebar "The 16-bit misnomer in Photoshop" for an explanation.)

So, my suggestion is, keep it simple. There are three places where setting the correct color space is important when working with Camera Raw, Lightroom, and Photoshop. **Figure 2.15** shows how I set up my color management when creating my master RGB images.

As long as all three color space settings match up, you should have no color management issues when editing. That's not to say there are no other issues when dealing with RGB images. If you're expecting to upload images to the web, for example, you don't want to use ProPhoto RGB; saving or exporting as sRGB is ideal for the web or

FIGURE 2.15 Color management settings for Camera Raw, Lightroom, and Photoshop.

◀ THE WORKFLOW OPTIONS DIALOG BOX IN CAMERA RAW

▲ THE COLOR SETTINGS DIALOG BOX IN PHOTOSHOP

◀ THE EXTERNAL EDITING TAB OF THE PREFERENCES DIALOG BOX IN LIGHTROOM

multimedia devices. ProPhoto RGB also can be a problem when you're handing off images for outside printing or publishing. Once your images are beyond your direct control, you can't be sure other people will honor your color management settings. If you're sending your images to others, I suggest converting them to Adobe RGB instead of sending ProPhoto RGB.

You'll note in Figure 2.15 that I have my Color Settings in Photoshop set to a custom-saved setting named Jeff's ProPhoto RGB. I changed the RGB working space to ProPhoto RGB and altered my gray working space to a gamma of 1.8 (which for a photographer working with both RGB and grayscale images is useful). Under Color Management Policies, I have RGB, CMYK, and Gray all set to Preserve Embedded

THE 16-BIT MISNOMER IN PHOTOSHOP

It's pretty easy to understand an 8-bit channel: it has 256 discrete levels of tone between black and white (2^8 = 256 levels). A 10-bit channel contains 1,024 levels (2^{10} = 1,024) and a 12-bit channel has 4,096 levels (2^{12} = 4,096). So, shouldn't a 16-bit channel have 65,536 levels (2^{16} = 65,536)?

Well, yes and no... for programming reasons, Photoshop actually uses only 32,769 levels from 0 (black) to 32,768 (white). The advantage of this approach provides an unambiguous midpoint between black and white, which is useful for image-processing operations and blending.

To those who would argue that Photoshop should use true 16 bit, I would argue that 15-bit precision is sufficient for all but scientific processing and no camera that I'm aware of can actually capture a true, full 16 bits/channel. By the time cameras actually capture more than 32,769 levels per channel, we'll have already moved on from 16-bit integer channels to 32-bit floating-point channels. Photoshop, Lightroom, and Camera Raw already support 32-bit floating point TIFF files.

Profiles. This is the one scary thing about using ProPhoto RGB: if someone has his policies set to ignore embedded profiles, your images will probably look like crap on his display. The other setting I've modified is to not bother asking about profile mismatches when opening an image or pasting between open documents. I really don't want or need to see the nag warnings. However, I do want to be alerted if I happen to open an image that has no embedded profile. This situation is what my good friend Andrew Rodney (The Digital Dog) calls "mystery meat." The only time I see profile missing warnings are for images saved for the web because I strip the profiles when I export specifically for the web. But since I know I stripped the profile out when saving for the web, I can simply assign the sRGB profile in Photoshop when opening an image with no profile.

One additional critical aspect of color management for raw image processing is your computer display and its profile. Camera Raw, Lightroom, and Photoshop all depend on your display profile to accurately render your images on-screen. I'm going to keep this simple: you need a hardware-profiled display if you want to have any hope of having a clue what your image really looks like. It matters less what your display brand or model is and far more that you've calibrated and profiled your display.

I use wide-gamut displays in my imaging studio from NEC Display Solutions, using the SpectraView software. For my laptop, I use an i1Display Pro (although I never use the laptop display for color-critical use). But whatever display and profiling solution you use, be sure to use it properly. My displays are profiled to a white point of D-65 and a screen gamma of 2.2 (except for the laptop, where I use the native gamma to

avoid banding on-screen). I use a display luminance of 150 candela/square meter (cd/m^2) and a contrast range of 300/1. The key to picking your display luminance is to make sure your display white matches the white of your prints in your standard viewing environment. (I cover this issue in-depth in *The Digital Print* [Peachpit].)

DNG FILE FORMAT AND DNG CONVERTER

Given the very real problem of the rapid proliferation of proprietary and undocumented raw file formats, Adobe (read: Thomas Knoll) decided to do something about that. In September 2004, Adobe launched the initial Digital Negative (DNG) file format. The purpose of the DNG file format was to try to create some order out of chaos. As I outlined in Chapter 1, the photographic industry has spawned way too many file formats with no real likelihood of a real standardized raw file format in the short term.

To address this issue, Thomas advocated a standardized raw file format that was more structured and publicly documented. DNG is compatible with the ISO 12234-2 spec for TIFF Electronic Photography (TIFF/EP), which is used by most camera makers in one form or another. Adobe has offered the DNG specification to the Inernational Organization for Standardization (ISO) for an upcoming ISO update to TIFF-EP. Unfortunately, standards organizations are notoriously slow (and careful, which is a good thing) when it comes to revising existing standards. So, I can't tell what's going to happen about the TIFF-EP adoption of DNG.

Regardless of the political and technical implications of DNG as a file format (and it's mostly political not technical), the one thing that can be said for DNG is that it provides a chance for backward compatibility for users with new cameras using old software. The free DNG Converter, which is released concurrent with new versions of Camera Raw, can convert newly supported raw files into a DNG file that can be read in older versions of Camera Raw and Lightroom.

TO DNG OR NOT TO DNG?

So, here's the thing: in the short term, I'm really not all that concerned about being able to access all my proprietary raw files in current versions of Camera Raw and Lightroom. I don't see Adobe ever removing support for any cameras whose raw files are currently supported.

In fact, there's a real benefit when working with Camera Raw or Lightroom to maintaining your original raw files without conversion to DNG. In Camera Raw and

Lightroom, if you save your image settings into the DNG file, the modification date is updated. What that means is if you use a backup application that backs up based on changed modification dates, a DNG that is updated will require backing up. To show you the implications of this, consider the image of the rusty, old truck. The image was shot with a Phase One IQ 180 medium-format digital back. The back is an 80 MP back with a native file size of about 80 MB (give or take a few megabytes). Converted to DNG, the file size grows to about 105 MB (the DNG compression for IIQ files from Phase One isn't great). So, each time I adjust the DNG file image settings, my backup application will note the new file modification date and dutifully copy the 100+ MB file to backup.

Compare that to using the original Phase One IIQ file. If the image adjustments are saved to an XMP file (the text-based sidecar file that Camera Raw or Lightroom uses instead of trying to write into an undocumented raw file format), that text file is only 200 KB. So, 100+ MB versus 200 KB... you do the math.

On the other hand, when considering long-term digital conservation and preservation, things are a bit bleak (see the sidebar titled Digital Image Preservation).

ADOBE DNG CONVERTER

Regardless of where or when you decide to convert raw files to DNG, I need to point out that the DNG file format is advancing (as of early 2012, it's at DNG spec version 1.4). The free Adobe DNG Converter (**Figure 2.16**) and DNG conversion in Camera Raw 7.x and Lightroom 4.x offers some new and interesting features and functions.

TIP When using the DNG Converter, remember that it's designed to batch-process folders of raw files, not individual files.

FIGURE 2.16 Adobe DNG Converter.

DIGITAL IMAGE PRESERVATION

The long-term preservation and conservation of traditional analog photographic media has a tradition backed by research and known best practices. But digital photography (or any sort of digital object, such as video, audio, or text) is incredibly fragile and subject to corruption or erasure. It must be stored in redundant media and in redundant locations to be assured that it will still be available in the future. But even if you back up, archive, and store your digital images properly, will that guarantee that digital photography will be available in 5, 50, or 500 years? Maybe not.

The preservation of digital content has become a big challenge for society. Since digital forms of media are rapidly becoming the principal and often *only* forms used to create, distribute, and store all manner of content, digital content now embodies much of the nation's intellectual, social, and cultural history. Digital content, particularly photography, is at risk of becoming lost to our future. If society loses its current intellectual, social, and cultural history, it's a major loss for future generations. Imagine if we no longer had access to the Civil War photographs by Mathew Brady; the portraits of people such as Winston Churchill, Babe Ruth, or Albert Einstein; or the photographic records of the Wright Brothers' first flight.

In December 2000, Congress appropriated $100 million for a national digital preservation strategy effort, to be led by the Library of Congress, which founded a collaborative project called the National Digital Information Infrastructure and Preservation Program (NDIIPP; http://www.digitalpreservation.gov).

One of the most critical factors regarding the long-term preservation of digital content is the format in which the digital "objects" are stored. In order to have "sustainability," you need the ability to maintain a digital object in a technological environment in which users and archiving institutions operate. NDIIPP has identified seven sustainability factors that apply across digital formats for all categories of information (http://www.digitalpreservation.gov/formats/sustain/sustain.shtml):

- **Disclosure:** The degree to which complete specifications and tools for validating technical integrity exist and are accessible to those creating and sustaining digital content. Preservation of content in a given digital format over the long term is not feasible without an understanding of how the information is represented (encoded) as bits and bytes in digital files.

- **Adoption:** The degree to which the format is already used by the primary creators, disseminators, or users of information resources. This includes use as a master format, for delivery to end-users, and as a means of interchange between systems. If a format is widely adopted, it's less likely to become obsolete rapidly.

- **Transparency:** The degree to which the digital representation is open to direct analysis with basic tools. Digital formats in which the underlying information is represented simply and directly will be easier to migrate to new formats and more susceptible to digital archaeology. Transparency is enhanced if textual content, including metadata embedded in files, is encoded in standard character encodings and stored in natural reading order. Many digital formats employ encryption or compression. Encryption is incompatible with transparency; compression inhibits transparency.

- **Self-documentation:** Digital objects that are self-documenting (meaning containing information relating to the content and the format of the file) are likely to be easier to sustain over the long term and less vulnerable to catastrophe than data objects that are stored separately from all the metadata needed to render the data as usable information or understand its context. A digital

object that contains basic descriptive metadata and incorporates technical and administrative metadata relating to its creation will be easier to manage and monitor for integrity and usability and to transfer reliably from one archival system to its successor system.

- **External dependencies:** The degree to which a particular format depends on particular hardware, operating system, or software for rendering or use and the predicted complexity of dealing with those dependencies in future technical environments.

- **Impact of patents:** Patents (a form of intellectual property) related to a digital format may inhibit the ability of archival institutions to sustain content in that format. Although the costs for licenses to decode current formats are often low or nil, the existence of patents may slow the development of open-source encoders and decoders.

- **Technical protection mechanisms:** To preserve digital content and provide service to users and designated communities decades hence, custodians must be able to replicate the content on new media, migrate and normalize it in the face of changing technology. Content for which a repository takes long-term responsibility must not be protected by technical mechanisms such as encryption or implemented in ways that prevent custodians from taking appropriate steps to preserve the digital content and make it accessible to future generations.

As you can see from these seven sustainability factors, digital photography is at serious risk. Why? Undocumented, proprietary raw file formats. Some may argue that there are file formats available that do mitigate the risks such as JPG or TIFF, but they don't provide a format for the storage of the unprocessed raw sensor data. It's the original raw sensor data that we need to preserve because, as we've seen in just a few short years, the software for processing the raw data has improved considerably. Based on the NDIIPP sustainability factors, the DNG file format rates very highly for the prospect of long-term preservation and conservation of digital negatives.

How did this situation come to pass? In the history of photography, it's been the traditional role of film or paper manufacturers to develop standards relating to the preservation of photographic materials. The camera makers have had no such responsibility and have developed no such standards. When the digital photography revolution began, the camera makers found themselves in the unusual and rather awkward situation of expanding their traditional role of producing cameras and lenses into a role of processing the digital captures. The camera makers created short-term solutions to deal with technical issues of writing raw sensor data to disk or storage by creating proprietary raw file formats. Each sensor type and its raw file format was designed for the purpose of solving the short-term problem of writing the data. Little or no thought has been given to working toward standards that would help ensure long-term access to the data.

The camera makers, so far, are failing to address the long-term preservation of digital photography by their persistent use of undocumented and proprietary raw file formats. This must change. Standards must be developed and adopted that ensure sustainability of digital photography. This is the camera makers' new responsibility, and if they don't adopt it willingly, they must be forced to adopt it by the photographic industry.

Okay, I'll get off my soapbox now.

Using the DNG Converter is pretty simple. You select the folder that contains the original raw files, select the folder where you want to save the DNG files, decide if you want to rename those DNG files (by default a DNG file extension is appended to the original filenames to prevent overwriting your originals), and then set the DNG Converter Preferences. Both Camera Raw 7.x and Lightroom 4.x also contain the same basic functionality and options of saving DNGs.

The preferences you set for DNG conversion are important to consider. If you're trying to convert to DNG for older software, you'll need to have the correct compatibility settings. New to DNG specification 1.4 is the ability to create what's called Fast Load Data. Checking this option stores additional preview data in the DNG file. This can speed the loading of images in Camera Raw and the Lightroom Develop module. It will increase the size of the DNG slightly, but it's a useful trade-off. However, it should be noted that third-party applications that claim DNG compatibility might not support DNGs with Fast Load Data.

Another new function of DNG is the ability to apply lossy compression to make DNG file sizes much smaller and even downsample the actual DNG image file. Previous versions of DNG Converter allowed adding lossless compression for some size savings, but this new feature can make really small DNG files. **Figure 2.17** shows the various options available in the DNG Converter Preferences dialog box.

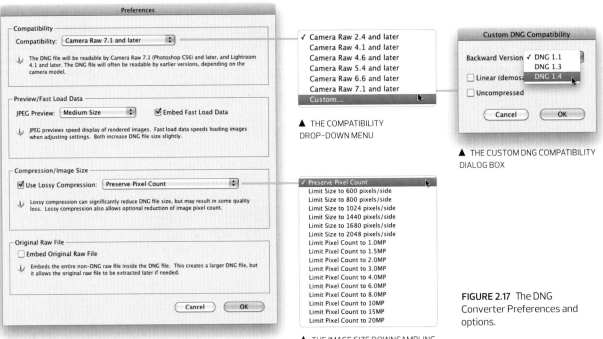

▲ THE COMPATIBILITY DROP-DOWN MENU

▲ THE CUSTOM DNG COMPATIBILITY DIALOG BOX

▲ THE DNG CONVERTER PREFERENCES DIALOG BOX

▲ THE IMAGE SIZE DOWNSAMPLING DROP-DOWN MENU

FIGURE 2.17 The DNG Converter Preferences and options.

The ability to add lossy compression and downsampling to a DNG file is intriguing but a bit scary. Here's why it may be scary:

- **Lossy compression loses something from the original.** The lossy compression it uses is JPEG (about level 10, but that could change). In order to process the image, the image must be demosaiced and saved as a linear DNG file. So, it's no longer a true raw file in the classic sense, but it's still in a linear gamma, which means it can be processed in Camera Raw and Lightroom as a raw file with excellent results.

- **Downsampling reduces the original resolution.** Although the lossy compressed DNG is editable, it will no longer have the full resolution of your original file. That's not necessarily a problem as long as you take great pains to make sure you have a filenaming convention that will never save a downsampled DNG over your original DNG.

But the lossy compression and downsampling can be very interesting when it comes to the ability to transmit or exchange DNG files that can still be edited in Camera Raw and Lightroom. To get an idea, check **Table 2.1**. The image I converted to DNG is the same rusty, old truck.

TABLE 2.1 Lossy DNG File Sizes

FILE FORMAT	FILE SIZE
Original DNG with Fast–Load Data	105.7 MB
DNG with lossy compression	29.1 MB
DNG with lossy compression sized to 20 MP	10.3 MB
DNG with lossy compression sized to 3 MP	1.8 MB
DNG with lossy compression sized to to 1 MP	541 KB

As you can see, there is great potential. Unfortunately, we're really just at the beginning of a lot of the potential for DNG with lossy compression. While the compressed DNGs retain the capability for editing, moving the XMP settings data back and forth between the original DNG and the lossy DNG hasn't really been worked out yet. The concept of some sort of proxy DNG would make it possible to store your originals while transporting your downsized compressed DNGs and retaining the ability to update the new editing back to your originals. I have no doubt that's what's in the minds of Thomas Knoll and the Camera Raw engineers, but at this point I don't know what's going to happen.

A lounging leopard seal in the Iceberg Graveyard near the
Lemaire Channel in the Antarctic Peninsula. Image captured with
a Canon EOS-1Ds MII with a 70–200mm lens at ISO 200.

FUNDAMENTALS OF LIGHTROOM AND CAMERA RAW

Whether you use Lightroom or Camera Raw, the fundamentals of raw image processing remain the same. Based on the initial default preview of the image, you'll need to adjust both the *global* (the entire image) and *local* (isolated parts of the image) tone mapping and color correction of the image. You'll also make basic modifications such as cropping and spot healing.

If you're like me, adjusting the image and getting it where you want is enjoyable, although occasionally it can be frustrating and somewhat time-consuming. This chapter endeavors to remove the frustration factors and make image adjustments more efficient and the processing of your digital negs more fun.

LIGHTROOM AND CAMERA RAW DEFAULTS

When you first import your images into Lightroom or browse your images in Bridge, Lightroom and Camera Raw must make some assumptions about how to show you your digital negatives. As I illustrated in Chapter 1, looking at a completely raw capture is pretty useless. Lightroom and Camera Raw must convert the raw-capture image data into something you can see and evaluate. To do this, some adjustments must be made to both tone and color based on the camera you're using and certain metadata in the image, such as ISO and white balance. The processing pipeline for both Lightroom and Camera Raw normalizes the preview you see. From this preview, you can make judgments about how to further adjust and tweak your image.

If you fell in love with the way your image looked when you chimped the LCD on the back of the camera, this first look in Lightroom or Camera Raw might be disappointing. Neither Lightroom nor Camera Raw uses the camera-maker's software development kit (SDK) for rendering the digital negative, so expecting the preview to look like the camera LCD is unreasonable. When he was designing the rendering engine, Thomas Knoll made a conscious decision *not* to try to match the camera companies' "looks" but, instead, to present you with a reasonable and normalized preview of your image.

When I look at the default renderings, I'm really concerned only with what the image looks like before making adjustments. I don't care what the camera company might think my image should look like. I use the initial default rendering for clues on how to end up adjusting the image later. **Figure 3.1** shows a bunch of images displayed with Lightroom's default rendering.

As you can see, most of the images are overexposed or underexposed (hey, I'm not perfect), and the colors are generally flat and dull. Some of the images look beyond any help and unworthy of the effort to fix them. Ah, but there's the rub: if you don't try, you won't know what you can tease out of the images. The one useful thing you can glean from the default renderings is what sort of adjustments you'll likely need to use to correct the tone and color.

In **Figure 3.2**, the same images are shown after adjustments have been made in Lightroom. Some of the adjustments were simply increases in the Exposure setting; others involved substantial local corrections. A few show the results of converting the images to black and white; others have been cropped, and one was flipped horizontally. Many have had significant color modifications to either the white balance or color hue, saturation, or lightness. I'll be the first to admit that some of the image adjustments might be viewed as, uh, aggressive... but I'm not known for subtlety. I'm not

FIGURE 3.1 A variety of images at the Lightroom default rendering.

FIGURE 3.2 The same set of images after adjustment in Lightroom.

really interested in an accurate reproduction of a scene. I tend to go for an enhanced rendering. If I were a photojournalist or documentary photographer, I would need to tone down my approach, but I'm not, so I go for impact instead.

The key takeaway from this is that what the images look like on the camera LCD or at default rendering in Lightroom or Camera Raw is not imperative. What you can get out of an image is limited only by what you start with at default and what you then can add by careful image adjustments. That's the fun part!

If you decide you want to change the Lightroom and/or Camera Raw defaults, you can. In Lightroom, from within the Develop module, go to the Develop menu and select the Set Default Settings option. The dialog box shown in **Figure 3.3** appears. The camera model is displayed, along with the serial number and ISO speed ratings. This is because I have my Lightroom General Preferences set to make Lightroom defaults specific to camera serial number and ISO settings.

NOTE There is a bit of confusion in the wording in the dialog box. It says that these changes are not "undoable," which is technically correct. But don't worry—if you want to revert your defaults back to the Adobe Default Settings, you can click the Restore Adobe Default Settings button. This restores any user-changed defaults back to the original defaults.

FIGURE 3.3 The Lightroom Set Default Develop Settings dialog box.

Camera Raw also offers the ability to change the defaults by selecting the Save New Camera Raw Defaults option in the main Camera Raw flyout menu. You also can reset Camera Raw's default to the original defaults from the flyout menu.

When changing the defaults, there are a couple points to keep in mind:

- **Make sure that all parameters you *don't* want to change are at their built-in, normal default settings.** You should alter only those settings that you want to have saved into your new default settings. For example, if you want to have a new default for noise reduction for a specific ISO setting, all other parameters should remain at their unchanged default settings and you should adjust only the noise-reduction settings.

- **Don't change your defaults willy-nilly.** Understand that the defaults are not image specific but are camera and potentially serial number and ISO specific. Defaults are not designed to be replacements for making image-specific adjustments. But if you find yourself *always* setting a certain parameter to a single numerical setting, that would be a good candidate to consider altering in a new

default. For example, if you've made a custom DNG profile for your camera and you want Lightroom or Camera Raw to use that profile instead of the Adobe Standard profile, simply open an image from the right camera, make sure all other settings are at default, select your custom DNG profile from the Camera Calibration panel, and then update in Lightroom or save new camera raw defaults in the Camera Raw flyout menu.

If you use both Lightroom and Camera Raw on the same machine, keep in mind that Lightroom and Camera Raw share the same default settings. So, if you make a custom default (or restore or reset the defaults) for Lightroom, Camera Raw will pick it up automatically.

TIP I have several ISO–specific custom defaults for a variety of cameras, but I rarely alter any of the other image settings.

LIGHTROOM AND CAMERA RAW FUNCTIONALITY

Aside from the obvious difference—Lightroom is an application, whereas Camera Raw is a plug-in for Bridge and Photoshop—there are some subtle (and not so subtle) user interface (UI) and usability differences between the two.

For example, in Camera Raw, there is a Color Sampler tool that can store up to nine individual sets of RGB color readouts with units of 0 to 255; Lightroom has just one color readout that uses units of 0 percent to 100 percent. The primary reason for this difference is that Camera Raw has the user define an RGB color space as part of the editing function, while the color space in Lightroom is undefined until you output or turn on soft proofing. Another Camera Raw advantage is that when you're cropping, you can zoom into the image to see better detail of exactly where the crop will fall; in Lightroom, you're limited to seeing the entire image without the ability to zoom in.

NOTE In general, for this book, I'll tend toward showing the Lightroom UI and highlighting any differences that appear in Camera Raw rather than taking up the page real estate showing both.

On the other hand, Lightroom has some enhanced functionality, such as the ability to have multiple panels open at once; with Camera Raw, you must navigate to the various panels one at a time. Lightroom has multiple menus for accessing in-depth functions, whereas Camera Raw has only a simple flyout menu for a much smaller subset of functions. Lightroom has the ability to store a complete history of the image adjustments in the History panel; Camera Raw, while open, does have multiple undo, but it's lost when you click the Open or Done button. Both Lightroom and Camera Raw allow you to save and use presets to apply to images en masse; however, those presets are not interchangeable, even though Lightroom and Camera Raw do share the main defaults.

The bottom line is that both Lightroom and Camera Raw use the same underlying processing pipeline and offer the same image adjustments and rendering, as well as camera model support, assuming an equal version release. (Lightroom 4.x and Camera Raw 7.x will have the same pipeline as long as the x numbers are the same.)

THE HISTOGRAM

Both Lightroom and Camera Raw display a histogram of your image. The histogram is a graphical representation of the distribution of image data. The plot is from black on the left to white on the right, with a vertical graph showing the relative count of various image levels. In Lightroom and Camera Raw, the histogram displays the red, green, blue, cyan, magenta, and yellow colors of the levels or a gray color (Lightroom) or white color (Camera Raw) for neutral tones. On the upper left is a check box for displaying black clipping; on the upper right, a check box for displaying highlight clipping. If you click the respective box, the clipped areas in the image are displayed in a preview on the image. **Figure 3.4** shows both the Lightroom and the Camera Raw histograms, as well as an image that displays clipping in the whites and blacks.

There are some fundamental concepts you need to understand about histograms. There are no "good" or "bad" histograms. A histogram is simply a source of potentially useful information. You can see an indication that there may be clipping in your image, but clipping is not inherently bad. Some clipping may be unavoidable, such as particularly bright specular reflections or light sources. Deep shadow clipping is normal for many images with a wide contrast range. Many images do have a

FIGURE 3.4 Histogram and image preview of clipping.

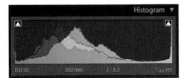

▲ LIGHTROOM HISTOGRAM

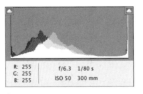

▲ CAMERA RAW HISTOGRAM

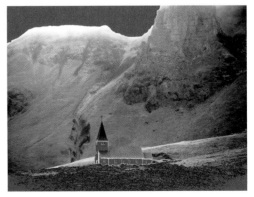

▲ A PREVIEW OF CLIPPED AREAS, RED FOR HIGHLIGHTS AND BLUE FOR SHADOWS

bell-shaped distribution, but such a distribution is really only a graph of information and doesn't tell you a lot about how to adjust the image. A histogram that has a lot of levels in the middle but few at either end is considered a low-contrast image, so you may need to increase the contrast to redistribute those levels. If you have a lot of levels below the middle but few in the highlights, that's an indicator of a potential underexposure and that you need to lighten the image. The same is true if there are a lot of levels on the right half but few on the left (a classic ETTR situation; see Chapter 1 for more on ETTR); in this case, you need to redistribute down.

The histogram in Lightroom does offer a few additional enhancements. In **Figure 3.5**, you can see the cursor inside the histogram display and a readout of both the current area of the adjustment (Exposure) and the current setting (+0.06). Lightroom allows you to grab areas of the histogram to make adjustments by dragging. This is a really cool feature that I rarely use because I'm looking at what the image looks like and I'm not fixated on the histogram display. But, hey, it's there if it tickles your fancy! Camera Raw doesn't have this on-the-histogram adjustment.

NOTE I often don't even bother to look at the histogram; instead, I simply make image adjustment decisions based on looking at the image. Particularly when working in the field on a laptop in Lightroom, I'll close the histogram to save screen real estate, a function in Lightroom that isn't available in Camera Raw.

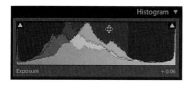

FIGURE 3.5 The Lightroom live histogram adjustment and readouts.

LIGHTROOM AND CAMERA RAW ADJUSTMENT PANELS

Although Lightroom and Camera Raw share the same image adjustment panels and adjustments, the UI and method of accessing them is different. In Lightroom, you have all the panels in a vertical column, whereas in Camera Raw they're arranged in a row and labeled with icons for identification. **Figure 3.6** shows a comparison of the adjustment panels.

When working in the field on a laptop, I like to use Solo Mode for the Lightroom panels to make better use of the screen real estate. To access Solo Mode, right-click (Control+click on Mac) directly on the panels and select Solo Mode from the context menu. At the studio with a large display, I turn off Solo Mode and click the various panels I may need and keep them open.

TIP When using Lightroom, get in the habit of using the context menu (the one you get to by right–clicking or Control+clicking) because a lot of very commonly used functions are available at the touch of the mouse.

FIGURE 3.6 Comparing the Lightroom and Camera Raw adjustment panels.

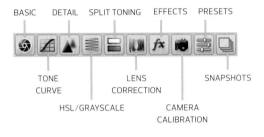

▲ THE LIGHTROOM ADJUSTMENT PANELS

▲ THE CAMERA RAW ADJUSTMENT PANEL ICONS

TIP If for some reason one of your Lightroom panels isn't visible, odds are, you've accidentally hidden it. The context menu will show all the panel names with check marks for the visible panels. If one is unchecked, simply selecting it will make the panel visible again.

In Camera Raw, you must either click the panel icons to access the various panels or use keyboard shortcuts. On a Mac, the keyboard shortcuts are Command+Option+1–9; on Windows, they're Control+Alt+1–9. Sadly, there is no shortcut key to get to the Snapshots panel, which means you must click the icon.

BASIC PANEL

The Basic panel is aptly named because it's the place where you'll be making all your "basic" tone and color adjustments. The Lightroom and Camera Raw Basic panels feature the same sets of controls, although Camera Raw doesn't have a Treatment section for converting to black-and-white, and the White Balance tool must be selected from the Camera Raw toolbar.

You'll notice that I've included two panels in **Figure 3.7**. That's because the set of adjustments you see is dictated by what Process Version is active. For more info on process versions, see the nearby sidebar.

TIP There is a reason that the controls are in the order in which they appear: the controls are in the order in which the engineers suggest you make adjustments—and this is a very strong suggestion.

▲ CONTROLS FOR PROCESS VERSION 2012

▲ CONTROLS FOR PROCESS VERSION 2010 AND 2003

FIGURE 3.7 The Basic Panel controls.

The Basic panel has four main subsections: Treatment, WB (which stands for white balance), Tone, and Presence. The controls in each section are fairly self-explanatory, so I won't belabor the various section descriptions, but I will make some suggestions.

Treatment

The Treatment section of the Basic panel exists only in Lightroom and can be used to change an image from color to black-and-white and back. If you find yourself wondering what an image *might* look like in grayscale, it's a quick way to preview the image without having to go to the HSL/Color/B&W panel.

WB

You really should adjust the white balance before launching into the tone adjustments, because having the correct white balance will impact the tones in your image. There are three main ways of adjusting the white balance:

- Using the WB drop-down menu and selecting a preset option
- Using the White Balance tool and selecting a nonspecular neutral in your image
- Simply adjusting the sliders (which is what I usually do)

If you know for a fact that something in the image should be neutral, such as a white dress or the white of a person's eyes, the White Balance tool is useful. If you need a very accurate white balance adjustment, I suggest shooting a frame with a spectrally neutral target such as the ColorChecker Passport (about $99) from X-Rite Photo (www.xritephoto.com). I use one and recommend it, although there are other brands of white balance targets out there. The reason I like the ColorChecker Passport is that it not only serves as a white balance target but also contains color samples that can be used for making custom DNG profiles. **Figure 3.8** shows a ColorChecker Passport shot with the White Balance tool on the second from brightest white sample.

TIP If you want to have a finer control over the adjustment sliders in Lightroom, you can extend the adjustment panels to the left and make the range of the sliders longer. This doesn't change the numerical range of the adjustments—it just changes how much slider movement is needed to make an adjustment. Camera Raw doesn't have this ability.

FIGURE 3.8 The ColorChecker Passport color targets and the Lightroom White Balance tool.

WHAT'S A PROCESS VERSION?

When the engineers make substantial and fundamental changes to the Camera Raw processing pipeline, the rendering of images will be different. Some differences are slight, such as the change from Process Version 2003 to Process Version 2010, which changed the way the pipeline rendered image detail and noise reduction. Other differences are massive, such as the change to Process Version 2012. Instead of forcing this rendering change on users, the engineers devised a method of dealing with these rendering changes: a process version. Images in more recent versions of Lightroom and Camera Raw that already had edits to the images would have those edits maintained in the original process version. The new process version would be applied only on new images that had no existing edits. You can choose to update to the new process version, and the pipeline will try to update your settings. With the update from 2003 to 2010, the changes were subtle and you had to zoom in to see the differences. Most users did this without any hesitation. However, Process Version 2012 totally changed the tone-mapping controls to use new image-adaptive adjustments; when you update your image to Process Version 2012, the rendering will change—sometimes a lot! Generally, the change is a good thing, but sometimes it isn't.

When you click the ampersand warning in Lightroom (or choose Process Version 2012 from the drop-down menu in the Camera Calibration panel), the dialog box shown in **Figure 3.9** appears. Take great care when you see this dialog box. Depending on how you've gotten your image into the Develop module, you may have a *lot* of images available in your filmstrip. If you click Update All Filmstrip Photos, that's exactly what will happen to all the images currently in your filmstrip. If you do that to thousands or hundreds of thousands of images, you might hate yourself in the morning. It's far safer to update the Process Version one image at a time. In Camera Raw, you don't get that warning dialog

FIGURE 3.9 The Update Process Version dialog box in Lightroom (not available in Camera Raw).

box; it simply updates the process version to a single image or selected images if you're in filmstrip mode.

I have a rule I use with my images: if I'm totally happy with the rendering of images from the past and if I have images already published or printed, I leave the image in the previous process version. If I have an image that I've worked on, but I'm not really satisfied with, and I don't need to worry about previous uses, I update the process version. What I suggest is to use the Snapshot feature of either Lightroom or Camera Raw to preserve your previous rendering before updating and create a second snapshot after updating to the new process version. That way you can preserve the old rendering just in case you need to revert.

When the public beta of Lightroom 4 was released in early 2012, there was a lot of discussion on the beta forums. Most of it was good, but some users were very disturbed by the changes, particularly those who relied on the old Fill Light adjustment. Advanced users of previous versions seemed to have more problems adapting and adopting the new controls because all their experience (some going back to 2003) made it more difficult to adjust to the new behaviors. But things have settled down, and by the time this book is released, I suspect the furor will have gone away.

For those people who are curious about the reasons for these changes (besides the improvements), I asked Eric Chan, a principal scientist at Adobe who works on the Camera Raw team to explain why the changes were made. This is what Eric wrote:

There are many reasons why we're revising the tone controls in Process Version 2012. Here are some of them. We're striving to provide controls that:

- *Implement a new tone-mapping algorithm, for easy yet powerful contrast management.*

- *Are more accessible and intuitive to new users. Ideally, it should be clear to users which control to grab when faced with a specific photographic problem. In other words, fewer overlapping behaviors among the controls. For example, in 2010 there are three ways to adjust the overall image brightness: Exposure, Brightness, and Fill Light. They affect the highlights and shadows in different ways, but they all affect the midtones. In 2012, there is one way to adjust the overall image brightness: Exposure.*

- *Subset cleanly for mobile and tablet applications, where UI real estate is at a premium. For example, there are six basic tone controls, but the recently announced Adobe Revel exposes just the first four (Exposure, Contrast, Highlights, and Shadows).*

- *Are more easily syncable between raw and JPEG. In 2010, this is hard because raw and JPEG have different baseline settings (for example, Brightness, Contrast, Blacks, and Point Curve have different defaults) and because some of the internal math is different. In 2012, tone controls have the same default settings and the same math for raw and JPEG. This facilitates mixed raw/JPEG workflows and means that tone presets can be applied effectively to both raw and JPEG images.*

- *Are available in both global and local tools, with the same behavior.*

- *Reduce the need for parametric and point curves when performing common tonal adjustments (because curves are less intuitive to new users).*

- *Fix known issues with the 2010 and earlier controls.*

One additional note I'll add is that the changes in Process Version 2012 apply not just to the Basic panel but also to the local image adjustment panels for the Graduated Filter and the Adjustment Brush.

FIGURE 3.10 Comparing aesthetically and technically correct white balance settings.

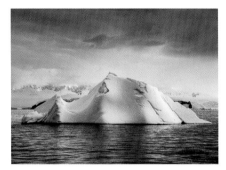

▲ IMAGE CORRECTED MANUALLY ▲ IMAGE CORRECTED USING THE WHITE BALANCE TOOL

TIP Depending on your camera's auto white balance (AWB) capability, Lightroom and Camera Raw's As Shot settings from the White Balance drop-down menu may give you a really good starting white balance. However, some cameras' AWB capability is less than optimal. If you find that your camera does a poor job of AWB, I suggest setting your camera to the Daylight setting. In many cases, it won't be "right," but it may provide a much better starting white balance than an inaccurate AWB setting.

Having a technically correct white balance isn't always aesthetically correct. Correcting for white balance at sunset should maintain the warm look, and if you're shooting in Antarctica, you *don't* want a warm look to your ice (nobody likes yellow ice). **Figure 3.10** shows two white balance settings; the one on the left was manually set to about 5500 K, while the one on the right is the "technically correct" setting obtained by using the White Balance tool in the center of the iceberg. Neutral isn't good in this situation, right? Actually, white balancing any sort of winter scene with snow and ice is very challenging—I always do it manually.

Tone

When adjusting the tones in your image, start with the Exposure control to adjust the overall brightness of the image followed by the Contrast adjustment. Many people think the Contrast adjustment isn't really useful and prefer using curves or other controls. That's okay but not optimal. All the Tone controls in Process Version 2012 are image adaptive—meaning, the adjustments adapt to your image by setting up an optimal range for the separate tone controls. Lightroom and Camera Raw also automatically recover highlight detail. Highlight recovery can extract image detail even when one or two color channels are clipped.

Here are the Process Version 2012 tone controls:

- **Exposure** sets the overall image brightness levels by primarily moving the midtones. Values are in increments equivalent to aperture values (f-stops) on your camera. An adjustment of +1.00 is similar to opening the aperture one stop; similarly, an adjustment of −1.00 is similar to closing the aperture one stop. Increasing exposure can introduce clipping, but the adjustments are rolled off extreme highlights to mitigate white clipping.

Contrast increases or decreases image contrast by applying a simple S-curve. Increasing the contrast lightens the ¼ tones (highlights) while darkening the ¾ tones (shadows). Increasing contrast is important for low-contrast scenes. If you're adjusting a high-contrast scene, reduce the contrast before adjusting the Highlights or Shadows.

Highlights is designed to further refine the highlight image areas after basic contrast settings. Minus adjustments kick in highlight recovery logic; plus adjustments lighten the highlights, but adjustments of the extreme white areas are rolled off to reduce clipping. Highlights takes over (and improves) the job previously done by the Recovery slider in Process Version 2010.

Shadows is designed to further refine darker image areas after basic contrast settings. Minus adjustments darken shadows while minimizing black clipping; plus adjustments lighten shadows and recover shadow details. Shadows takes over (and improves) the job previously done by the Fill Light slider in Process Version 2010.

Whites is designed to fine-tune the exact white clipping in the image. Minus settings reduce clipping in highlights; plus settings increase highlight clipping.

Blacks is designed to fine-tune the exact black clipping in the image. Minus settings increase black clipping (map more shadows to pure black); plus settings reduce shadow clipping.

The following image adjustments represent the older adjustments found in Process Version 2003 and Process Version 2010:

Blacks sets which image values map to black. Moving the slider to the right increases the areas that become black. The greatest effect is in the shadows, with much less change in the midtones and highlights.

Recovery reduces the tones of extreme highlights and attempts to recover highlight detail lost because of camera overexposure. Lightroom can recover detail in raw image files if one or two channels are clipped. However, the color integrity is sometimes lost, causing color tints in the recovered tones. This issue was substantially reduced and improved in the Process Version 2012 Highlights adjustment.

Fill Light lightens shadow to reveal more detail while maintaining blacks. Fill Light has a tendency to cause halos around areas of higher contrast. This issue was substantially reduced and improved in the Process Version 2012 Shadows adjustment.

Brightness adjusts image brightness, mainly affecting midtones. Adjust Brightness after setting the Exposure, Recovery, and Blacks sliders. Large Brightness adjustments can affect shadow or highlight clipping, although the extreme highlights are rolled off to reduce clipping.

TIP You can change the slider values incrementally in Lightroom by hovering over the adjustment name and using the + and – keys, hovering over the numeric field and using the up and down arrow keys, or using the scrubby slider. In Camera Raw, clicking a control highlights the entry field and allows the use of the up and down arrow keys. Holding down the Shift key in either Lightroom or Camera Raw increases the numeric increment. Double-clicking the slider name resets the value to zero in Lightroom. In Camera Raw, you must double-click the slider bar.

TIP If you hold down the Option key (Mac) or Alt key (Windows), the image preview will display the clipping areas in your image when adjusting certain controls. Adjusting Exposure, Highlights, and Whites will preview the white clipping points; adjusting Shadows and Blacks will preview the black clipping points.

You might be tempted to try to use the Auto button to have Lightroom or Camera Raw automatically determine the optimal tone settings for your image. I've found that it sometimes works really, really well and it sometimes really sucks. I think that far too much weight is given for really conservative Exposure settings to avoid clipping, but it does a reasonable job on the other tone adjustments. One trick I use in Lightroom is to hold down the Shift key and double-click the control name to use the auto settings for that specific adjustment. (Sadly, that trick doesn't work in Camera Raw. I should mention this to Thomas Knoll and see if he'll put that in the next version.)

Now I'll explain how I use the Tone controls in Lightroom and Camera Raw. First (after correcting white balance), adjust the Exposure settings. Depending on the camera exposure and the areas of importance in the image, I might defer some of the overall exposure adjustments to a later control set or even a Curves adjustment, but generally the first step is to get a correct exposure.

In workshops and seminars, I see a lot of people ignoring the next step, which is Contrast. That's a mistake. If you're working on a low-contrast scene, you really should pump up the default contrast. On a high-contrast scene, it's important to reduce the contrast. The default setting does apply a normalized curve, but it's not image specific, so it's important to start to correct contrast sooner instead of relying on later adjustments or curves.

Beware that in Lightroom and Camera Raw, increasing the contrast does increase the saturation of the image, while reducing contrast reduces saturation. I deal with saturation adjustments later. Why is saturation connected to contrast? It really goes back to analog film. Thomas Knoll felt that altering contrast should alter saturation because that's the expected result when pushing or pulling film development. It could be argued that it's not needed in digital, but then you would have to argue with Thomas. (He's perfectly willing to listen, but you have to make a very good argument.) Personally, I don't have a problem with saturation changing with contrast changes.

When you get the basic exposure and contrast setting, Highlights and Shadows allow further refinement in ¼ and ¾ tone areas of the overall tone mapping. Obviously, with a high-contrast scene, toning down the highlights of the image with the Highlights setting helps control the scene contrast range. If your ¾ tones are too dark, adding a plus Shadows adjustment can bring out a lot of shadow detail. Just know that increasing the shadows of your image can make noise more perceptible. With low-contrast scenes, you can use Highlights and Shadows to refine the areas of an image that are more important. It's not unusual to add a plus Highlights adjustment with a minus Shadows adjustment for a more asymmetric tone mapping. Because Contrast is symmetric, having separate controls comes in handy at this stage.

Assuming the image is now looking pretty good, use Whites and Blacks adjustments to fine-tune the exact point where textural detail is retained and specular

highlights transition to clipping. Adding a minus Blacks to a plus Shadows helps open up the extreme toe of the curve. Adding a minus Highlights to a plus Whites helps control the shoulder of the tone curve. It's really an iterative process.

I find myself using Whites and Black less often with Process Version 2012, largely because of the image-adaptive nature of the current tone controls. The one caution I would give you is this: don't try to start your tone control with the Whites and Blacks. Setting Whites and Blacks before Exposure and Highlights and Shadows tends to work against the image-adaptive nature of the image adjustments. My time spent in the Curves panel has been reduced because of the improved precision of the Basic panel tone mapping.

Presence

To round out the Basic panel, there are three final controls (bet you thought I would never get there, huh?): Clarity, Vibrance, and Saturation.

- **Clarity** is an image-adaptive contrast control for increasing or decreasing midtones contrast. I like to think of it as sort of an algorithmic lens-cleaning solution to punch up the images.

 A word of caution when using Clarity: you can very easily overdo the effect if you apply a really high setting. The look can take on a bad-HDR sort of appearance. Also, note that Clarity has been changed in Process Version 2012 to eliminate most of the bad halos and artifacts it exhibited in earlier incarnations. With the changes, the engineers also made the effect strength about two times stronger than the older Process Version 2010 Clarity.

 I use Clarity a lot, but I tend to use it carefully and often use it less in the Basic panel and apply it more in local adjustments. I often prefer to make my midtones contrast adjustments in Photoshop because of the flexibility it offers. (I'll show how to do that in Chapter 5.)

 Clarity is really a hybrid control: one part tone mapping, one part sharpening, and one part magic.

- **Vibrance** is a hybrid of a normal color saturation adjustment, but it works in a nonlinear manner. Vibrance increases the saturation of less-saturated colors more than really saturated colors. This reduces the tendency for slamming highly saturated colors into oversaturation. A negative Vibrance reduces saturation, but it can't completely remove color to the point of being monochromatic grayscale. It gives an old faded look, which can be useful. Vibrance also is designed to respect skin color and avoid making skin look too ruddy red in color.

NOTE Ironically, Punch was the original name of the Clarity adjustment, but Adobe decided that was too violent and changed it.

TIP Negative Clarity can be very useful for reducing midtones contrast, particularly on skin.

■ **Saturation** is simply a linear saturation control. A –100 setting turns the image into a monochromatic grayscale. I rarely use Saturation; I prefer to use Vibrance overall or the HSL controls to modify hues, saturation, and luminance to individual colors. I find that approach more powerful.

TONE CURVE PANEL

The Tone Curve panel is the first panel with two tabs: the Parametric Curve Editor and the Point Curve Editor. Why two curve editors? Parametric curve editing was introduced in Lightroom, and to maintain cross-compatibility, it was incorporated into Camera Raw, which already had a point curve editor. For some functions, such as relatively simple tone curve adjustments, either curve editor can be used.

Their capabilities are similar, but their usability is vastly different: The Parametric Curve Editor offers a quicker means of achieving a desired tone mapping, whereas the Point Curve Editor can help you obtain a more accurate placement of points on a curve. Your choice should be predicated on the precision your image needs versus the ease of accomplishing what you need. Both require practice and both work with the Targeted Adjustment tool (although, in Camera Raw, the Targeted Adjustment tool works only with the Parametric Tone Curve Editor).

Parametric Curve Editor

The Parametric Curve Editor uses a simplified UI to allow quicker adjustments of the Highlights, Lights, Darks, and Shadows. Two of the adjustments happen to share their names with adjustments in the Basic panel, but don't think that they behave the same. The Basic panel adjustments are image adaptive, while the curve versions are simple curves adjustments (although they do control similar portions of the overall tone mapping). In Lightroom, when you hover over an area in the curve display, the active areas are highlighted in the curve, as shown in **Figure 3.11**. This interactive display doesn't happen in Camera Raw (even though the control zones are the same).

In my opinion, the best way to use the controls is to adjust specific areas while using the Targeted Adjustment tool directly in the image. (You also can drag areas live from within the curve display, as well as just drag the sliders, but using the Targeted Adjustment tool is far more efficient.) In Lightroom, you access the Targeted Adjustment tool by clicking the upper-left circle area, which, when active, lights up with the Targeted Adjustment tool cursor. In Camera Raw, you select the Targeted Adjustment tool from the main toolbar.

The effectiveness of the Parametric Curve adjustment is further enhanced by the range adjustment sliders underneath the curve plot, which are used to expand or

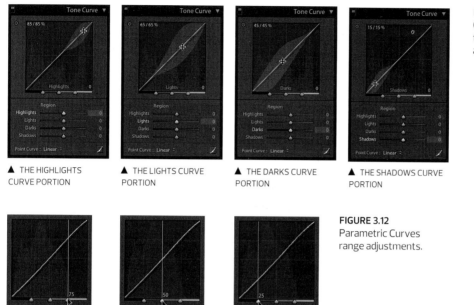

FIGURE 3.11 The Parametric Curve Editor panel showing the active areas in the curves adjustment.

▲ THE HIGHLIGHTS CURVE PORTION

▲ THE LIGHTS CURVE PORTION

▲ THE DARKS CURVE PORTION

▲ THE SHADOWS CURVE PORTION

FIGURE 3.12 Parametric Curves range adjustments.

▲ ¼ TONE RANGE ADJUSTMENT

▲ MIDTONE RANGE ADJUSTMENT

▲ ¾ TONE RANGE ADJUSTMENT

contract the range over which the curve adjustments are applied. **Figure 3.12** shows the range adjustments for ¼ tone, midtone, and ¾ tone ranges.

Adjusting the range controls allows you to confine or expand the range of the specific curve adjustments. I tend not to bother to adjust these because if I need a more precise curves adjustment, I simply use the Point Curve Editor.

Point Curve Editor

The Parametric Curve Editor often can produce the right tone curves more quickly, but there's no denying that the Point Curve Editor can accomplish far finer-tuned controls—particularly in the data-rich areas of extreme highlights. The curve behaves as a Bézier curve, which means adding a point and moving it has an impact both above and below the curve point. Moving a point will have an impact on the other side of the next point.

To place very fine point curves, you can click the curve to add a point. This adds a locking point that can modify the Bézier curve behavior of adjoining points. To delete a point, just drag it off the curve plot.

In Lightroom, you can use the Targeted Adjustment tool to place points based on the tonal areas where you click in the image. In Camera Raw, the Targeted

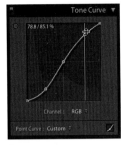

▲ A SIMPLE S-CURVE TO
ADD CONTRAST

▲ A SIMPLE S-CURVE TO
REDUCE CONTRAST

▲ A COMPLEX CURVE WITH MANY
POINTS PLACED FOR ACCURACY

◀ THE CHANNEL
DROP-DOWN MENU

FIGURE 3.14 The Point Curve drop-down
menus.

◀ THE POINT CURVE DROP-
DOWN MENU SHOWING THE
ABILITY TO SAVE A CUSTOM
CURVE

Adjustment tool doesn't work for the point curve. However, if you Control+click (Mac) or Ctrl+click (Windows), you can place a point on the curve. In Camera Raw, you can then use the up and down arrow keys to adjust the point. In Lightroom, you can't move a curve point from the keyboard (just use the Targeted Adjustment tool). **Figure 3.13** shows three example point curves.

New to Lightroom 4 and Camera Raw 7 (and requiring Process Version 2012 to use) is the ability to create not only luminance-based curves but also per-channel color curves to address color casts. The color-channel curves can adjust for situations where a cast may exist only in the highlights or the shadows. The color curves also can be used for special color effects, such as replicating an analog film cross-processing effect or aged color prints.

If you find a specific curves effect (either a luminance or a color curve) that you use a lot, you can save that curve and have the curve appear in the Point Curve drop-down menu. **Figure 3.14** shows the Channel drop-down menu for selecting which channel to apply a curve to and the Point Curve drop-down menu, which allows selecting or saving custom curves.

TONE MAPPING IN THE BASIC AND TONE CURVE PANELS

How do the two flavors of curves work with or impact the use of the Basic panel adjustments? Well, that's complicated. Obviously, the curves adjustments are simple tone–mapping controls without the magic sauce thrown in. Some experts have advocated essentially ignoring the Basic panel for anything other than white balance and doing all the tone mapping in the curves (predominantly the Point Curves). That was okay in previous versions of Lightroom and Camera Raw because the Basic panel controls were basically dumb. Now they're smart, and it would be a shame to ignore the power and control they offer.

I see the Curves panel as a place to make refinements of the tone mapping after optimizing an image in the Basic panel. Clearly, the Point Curve Editor has a very high degree of precision that may elude you in the Basic panel. One strong reason for using the curves is the ability to make a color–cast correction, which can fix color problems that white balance and HSL adjustments can't really accomplish. If you consider the Basic tone controls and the Curves panel to be complementary and capable of working together instead of either/or, I think your final tone mapping will lead to superior results.

HSL/COLOR/B&W PANEL

I didn't realize until I started writing this section that the order of the adjustment panels differs between Lightroom and Camera Raw. In Camera Raw, the next panel would be the Detail panel, but I'll stick with the Lightroom order.

The HSL/Color/B&W panel is another multiface panel that offers pretty powerful controls over color and black-and-white adjustments. The main panel name has three active buttons that take you to the different functionalities in the panel.

HSL

When you click HSL, you see the adjustments that can be applied based on the Hue, Saturation, and Luminance of the color in your image. **Figure 3.15** shows the three HSL subpanels.

There's a really good reason that HSL is a better place to deal with color saturation than the main Saturation slider in the Basic panel: here you can discreetly adjust color hue, saturation, and luminance based on eight channels of color.

Again, the best way to use the HSL controls is via the Targeted Adjustment tool. Being able to click an area in an image and adjust the HSL setting by dragging up

NOTE You might ask why eight instead of the normal six colors of additive and subtractive primaries (red, green, blue, cyan, magenta, and yellow). The answer: because Thomas Knoll and Mark Hamburg decided that six channels weren't optimal. Certain photographic colors didn't translate well to the traditional primaries. That's why cyan was changed to aqua and orange and purple were added. This allows for more targeted and smoother color adjustments.

FIGURE 3.15 The HSL subpanels.

▲ THE HUE SUBPANEL ▲ THE SATURATION SUBPANEL ▲ THE LUMINANCE SUBPANEL

TIP When you go to the HSL panel, you can have the individual Hue, Saturation, or Luminance subpanels open individually or have all of them open, showing 24 sliders. Personally, I find showing all 24 sliders overwhelming. Even with All selected, you still need to select the individual Targeted Adjustment tool for each subpanel.

or down is better than trying to drag a slider. One special advantage of the Targeted Adjustment tool is that many colors in images aren't constrained to just one of the eight HSL colors but a combination of two colors. So, if you use the Targeted Adjustment tool, you can adjust two sliders at once. The Targeted Adjustment tool also gives you a better clue as to what color you may want to adjust. You may think the green of a grassy field is green, but it's actually predominantly yellow. The Targeted Adjustment tool always knows which color(s) to adjust based on the position of the cursor in the image.

Color

If you click the Color portion of the panel, you get an entirely different subpanel that has a different UI for accessing the Hue, Saturation, and Luminance. Personally, I think this is a total waste of engineering effort, and I'm not even going to bother to show a screenshot. The Color subpanel isn't in Camera Raw, and I find it useless because it doesn't offer one major function: the Targeted Adjustment tool.

If you use Lightroom, you can discover for yourself how useless this subpanel is compared to the HSL panel. If you use Camera Raw, forget I even mentioned it.

B&W

I may be revealing my old age, but when I started in photography, we still used a thing called film. You know, that photosensitive stuff they put in gelatin and that turned silver halite into an image? Back in the old days, when you wanted to make black-and-white prints, you shot black-and-white film. But simply putting the film in the camera wasn't really good enough. You needed to put various black-and-white contrast filters in front of the lens to adjust the panchromatic response of the film. You used a medium yellow to get normal skies and a deep red to get really dark skies. An orange filter was great if you were shooting a woman's face because it tended to minimize skin texture. But if you were shooting an old guy, you used a green filter to maximize the "character" of the face (meaning, the weather-beaten, manly look).

Digital has changed things. Aside from a few specialty cameras that shoot gray-scale raw captures, all digital cameras shoot full-color images. Yes, you can set the picture mode to B&W in many DSLRs, but if you're shooting a raw file instead of a JPEG, you're still shooting a color image; the B&W tag is simply metadata that Lightroom and Camera Raw ignore.

There are multiple ways to take a digital negative and convert it to a black-and-white image in Lightroom, Camera Raw, or Photoshop. Here, I'll concentrate on Lightroom and Camera Raw. You can simply move the Saturation slider in the Basic panel to zero and get a no-color image, but that approach lacks control. The best method in Lightroom or Camera Raw is to use the B&W subpanel. When you click it, your image is changed from color to B&W.

The color to black-and-white conversion is slightly different from a pure desaturation (which most resembles converting to Lab and using the Luminance channel). The basic black-and-white conversion has a specific panchromatic response (meaning, which colors are turned into which monochromatic black-and-white tones).

Figure 3.16 shows the basic B&W subpanel with a normal zeroed setting giving the normal conversion, as well as what happens when you click Auto.

Depending on your Lightroom and Camera Raw preferences, you may never really see the zeroed B&W settings. The Auto button can be useful as a baseline conversion, but the odds are very good you'll want to modify the Auto results. What the Auto button does is attempt to optimize the color relationships to the resulting black-and-white tone. It's not unusual for two very different colors to convert to very similar black-and-white tones. Again, the Targeted Adjustment tool to the rescue! Turning on the Targeted Adjustment tool allows you to dynamically alter the color-based results of the black-and-white conversion. It's really easy to darken sky or lighten skin just by using the Targeted Adjustment tool and dragging up or down with your cursor. I gotta tell you, this is a far cry from trying to slap color-contrast black-and-white filters over the lens when shooting out in the field. This is like having an omnichromatic response instead of a panchromatic response to your digital negs.

TIP Both Lightroom and Camera Raw allow you to decide whether you want to apply Auto when converting to B&W. That's controlled by the Preferences.

▲ B&W SUBPANEL ZEROED

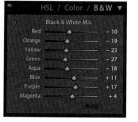

▲ B&W SUBPANEL AFTER AUTO

FIGURE 3.16 The B&W subpanel.

This is cool stuff if you like black and white (which I really do). However, there's one limitation to doing this in the B&W subpanel: it's a global adjustment. You can't really control the local area color to black-and-white conversions. That's a subject I'll cover in Chapter 5.

For many conversions from color to black-and-white, I suspect Lightroom and Camera Raw will do a fine job. How you *output* the black-and-white images will vary, but that's a subject for a different book.

SPLIT TONING PANEL

While the Split Toning panel was originally conceived as a place for color toning of B&W monochromatic images, it's also very useful when used with color images. The Highlights and Shadows can have different color hue tints applied (hence, the term *split toning*) with adjustable levels of saturation. The Balance slider allows you to adjust where the cutoff is for Highlights and Shadows. **Figure 3.17** shows the Split Toning panel and a split tone example.

There are a few tricks to using the Split Toning feature. If you hold down the Option key (Mac) or the Ctrl key (Windows), you get a live preview on your image of the color hue while you drag the Hue slider to various colors. That lets you select the hue you want before adjusting the Saturation slider. In Lightroom, you also can click in the color box and get Lightroom's Color Picker, shown in **Figure 3.18**. You

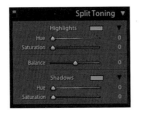

FIGURE 3.17 The Split Toning panel. This example shows the results of applying a warm/cool split tone to grayscale swatches originally photographed on a GretagMacbeth ColorChecker card. This effect is designed to simulate a traditionally toned silver gelatin print using sepia toning chemicals.

▲ GRAY SWATCHES BEFORE TONING

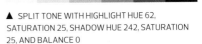

▲ SPLIT TONE WITH HIGHLIGHT HUE 62, SATURATION 25, SHADOW HUE 242, SATURATION 25, AND BALANCE 0

▲ SPLIT TONE WITH PREVIOUS HUE AND SATURATION SETTINGS BUT BALANCE +50 (MAKING EVERYTHING WARMER)

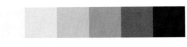

▲ SPLIT TONE WITH PREVIOUS HUE AND SATURATION SETTINGS BUT BALANCE −50 (MAKING EVERYTHING COOLER)

▲ THE COLOR SAMPLER

▲ PICKING OR SAVING A COLOR PRESET

FIGURE 3.18 The Lightroom Color Sampler.

can either drag the sampler in the spectrum to select the hue and saturation or click the saved color samples at the top. If you have a specific hue and saturation you like, you can add the color to the saved samples. You also can drag the color sampler over to your image preview and sample colors directly from your image.

I use the Split Toning feature a lot with color images. I'll warm the highlights and cool down the shadows to give a more "golden light" look to my images.

DETAIL PANEL

The Detail panel contains the Lightroom and Camera Raw "capture sharpening" and noise-reduction image adjustments. I put capture sharpening in quotes because the sharpening in the Detail panel is designed to work within the multipass sharpening workflow, as devised by the late Bruce Fraser. Bruce developed the concept of doing an initial image sharpening to regain the loss of sharpness that occurs during the process of turning continuous light into discrete image pixels. This is called *capture sharpening*. The next separate sharpening pass, called *creative sharpening*, is applied more for effect and can also include blurring some areas to make other areas appear sharper. This is usually applied locally in the Graduated Filter or Adjustment Brush in Lightroom or Camera Raw. The final sharpening pass is *output sharpening*, which is done after the image is at its final size and resolution; it applies sharpening appropriate to the final paper and printer or media device. This would be done in the Print module in Lightroom or Photoshop before outputting the image.

Adobe was impressed enough with the concept of a multipass sharpening workflow that it hired Bruce to consult for the Camera Raw engineering team to help incorporate capture sharpening in the Detail panel. With Bruce's untimely passing, I stepped in to help fulfill the consulting contract, but the results still have Bruce's fingerprints all over them. That's not to say that Mark Hamburg and Thomas Knoll, and, more recently, engineer Eric Chan, didn't do the hard work—they wrote the code. The Camera Raw engineers took Bruce's ideas as inspiration and incorporated those ideas into a series of four parametric sharpening adjustments. **Figure 3.19** shows the Detail panel that includes the sharpening and noise-reduction adjustments.

NOTE For the purposes of full disclosure, Bruce Fraser designed a sharpening plug-in for Photoshop called PhotoKit Sharpener, which was produced by PixelGenius (www.pixelgenius.com). Bruce and I were founding members of PixelGenius, along with our other founding partners, Martin Evening, Seth Resnick, and Andrew Rodney. Mac Holbert joined PixelGenius after Bruce's passing. We also worked with the Lightroom/Camera Raw engineering team to incorporate PhotoKit Sharpener's Output Sharpening directly into the Lightroom Print module.

FIGURE 3.19 The Lightroom Detail panel and image example for sharpening.

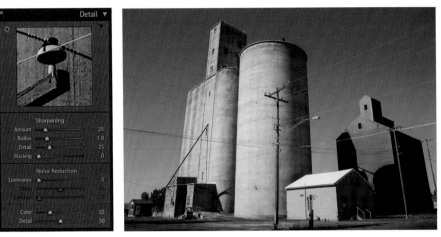

▲ THE DETAIL PANEL IN LIGHTROOM

▲ THE IMAGE EXAMPLE

Sharpening

NOTE Capture sharpening is not designed to counter camera shake or subject motion, nor is it designed for other sharpening effects. Those are things that need to be done in creative sharpening in Photoshop.

The image-sharpening controls are designed to allow you to sharpen by eye at a screen zoom of 1:1 (Lightroom) or 100 percent (Camera Raw). You need to evaluate the image at 1:1 because only 1:1 allows one image pixel to be shown on one screen display pixel. At any other zoom, pixel dithering has an impact on the accuracy of the image preview on-screen. The settings in Figure 3.19 show the Lightroom and Camera Raw defaults, which are okay as a starting point but never optimal. The idea for capture sharpening is to sharpen the image to recover the loss of sharpness caused by turning continuous tone light into pixels in a digital capture. Many cameras also have aliasing or high-pass filters to reduce moiré patterns or image artifacts that make images softer.

Here are the four sharpening controls:

▪ **Amount:** Amount is a volume control that determines the strength of the sharpening being applied. It runs from 0, meaning no sharpening is being applied (this is the default amount set for non-raw images), all the way to 150. If you go to 150 without adjusting other controls, your image will be pretty much oversharpened to death! But depending on the other sharpening parameters, you can go up to 150 when you apply other controls because they'll impact how the sharpening amount is applied.

- **Radius:** Radius defines how many pixels on either side of an "edge" the sharpening algorithm will be applied to in order to increase the apparent sharpness. The Radius control goes from a minimum of 0.5 pixel to a maximum of 3 pixels. In general, images with high-frequency edges need a lower radius, while low-frequency images need a higher radius.

- **Detail:** Yeah, there are *three* Detail sliders in the Detail panel (including noise reduction). Confused yet? The engineers tried to come up with a better term, but Detail is at least descriptive. The Detail sharpening adjustment is pretty complicated. When adjusted downward toward 0, the Detail slider kicks in a halo suppression algorithm that limits how strong the halos get with your Amount settings. Halos are a result of image-sharpening algorithms, but the idea is to have the halos be invisible at normal viewing distances. Lowering the Detail slider can reduce the halo visibility. Moving toward 100, the Detail kicks in a deconvolution-based sharpening that is very similar to Photoshop's Smart Sharpen filter when set to remove Lens Blur. Deconvolution sharpening attempts to deblur an image based on determining what kind of blur is in the image. The processing algorithm uses a point-spread function (PSF) to approximate a mathematical description of the blur and then inverts the PSF to try to sharpen away the blur. Accurately calculating the PSF can be really difficult, but the Detail slider at 100 does a reasonable job of attempting to deblur based on a generic lens-blur PSF. The Detail slider interpolates between these two different sharpening algorithms. The default is 25, but I usually increase this toward the middle of the range (rarely to +100, though). You should be aware that running the Detail slider up on a noisy image will substantially increase the sharpening of the noise.

- **Masking:** Masking reduces the sharpening of non-edge areas (surfaces) and concentrates the sharpening on edges, which is a principle of capture sharpening. The fact that Lightroom and Camera Raw are creating an edge mask on the fly parametrically is very impressive.

Generally, I think it's useful to apply masking to almost any image. For very textural image, less masking is needed. For Sharpening faces, you'll want a much higher masking setting.

When trying to evaluate what settings to use, you can use an on-screen preview of what Lightroom and Camera Raw parameters are doing. Hold down the Option key (Mac) or Alt key (Windows) to see the relevant parameters. Lightroom has a small preview window in the panel (which can be hidden by clicking the arrow next to the preview). Camera Raw doesn't have the panel preview, but both Lightroom and Camera Raw have the on-screen preview. **Figure 3.20** shows the panel preview with various settings starting at the top with the Amount.

TIP To determine the edge frequency, think about how much texture is in the image. A landscape image with lots of texture like trees or rocks will have a higher overall edge frequency. A person's face will have a lower frequency because much of the face is simply skin, which you don't really want to hit with a lot of sharpening.

NOTE Masking control is relatively processor intensive, and you may see a slowdown on old machines when using it. That is why, by default, Masking is set to 0, meaning there's no masking and no mask needs to be built.

NOTE I'll be covering the creative sharpening pass of the sharpening workflow and how it interacts with capture sharpening in the Detail panel later in this chapter and additional creative sharpening in Chapters 4 and 5.

FIGURE 3.20 Sharpening previews. The final settings used for the image were Amount 75, Radius 0.5, Detail 80, and Masking 15.

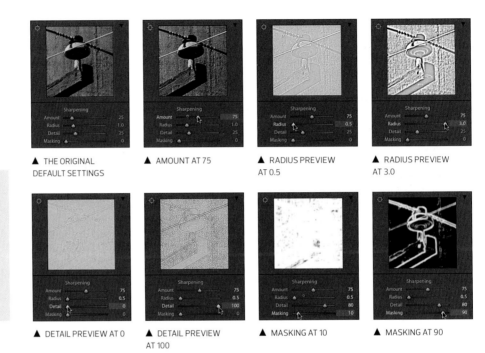

▲ THE ORIGINAL DEFAULT SETTINGS

▲ AMOUNT AT 75

▲ RADIUS PREVIEW AT 0.5

▲ RADIUS PREVIEW AT 3.0

▲ DETAIL PREVIEW AT 0

▲ DETAIL PREVIEW AT 100

▲ MASKING AT 10

▲ MASKING AT 90

NOTE The sharpening is applied to the luminance data in the image and doesn't impact color information. That's why the Amount slider is previewed as a grayscale image.

TIP You can change the zoom in the Lightroom panel preview from 1:1 to 1:2 by right-clicking (Control+clicking on Mac) directly on the preview. You also can change the framing of the panel preview by clicking the little square icon on the upper right. It isn't really called a Targeted Adjustment tool, but clicking the icon allows you to move through your image and see a preview of what's under your cursor.

NOTE You might be wondering what camera I used for this image. I shot it using a Phase One 645DF camera with a 45mm lens on an IQ180 80MP camera back. This back produces captures that can stand rather high amounts of sharpening, even though it's a CCD sensor with no aliasing filter.

Officially, the Detail panel has only four sharpening sliders, but I actually think there are five sliders you need to adjust to optimally get the best image detail from your digital negs. The fifth slider is the Luminance Noise Reduction slider. The reason I almost always add luminance noise reduction is that, even for low-ISO images, image sharpening and noise reduction really are two sides of the same coin. When you increase sharpening, you inevitably increase the appearance of noise in the image. Luminance noise reduction is important, particularly if you're using a high Amount and/or Detail setting with a low radius Setting. As you run the Detail slider up, the impact of the deconvolution-based sharpening really can hit the noise hard. By increasing the luminance noise reduction, you can use a higher amount and detail settings while mitigating the noise bloom. I'm going to drill down on noise reduction in the next section with an image shot at really high ISO. **Figure 3.21** shows the adjustment of the luminance noise reduction, as well as a before and after of the sharpening. The views of the images are done at a screen view of 1:1.

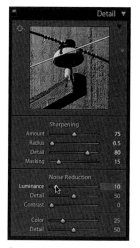

▲ FINAL DETAIL PANEL
SETTINGS

▲ THE ORIGINAL IMAGE WITH ZERO SHARPENING AND
NOISE REDUCTION

▲ THE FINAL IMAGE WITH ALL THE DETAIL PANEL SETTINGS
APPLIED

FIGURE 3.21 Adding noise reduction and comparing the before and after of the Detail panel settings.

WANT SOME SHARPENING PRESETS?

Lightroom actually ships with two sharpening presets I devised for the Lightroom engineers. They're located in the Lightroom General Presets, and they're named Sharpen–Faces and Sharpen–Scenic. Camera Raw doesn't ship with any presets, but I'll tell you what the settings are so you can make your own. The Sharpen–Faces preset settings are: Amount 35, Radius 1.4, Detail 15, and Masking 60. The settings for Sharpen–Scenics are: Amount 40, Radius 0.8, Detail 35, and Masking 0. They're useful improvements over the default, but you still need to hand–tune the settings image by image.

Noise reduction

Noise can come from using a high ISO and the resultant amplification of the signal in the analog-to-digital conversion, or it can be the result of underexposing the image and trying to recover detail from the extreme shadows. Noise can become more visible if you use high amounts of sharpening or high Detail slider settings. The basic way noise reduction works is by applying a low level of smoothing by blurring—hopefully, without overblurring actual image detail.

TIP Noise and sharpening are two sides of the same coin, and one will inevitably impact the other. To get optimal image detail, regardless of the ISO, you need to optimize both sides of the coin.

To demonstrate the Noise Reduction controls, I'll use a shot of the interior of the Santa Escuela Church in San Miguel de Allende, Mexico. The interior was quite dark, so I used an ISO of 12,800 on a LUMIX GH2 camera. At that ISO, the image is pretty darn noisy. **Figure 3.22** shows the full image uncropped and the final sharpening and noise reductions used.

I suspect at the final size of this relatively small reproduction, you won't see any appreciable noise because one of the *best* ways of reducing noise is downsampling. But I assure you the image was incredibly noisy to start with. But before I go through the steps I used to arrive at the final adjustments, let me explain the fundamentals of using the noise-reduction sliders in the Detail panel. The following descriptions are from Eric Chan, the Camera Raw engineer largely responsible for creating the noise-reduction processing (so I'm pretty sure they're correct).

- **Luminance:** This slider controls the amount, or "volume," of luminance noise reduction applied. The adjustment is tuned so that a setting of 25 is a reasonable balance of noise reduction applied and detail preserved. This also means that the extra range between 25 and 100 can be used to control how much additional noise reduction to apply. A value of 0 means "do not apply any luminance noise reduction." When set to 0, the Luminance Detail and Luminance Contrast sliders are disabled, or grayed out. The Luminance slider is always enabled for any process version. The default value is 0.

- **Luminance Detail:** This control sets the noise threshold. You can drag the slider to the right to preserve more detail; however, this may cause noisy areas of the image to be incorrectly detected as details and, hence, not be smoothed. You can

FIGURE 3.22 Final sharpened and noise–reduction settings.

▲ FINAL IMAGE

▲ FINAL DETAIL PANEL SETTINGS

drag the slider to the left to increase image smoothing; however, this may cause real image details to be incorrectly detected as noise and, hence, smoothed out. This effect is mainly observable on very noisy images only. It's disabled for Process Version 2003 or when the Luminance slider is set to 0. The default value is 50.

- **Luminance Contrast:** Drag this slider to the right to better preserve image contrast and texture; however, doing so also may increase perceived "noise blobs" or mottling in high-ISO images. You can drag it to the left to achieve very smooth, fine-grained results; however, you may lose local image contrast and textures may get smoothed out. As with Luminance Detail, the results are more noticeable on very noisy images (above ISO 6400 on a DSLR). The Luminance Contrast slider is disabled for Process Version 2003 or when the Luminance slider is set to 0. The default value is 0.

- **Color:** This adjustment is designed so that its default value of 25 does a pretty good amount of color noise reduction, balancing the competing requirements of suppressing ugly color noise blobs yet maintaining color edge detail. Setting the slider to 0 means that no color noise reduction will be applied. Setting the slider to values higher than 25 means that much more aggressive color noise reduction will be applied, which will likely cause color bleeding at the edges. The default value is 25 for raw files, 0 for non-raw files.

- **Color Detail:** This control is most useful for extremely noisy images. It lets you refine color noise reduction for thin, detailed color edges. At high settings (75 to 100), Lightroom and Camera Raw will try to retain color detail in edges, but this may cause pixel-level "color speckles" to remain in the image. At low settings (0 to 25), Lightroom and Camera Raw will suppress these small, isolated color speckles, but thin features in the image may become desaturated (i.e., there may be some color bleeding at fine edges). For testing purposes, try zooming to 400 percent pixel view to get a clearer understanding of the effect. The Color Detail slider is disabled for Process Version 2003 or when the Color slider is set to 0. The default value is 50.

The screenshots of the church image were done in Lightroom with the image zoomed to 2:1 (200 percent in Camera Raw). I think it's critical to use a 1:1 zoom to evaluate and adjust image sharpening, but I think it's important to zoom to 2:1 (or higher) to really get a sense of how the noise reduction is impacting both the noise in a good way and your image detail in a bad way. For low-ISO digital negs, the odds of needing to adjust the Detail and Contrast settings for Luminance and the Detail settings for Color are pretty low. Depending on your sensor, you may never be able to see any difference, so I don't even bother to try to adjust them for low-ISO images. **Figure 3.23** shows the 2:1 zoom of the very center of the image from Figure 3.22.

NOTE The Detail and Contrast sliders in the luminance noise subpanel and the Detail slider in the color noise subpanel are visible only with Process Version 2010 and Process Version 2012. In Process Version 2003, you don't have the additional sliders available and the noise reduction is considerably more primitive and not really very good.

▲ IMAGE WITH NO SHARPENING, LUMINANCE, OR COLOR NOISE REDUCTION

▲ OPTIMIZED SHARPENING WITH LUMINANCE 0, COLOR NOISE 25, COLOR DETAIL 50

▲ SHARPENING PLUS NOISE–REDUCTION SETTINGS LUMINANCE 70, LUMINANCE DETAIL 70, LUMINANCE CONTRAST 35, COLOR 30, COLOR DETAIL 50

▲ IMAGE SHARPENED AND NOISE REDUCED WITH ADDED GRAIN AMOUNT 23, SIZE 4, ROUGHNESS 65

FIGURE 3.23 Comparing before and after sharpening, noise reduction, and grain addition.

The image with no sharpening and noise reduction looks pretty bad, but I wanted to show you what the inherent noise signature of the camera is when set to ISO 12,800. It looks like a pointillist painting, right? The next image has the default color noise reduction set but with the optimized sharpening from Figure 3.22. The sharpening has made the luminance-based noise worse. The next image has the optimized sharpening, luminance, and color noise settings applied. The Luminance slider is up rather high, but I also raised the Luminance Detail slider up, which returned a bit of image detail. Adding the Luminance Contrast reduced some of the loss of micro-contrast that the noise reduction was causing. I also upped the default Color setting to 30.

The final image shows a little trick I use on really high-ISO images: when I use a strong noise-reduction setting, I add back some grain from the Effects panel. Why would I add grain back into an image that has been noise-reduced? I find that adding back very small grain (much smaller than the noise blocks of the original) at a very low amount seems to break up the flat and plastic-looking areas that high noise reduction produces. I think it gives a more photographic feel. It doesn't really add any micro-detail, but I think it helps. If you're going to downsample the image for any sort of output, you can forget about adding grain back in, since downsampling will remove any hint of the added grain.

One thing you should take care with when setting your color noise-reduction setting is to make sure you don't use a higher-than-necessary amount. Color noise reduction can leach color out of small areas of color detail. **Figure 3.24** shows a 2:1 zoom view of the flowers with the final Color setting of 30 and the other image with a Color setting of 60. Since the color noise-reduction algorithm is essentially

TIP The key here is to use as little as you can get away with. Actually, that advice holds true for all the settings in the Detail panel—don't over-sharpen or overblur your noise, and add a touch of grain if it helps.

FIGURE 3.24 Avoiding color detail loss.

▲ 2:1 ZOOM OF THE GOOD COLOR NOISE REDUCTION SETTING

▲ 2:1 ZOOM OF THE COLOR NOISE-REDUCTION SET TOO HIGH

blurring the color image data, a strong setting wipes out the color detail, which even increasing the Color Detail slider can't really fix.

LENS CORRECTIONS PANEL

The Lens Corrections panel is where you apply corrections for various lens aberrations as well as address issues involving how an image was formed. The Lens Corrections panel is made up of three separate subpanels:

- **Profile:** Employs a profile for lens distortion and vignetting
- **Color:** Provides chromatic aberration correction
- **Manual:** Allows you to manually correct lens distortion and vignetting, as well as keystone and rotation correction

Figure 3.25 shows an image before and after being corrected in the Lens Corrections panel.

FIGURE 3.25 Comparing the results of the application of lens corrections.

▲ BEFORE LENS CORRECTIONS

▲ AFTER LENS CORRECTION

The image was captured with a Canon EOS Rebel XTi camera using an EF-S 10–22mm lens. I took the shot along the Chicago River looking toward the Loop. As you can see, I was tilting the camera up, causing a keystone effect, which I corrected in the Manual subpanel. The first correction was made in the Profile subpanel.

Profile subpanel

Both Lightroom and Camera Raw have access to the same lens profiles supplied by Adobe. A lens profile uses lens performance data to apply corrections for lens distortion and vignetting. **Figure 2.26** shows the Profile subpanel of the Lens Correction subpanel.

Both Lightroom and Camera Raw will generally find the correct lens profile from the EXIF metadata of your digital negative. I say "generally" because there have been times when, for some reason, I had to manually select the lens make and model. I'm showing the Make drop-down menu to indicate the wide range of lens manufacturers whose lenses have been profiled. The lens manufacturers themselves created some of the profiles, and the Camera Raw engineers created others.

Not all cameras and lenses have been profiled. If your camera and lens don't show up in the lists, there are three potential reasons:

■ **Your camera and lens already may have the profile corrections built in because the information is embedded in the EXIF metadata.** In many Micro Four Thirds cameras (and many point-and-shoot cameras), the lens profile data is built in to the raw file and Lightroom and Camera Raw automatically apply the correction. If this is the case, you can't actually turn off the corrections.

FIGURE 3.26 The Profile subpanel.

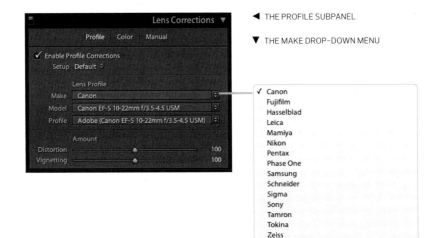

◀ THE PROFILE SUBPANEL

▼ THE MAKE DROP-DOWN MENU

- **You may be trying to use a profile created for use on a raw file on a JPEG or TIFF file.** If the profile was created to be used with a raw file and you're trying to apply it to a JPEG or TIFF, you'll need to select the correct make and model from the drop-down lists.

- **Your lens doesn't have a profile.** If there is no lens profile for your make and model, about the only recourse is to use the Manual subpanel corrections or build you own lens profile. Adobe has released the Adobe Lens Profile Creator, which is a free download from http://labs.adobe.com. The process of making a custom lens profile is tedious and not for the faint of heart. You start out by printing out lens targets and then photographing them in a very prescribed method. You'll need to take a lot of shots at various subject distances and lens apertures. If you're profiling a zoom lens, you'll have to do the same series at multiple zoom ranges. If you think that's too much work, you can download and install the free utility called Adobe Lens Profile Downloader (available at http://labs.adobe.com), which is a free companion application to Photoshop, Lightroom, and the Camera Raw plug-in. It allows you to search, download, rate, and comment on the online lens correction profiles that are created and shared by the user community.

Once you've enabled the profile corrections and selected the correct lens profile, you have some options. You can alter the distortion and/or the vignetting correction amount to fine-tune the results. I often cut down the vignetting correction a tad because I think some profiles overcorrect vignetting and make the corners too bright. **Figure 3.27** shows adjusting the vignetting and the Setup drop-down menu.

When you enable profile corrections on the Profile subpanel, the Setup menu defaults to Default. Tricky, huh? If you modify the Profile selected or the Correction Amounts for the correction parameters, the Setup menu changes to Custom.

There is also a menu item named Auto. I realize it can look confusing—I was plenty confused when I first saw it—but you can grasp the behavior logic if you understand the options. If you select Auto as a Setup menu item, Camera Raw will

> **NOTE** You might ask why there's an Auto menu item as well as a Default menu item in the Setup menu options. I wondered, too. The fact is, the difference between Auto and Default shows up only when you alter the settings for a particular lens profile. If you alter a lens profile's settings and you save that as a new lens profile default, there will be a difference in the menu items because Auto would be Custom unless you save a new lens profile default, in which case the menu would show Default.

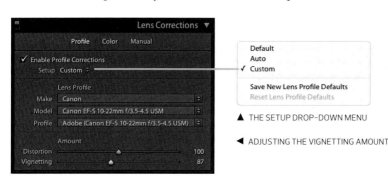

▲ THE SETUP DROP-DOWN MENU

◀ ADJUSTING THE VIGNETTING AMOUNT

FIGURE 3.27 The Setup drop–down menu options.

look for a matching profile and select it automatically. The Auto option seems pretty simple and straightforward, right? However, if you make any modifications to the Auto-selected profile's Correction Amounts or the lens profile selected (if you have multiple profiles for a lens), the menu will change to Custom. Assuming you do want to save the modifications you've made into a lens profile Setup default, you can do so by selecting the Save New Lens Profile Defaults menu option.

Why do these different Setup menu items matter? They dictate the way Presets you make regarding lens-profile correction end up behaving. They also play a role if you want to have Lightroom or Camera Raw incorporate lens corrections automatically as the Lightroom/Camera Raw default. (**Remember:** Lightroom and Camera Raw share defaults.)

If you've selected Auto and you create a new Lightroom or Camera Raw Preset, you can apply that preset upon importing in Lightroom (or in Bridge if you're using Camera Raw). Regardless of the camera model or lens on the camera, if Lightroom or Camera Raw can find a profile for the lens, an Auto lens correction preset will apply the correct lens corrections. This is incredibly useful and time-saving.

Whether you want to automatically apply lens profile corrections really depends on the type of photography you do. Obviously, if you shoot architecture, you'll want to apply profile corrections—that's a no-brainer. For landscape or portraiture, you may or may not. The profile corrections are computationally intensive, so you may see slowdowns due to the corrections. I also think it depends on your lens. The lens used in this example exhibits strong aberrations, which are easily fixed by the profile and by using the Color subpanel controls.

Color subpanel

Most wide-angle lenses and many zoom lenses suffer from lateral chromatic aberrations (CAs). In previous versions of Lightroom and Camera Raw, you had to manually adjust sliders to fix the CA. In Lightroom 4 and Camera Raw 7, lateral CA can be fixed automatically simply by clicking the Remove Chromatic Aberration option. It's unchecked by default, but this is one of those image adjustments you may want to have applied automatically by Lightroom and Camera Raw. **Figure 3.28** shows the uncorrected and corrected images at a zoom of 3:1 and the Color subpanel.

This lens produces noticeable lateral CA, but it doesn't really have any longitudinal chromatic aberration.

Longitudinal (or axial) CA is often called "fringing." It shows up on longer lenses and appears particularly objectionable on high-contrast areas of an image that are out of focus. Purple fringe appears in front of the plane of focus, and green fringe appears behind the plane of focus. Fringing affects nearly all lenses, from inexpensive cellphone lenses to very expensive prime lenses. It's particularly noticeable

NOTE The Remove Chromatic Aberration feature calculates the amount of CA correction based on your image. The lens profile correction can't really be used for tilt/shift lenses, but the auto CA correction works well. The reason that tilt/shift lenses can't be corrected by a profile is that when you tilt or shift a lens off-axis, the optical center of the lens is changed so distortion and vignetting is no longer symmetrical. Lens profiles rely upon the optical properties remaining symmetrical.

▲ UNCORRECTED IMAGE SHOWING GREEN AND MAGENTA FRINGING

▲ CORRECTED IMAGE REMOVING THE CA

FIGURE 3.28 Correcting CA in the Color subpanel.

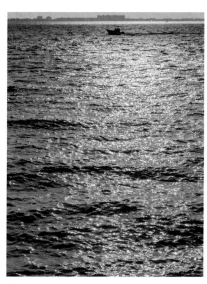

▲ FULL-CROP IMAGE SHOWING PURPLE FRINGING

FIGURE 3.29 Using the Defringe tool.

◀ DETAIL SHOWING THE FRINGE COLOR SELECTOR TOOL

▲ THE DEFRINGE SETTINGS

◀ DETAIL SHOWING CORRECTION

with fast lenses at wide apertures. Using a smaller aperture can reduce fringe when shooting, but the new Defringe correction can virtually eliminate color fringing in post-processing. The image in **Figure 3.29** shows some pretty serious and obvious purple color fringing.

The Fringe Color Selector tool is similar in function to the White Balance tool. You pick up the tool by clicking it; then hover over the fringe and click to automatically

▲ PREVIEW BEFORE FINE-TUNING AMOUNT ▲ PREVIEW AFTER FINE-TUNING AMOUNT ▲ PANEL ADJUSTMENT OF PURPLE AMOUNT

▲ PREVIEW BEFORE FINE-TUNING PURPLE HUE ▲ PREVIEW AFTER FINE-TUNING PURPLE HUE ▲ PANEL ADJUSTMENT OF PURPLE HUE TO
EXPAND TOWARD RED

FIGURE 3.30 Using the preview to adjust the Amount Hue and Purple Hue sliders.

select the Amount and either the Purple Hue or the Green Hue (depending on the color of the fringe).

The Purple Amount and Green Amount sliders determine the strength of the color removal. Fringe removal is limited to the hue range defined by the Purple Hue and Green Hue sliders. The hue sliders determine the range of hues removed and have set hues and ranges. The control has two sliders, which determine the endpoints of the hue range.

You can either use the Fringe Color Selector to determine the amount of the hue fringe removal or manually drag the sliders—or do what I do, which is to first use the tool and then manually tune the results. Similar in concept to the Detail panel visualization, while holding the Option key (Mac) or Alt key (Windows), you can get a preview of either the Amount slider or Hue slider directly on your image. **Figure 3.30** shows the preview visualization of the Amount and Hue sliders.

The previews take a bit of getting used to. In the Amount slider, the preview is trying to show you the non-white area that will get the defringe removal. As you adjust the amount, the color will go away. In the Purple Hue preview, black is shown to indicate the range of the area in which the hue expansion is being adjusted. Yeah, it looks a bit weird, but with a little practice on your own images, you should get pretty good at making both the initial and fine-tuning adjustments. **Figure 3.31** shows a before-and-after defringe correction.

▲ BEFORE

▲ AFTER

FIGURE 3.31 Comparing before and after.

▲ BEFORE USING THE FRINGE COLOR SELECTOR TOOL

▲ AFTER USING THE FRINGE COLOR SELECTOR TOOL

▲ AFTER MANUAL ADJUSTMENT AND USING AN ADJUSTMENT BRUSH USING DEFRINGE TO PAINT AWAY THE FRINGING

FIGURE 3.32 Dealing with colored objects by painting away color fringe.

Some images may need both purple and green defringe corrections. The Fringe Color Selector can be used for both. When you hover and click on the purple fringe, the tool adjusts the purple amount and hue. If your image also has green fringe, clicking the green will set the green amount and hue without altering the purple fringe settings. If you again click the purple fringe, the purple settings will change again, but it won't impact the green settings.

One thing you may face is an image that actually has purple and green objects in your images. In those situations, you'll want to be very careful setting the amounts or risk having the edges of the purple or green objects eroded. **Figure 3.32** shows an example where the Fringe tool doesn't work optimally.

This is an example where the Defringe corrections in the Color panel won't work well. I have a purple flower but also some color fringe on a stem. Clicking with the Fringe Color Selector tool works well to remove the fringe on the stem but eats into the boundary of the purple flower. In this case, the only option is to cut way back on the global Defringe amount and resort to using the Defringe control in the Adjustment

Brush and literally painting the color fringe away. Although the local control for Defringe doesn't have the same set of parameters, it does have the advantage of targeting the Defringe to only those areas where you brush it in.

Manual subpanel

The last panel in the Lens Corrections panel is the Manual subpanel, as shown in **Figure 3.33**. I'm using the same image that I used in Figure 3.25 to show correcting the keystone and rotation adjustments.

To get the buildings corrected, I applied a –33 Vertical correction and applied a –0.4 rotation. I also selected the Constrain Crop check box (I'll get to that option in a moment). You'll notice that Lightroom automatically provides a grid preview over your image when you hover over a transform slider. You can't turn that off or adjust the grid. In Camera Raw, you can turn the grid on or off using the V key to toggle the grid. The Scale command allows you to make the image bigger or smaller (+150 down to –50) within the crop area. If you have the Constrain Crop box checked, you'll probably not need to use this. However, if you uncheck that box, you can alter the live area of the crop and preserve as much of your image as you want after making the manual transforms. **Figure 3.34** shows the Constrain Crop on and off.

Because the transforms change your image to correct for distortion, you end up losing some of your boundary pixels. If you've framed your shot loose enough, that might not matter. But if you want to preserve as much of your original frame, unchecking the Constrain Crop check box allows the crop to go beyond the image boundaries. Lightroom and Camera Raw add a medium gray color to those areas of the image consumed by the transform. If you need to keep some edge detail, you

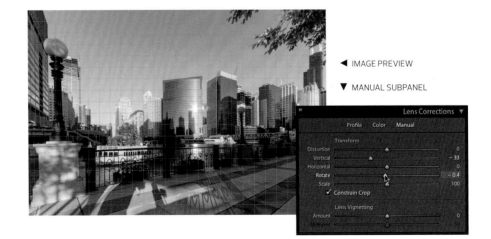

FIGURE 3.33 Adjusting keystone and rotation.

▲ CONSTRAIN CROP OPTION ON

▲ CONSTRAIN CROP OPTION OFF

FIGURE 3.34 The Constrain Crop option.

can take the uncropped image into Photoshop and try to use Content Aware Fill to restore or rebuild those areas.

As you can see, the Lens Corrections panel has a lot of power and complexity, but it's critical to take advantage of the tools offered to achieve maximum image quality.

EFFECTS PANEL

The Effects panel has only two functions: Post-Crop Vignetting and Grain. (In Camera Raw, the order is reversed for some reason.) Some may denigrate these two tools, but I use them a lot—although with restraint (meaning that, for me, a little goes a long way).

Post–Crop Vignetting

As the name suggests, the Post-Crop Vignetting feature applies the vignetting *after* the image is cropped. In the Lens Corrections panel, vignetting controls are applied to the uncropped original because it's intended to correct a lens flaw, not apply a creative effect. Ironically, I often either reduce the amount of correction applied in the Lens Corrections panel (as I previously showed) or come to this panel to adjust after cropping. Although lens vignetting corrections are usually used to lighten darkened corners, the Post-Crop Vignetting adjustments are more often used to darken the corners to concentrate viewer interest toward the center (although you can certainly lighten the corners all the way to white). **Figure 3.35** shows a typical example of the way I use the tool.

NOTE One special-case capability of the profile correction is the ability to take an image shot with a fisheye lens and de-fisheye it. The capability is pretty remarkable, but I think it's kind of silly to shoot something with a fisheye lens and then remove the effect, so I won't bother showing an example. If you have a fisheye lens, try it for yourself. It works, but I think you'll find the extreme corners of your image will be very soft and degraded after the lens correction.

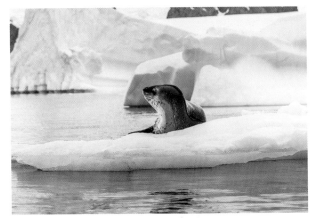

▲ BEFORE CROPPING AND POST-CROP VIGNETTING

▲ AFTER CROPPING AND POST-CROP VIGNETTING

FIGURE 3.35 Before and after Post–Crop Vignetting adjustments.

I shot this image of a leopard seal in Antarctica with a Canon EOS 1Ds Mark II camera with a 70–200mm lens. The full-frame image was at the maximum 200mm and needed cropping to make the seal bigger. I also felt that the surrounding excess of ice needed to be darkened down to concentrate attention on the seal because, well, it's really important to pay close attention to leopard seals because they're big, scary animals. They range from 8 feet to 11 feet long, weigh up to 600 pounds, and have lots of teeth. I figured he deserved some Post-Crop Vignetting!

I'll show you the settings I used, but first I'll describe the fundamentals of the controls:

- **Amount** controls how much darkening or lightening will occur in the Post-Crop Vignetting.

- **Midpoint** moves the effect in toward the center or out toward the corners.

- **Roundness** allows you to adjust how round or oval or, in the extreme, nearly rectangular, the resulting effect is applied. A value of –100 will result in almost an image-edge-only effect.

- **Feather** controls how hard or soft the effect will *gradate* (feather) in and out. Generally, you'll want the effect soft enough so you don't see obvious start or stop points.

- **Highlights** controls how much highlight detail is preserved in the corners. The Highlights control is dimmed when the Style drop-down menu is set to Paint Overlay.

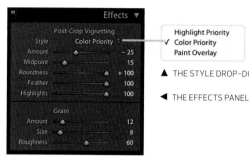

FIGURE 3.36 The Effects panel showing the Post–Crop Vignetting adjustments.

▲ THE STYLE DROP-DOWN MENU

◄ THE EFFECTS PANEL

Figure 3.36 shows the settings I used for the image in Figure 3.35. I used a relatively low –25 setting and moved the midpoint to 15 to draw the effect toward the center. Both the feather and highlights settings are at 100. I wanted the feather to be very subtle, and I didn't want the highlights to get too gray. I used the Color Priority blending option.

The Style drop-down menu, shown in Figure 3.36, controls how the vignetting adjustments are blended into the image. Color Priority is usually the best option for keeping the color natural at the corners while still being able to maintain believable highlights. Here's a description of the various options:

- **Highlight Priority** closely resembles the manual vignetting tools in the Lens Correction panel. The Highlights slider is available to control the brightness of highlights in the corners. Highlight Priority tends to contaminate saturated colors.

- **Color Priority** preserves the color appearance while darkening the corners. Color Priority enables the Highlights slider to preserve the brightness of the highlights in the image that may be found in the corners.

- **Paint Overlay** darkens the image without regard to its contents. Everything gets darker, which often results in a rather drab effect.

Grain

Figure 3.36 also shows that I added a small amount of grain to the image. With an ISO of 200, the shot required a touch of noise reduction, so I added a small amount of grain on top of the noise reduction. As I indicated in the "Noise reduction" section, earlier in this chapter, adding a tiny bit of grain can help reduce the synthetic look you may find after applying noise reduction. Yes, I understand that it sounds counterintuitive to add grain back in after reducing noise, but as long as the added grain is smaller than the noise, grain works with noise reduction to give an appearance of micro-detail. If you've never tried adding grain to a noisy image with strong noise reduction, give it a shot. You may like it.

The Grain adjustments in the Effects panel provide the following controls:

- **Amount** controls how strong the grain effect will be. Generally, you'll want to use a subtle amount unless you're looking for a specific special effect. You may need to readjust this setting after setting the size and roughness.

- **Size** controls the size of the grain. The size of the grain isn't dependent upon the resolution of your images, but the impact of the grain is. You'll want to use smaller grain for lower-resolution images to avoid having the grain blow out image detail. Larger grain sizes soften your image a lot.

- **Roughness** controls the grain clumps to more accurately simulate film grain. The default is 50. Reducing the setting will make the grain look like a fine-patterned reticulation. Increasing the Roughness will simulate a high-ISO film or film that has been push processed. Another use for the Grain effect is to match up multiple ISO digital captures if you need to create an image assembly. You can add grain to the lower-ISO image to try to match the grain structure of the higher ISO image.

CAMERA CALIBRATION PANEL

The settings in the Camera Calibration panel of Lightroom and Camera Raw let you control how the colors from your camera are rendered (and select the process version). This is not to be confused with color-correction adjustments. The profiles are designed to calibrate a camera model's particular color rendering. Both Lightroom and Camera Raw support a staggering number of raw file formats, and the engineers have profiled each camera model supported. Obviously, the engineers can't come to your studio and make a custom profile for *your* camera, so they do the profiling on a small sample of cameras. It's entirely possible that your particular camera might be a bit different from the one they profiled, so you might be able to make a custom profile for your camera that would produce a more accurate rendering than what comes with Lightroom and Camera Raw. **Figure 3.37** shows the Camera Calibration panel with several drop-down menus.

The exact menu display will depend on your camera. The DNG profiles are based on the camera's EXIF metadata. Not all cameras show all these options, and the naming of the camera-based options vary based on the naming convention the camera maker uses. The options are meant to simulate the camera maker's JPEG rendering based on the settings used onboard the camera. Note, however, that Camera Raw can't automatically pick the profile based on the EXIF metadata, so you must manually choose something other than the Camera Raw default of the Adobe Standard profile. Some cameras have only the Adobe Standard option; files from Sigma cameras default to the Embedded profile.

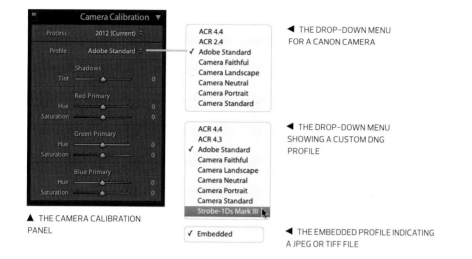

FIGURE 3.37 The Camera Calibration panel and menus.

▲ THE CAMERA CALIBRATION PANEL

◀ THE DROP-DOWN MENU FOR A CANON CAMERA

◀ THE DROP-DOWN MENU SHOWING A CUSTOM DNG PROFILE

◀ THE EMBEDDED PROFILE INDICATING A JPEG OR TIFF FILE

If you have a camera that shows an entry such ACR 4.4 or ACR 2.4, as shown in Figure 3.37, that means the initial support for that camera in Camera Raw was with that version. If you have double entries, it means the earliest version was revised in a later version of Camera Raw. Using the older, matrix-based profiles isn't suggested, unless you don't want the rendering of a previously edited image to change.

Whether your particular camera could benefit from a custom profile will really depend on how closely your personal camera matches the sample that was profiled. Most of my cameras seem to be accurately profiled, so the Adobe Standard is satisfactory. I originally had issues with my Phase One P65+ color rendering and benefited from creating my own custom dual-illuminate DNG profile. In the second drop-down menu in Figure 3.37, you'll see a custom profile I made for my Canon EOS-1Ds Mark III camera for shooting under studio strobes. It's very similar to the Adobe Standard DNG profile but perhaps slightly more accurate when rendering blues and purples.

MAKING YOUR OWN DNG PROFILES

If you want to explore the possibility of making your own DNG profiles or editing existing ones, Adobe has released a free application called the DNG Profile Editor at http://labs. adobe.com. With it, you can create custom DNG profiles for your camera by shooting an X-Rite ColorChecker color chart.

X-Rite (www.xritephoto.com) also has released a new product called the Color-Checker Passport, which includes a newly developed ColorChecker color chart, as well as software for easily making DNG profiles.

If you're reproducing critical product color or artwork like paintings, I seriously suggest you create a custom DNG profile for your shooting setup. If you're shooting under lighting with spectral illumination that isn't full-spectrum, such as fluorescent, hydrargyrum medium-arc iodide (HMI movie lighting), or LED, a custom DNG profile is suggested.

Whether you need to create a dual-illuminate profile is up to you. But if you want to use the profile under both daylight and tungsten lighting, make the effort to shoot a target under both and create a dual-illuminate profile.

Some people don't think the Adobe Standard profiles are very accurate (in my experience they are), but the Adobe Standard profiles definitely don't match the colors from the camera LCD or in JPEGs. The whole reason the engineers have gone to the trouble to create vendor-matching profiles for many popular cameras is to offer alternative color rendering that does come very close to matching the camera color when shooting JPEGs. **Figure 3.38** shows two images: one a raw file rendered using the Camera Standard DNG profile and the other a camera JPEG. Both the raw and JPEG were shot at the same time using the camera's option to save RAW+JPEG. Can you tell the difference?

In addition to the camera profiles, the legacy camera calibration sliders dating from the time before Lightroom and Camera Raw used DNG profiles have been left in. You won't need these sliders unless you want to use them for creative purposes or to fine-tune your camera rendering on top of the DNG profile rendering—they're simply additive.

■ **Shadows Tint** controls the green–magenta balance in the shadows. Negative values add green; positive values add magenta. Check the darkest patch on the target. If it's significantly non-neutral, use the Shadows Tint control to get the R, G, and B values to match as closely as possible. Normally, there shouldn't be more than one level of difference between them.

FIGURE 3.38 Comparing raw and JPEG color rendering.

▲ CAPTURE A

▲ CAPTURE B

- **Red, Green, and Blue Hue sliders** work like the Hue sliders in Photoshop's Hue/Saturation command. Negative values move the hue angle counterclockwise; positive values move it clockwise.

- **Red, Green, and Blue Saturation sliders** work like gentler versions of the Saturation slider in Photoshop's Hue/Saturation command. Negative values reduce the saturation; positive values increase it.

The key points to understand when using the Hue and Saturation adjustments are these:

- The Red Hue and Red Saturation sliders don't adjust the red value; they adjust the blue and green.

- The Green Hue and Green Saturation sliders adjust red and blue.

- The Blue Hue and Blue Saturation sliders adjust red and green.

Got that? If it's Greek to you, I suggest opening a ColorChecker image in Develop and starting to play with the sliders. You'll get the hang of it pretty quickly, although odds are, you won't need this except for creative purposes (see Chapter 4).

NOTE If you couldn't guess, in Figure 3.38, Capture A was the JPEG and Capture B was the raw file.

LIGHTROOM AND CAMERA RAW TOOLS

Lightroom and Camera Raw both offer similar sets of tools for cropping, spot healing, red-eye removal, graduated filter, and an adjustment brush. The functions they perform are consistent, but the UI and usability differ.

For example, when selecting a tool in Lightroom, a drop-down panel comes down to provide access to the tool functions. In Camera Raw, when a tool is selected, a tool panel replaces the adjustment panels. There are mild usability differences, such as the fact that Camera Raw doesn't have an A/B brush toggle in the Adjustment Brush.

Also, when you select the Targeted Adjustment tool in Camera Raw from the toolbar, it defaults to the parametric curves, even if the Curves panel isn't active. This can be useful if you need to combine Basic panel adjustments with parametric curves adjustments. To use the Targeted Adjustment tool for HSL/Grayscale panel Camera Raw adjustments, the HSL/Grayscale panel must be active.

The brush cursors for Spot Healing and the Adjustment Brush are displayed slightly differently, although their functions remain the same. Camera Raw has a Color Sampler tool that allows up to nine placed RGB color samples, while Lightroom has single nonpersistent RGB color readouts where the cursor is hovering within the image.

In the grand scheme of things, these differences are minor. However, if you bounce back and forth between Lightroom and Camera Raw for different tasks, it's useful to be mindful of the differences. **Figure 3.39** shows a diagram of the Lightroom tools, and **Figure 3.40** shows the Camera Raw toolbars and the keyboard shortcuts to activate them. Yeah, it's a bit irritating that you have to learn slightly different keyboard shortcuts for Lightroom and Camera Raw, but that's the situation. Oh, and there's no keyboard shortcut in Lightroom for the Red Eye Correction tool—I guess the engineers ran out of keys.

In Lightroom, when you activate a tool, the toolbar along the bottom of the image changes to represent the options available for that tool. If you don't see the toolbar, you've likely hidden it and you can make it visible by pressing the T key.

Personally, I find some aspects of Lightroom tools better than Camera Raw tools, but it's not across the board in favor of Lightroom. I like the fact that I can zoom into the image when cropping in Camera Raw, but I prefer the Lightroom UI. I also find it faster and easier to use spot healing in Camera Raw than in Lightroom. However, none of the differences are enough to drive me to one or the other, it's pretty much six of one, half a dozen of the other.

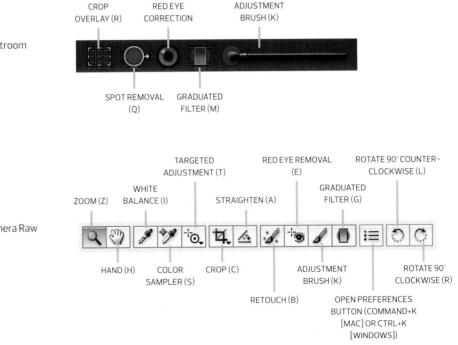

FIGURE 3.39 The Lightroom tools.

FIGURE 3.40 The Camera Raw toolbar.

LIGHTROOM AND CAMERA RAW CROP TOOLS

Both Lightroom and Camera Raw provide tools for cropping images. Although the results will be the same (the crop being stored as a metadata parameter), getting to that end result is different.

Lightroom cropping

Some people love the Lightroom crop, and others seem to hate the way the image moves around instead of the crop boundary. If you love it, I'll take credit for having played a tiny role in the development, but if you hate it, it's all Mark Hamburg's fault. When Mark was first developing Lightroom, I complained strongly about the poor usability of the Photoshop cropping tool. Adjusting the crop and rotation requires turning your head to see the resulting crop in Photoshop. I suggested moving the image underneath a fixed crop area so the preview of the crop was always straight on. Some people have a hard time adapting to this behavior, but once you get used to it, it's better. Heck, even Photoshop CS6 has redesigned the Crop tool to default to the same behavior (although if you suffer from motion sickness, you can turn it off). **Figure 3.41** shows the previous leopard seal image being cropped and the Lightroom Crop Overlay panel.

There is some fundamental functionality you do need to understand:

- When you first click the Crop tool, the cropping overlay and the handles appear over your image and allow you to change the crop and rotation.

- If you keep the aspect ratio locked, your original aspect ratio will be maintained. To change the aspect ratio, click the lock icon to unlock it.

> **NOTE** If you're wondering why the Post-Crop Vignetting isn't active, the preview of the vignette is removed while the Crop tool is active and returns after you commit to the crop. The Camera Raw Crop tool doesn't do this; the preview of the vignette effect remains while cropping.

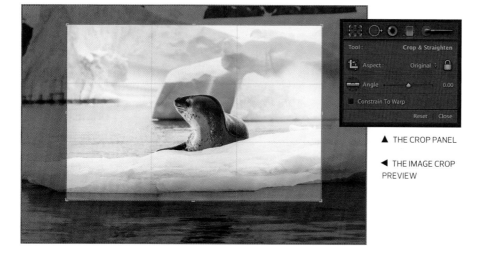

FIGURE 3.41 The Lightroom Crop tool.

▲ THE CROP PANEL

◄ THE IMAGE CROP PREVIEW

▲ ENTER CUSTOM ASPECT RATIO
DIALOG BOX

◄ ASPECT RATIO DROP-DOWN MENU

■ The Straighten tool allows you to drag along a line in your image to set the correct angle. Alternatively, you can hold down the Command key (Mac) or Ctrl key (Windows) to access the Straighten tool without needing to click the Angle button.

■ There is a Constrain To Warp option here (as well as on the Manual subpanel of the Lens Corrections panel).

Figure 3.42 shows the Aspect Ratio drop-down menu.

The Aspect Ratio menu allows you to select a variety of presets or to create your own by selecting the Enter Custom option, which brings up the Enter Custom Aspect Ratio dialog box; it defaults to 1 × 1. Enter your desired aspect ratio and click OK. The new custom aspect ratio shows up as an option at the bottom of the drop-down menu. You can save a total of five custom crops; if you add a sixth crop, the previous last crop is removed. In Figure 3.42, you can see that I've already created a couple: 3 × 2 and 9 × 11. Of course, 3 × 2 is a duplicate of an existing preset in the menu list. Silly me. I would delete that duplicate if I could, but here's the thing: you can't delete a custom preset once it's been created. Yes, a bit of a sticky wicket the engineers have left for us users to deal with. Here's how I deal with it: I generally don't make custom aspect ratio presets! Sort of an "if it hurts when you do that, don't do that" solution, but it's the reality.

One aspect of the Lightroom Crop tool that frustrates users (myself included) is that there is no way to measure the absolute crop size while cropping. Because you're dealing with a digital negative that hasn't yet been rendered into a pixel image, there is no size or resolution yet applied to the image—that's done at export. The only dimensions you can display are pixel dimensions and then only if you set your Develop View Options to display Cropped Dimensions. **Figure 3.43** shows the Develop View Options dialog box found under the main View menu. The problem is, you have to release the Crop tool corner to see the new pixel dimension. I think they need to work on that for the next version.

TIP If you start off with one orientation of your crop and you want to change it, press the X key. That toggles a horizontal crop to a vertical or vice versa. Keep in mind that the crop will be resized if the narrow edge of the image is too small to accommodate the new orientation.

FIGURE 3.43 The Develop View Options dialog box and display.

▲ THE DEVELOP VIEW OPTIONS DIALOG BOX ▲ THE LOUPE INFO DISPLAY

The image in Figure 3.41 displays the Thirds overlay option (based on the Rule of Thirds guideline, which is what I mostly use). You can select a different overlay option in the Crop Guide Overlay menu, found in the main Tools menu. You also can use the keyboard shortcut O to cycle through the options (or Shift+O to rotate through several of the options, such as Golden Ratio or Golden Spiral). You also have the option to hide the crop overlay in the Tool Overlay menu in the Tool menu. Truth be told, the Rule of Thirds or the simple Grid provides better visibility unless you have a hankering to deal with Fibonacci numbers. (Google it if you're interested or having trouble falling asleep.)

That's pretty much it for the topic of cropping in Lightroom, other than to say that unless you find yourself locked into a specific aspect ratio because of frames, mattes, or albums, you shouldn't get too worked up about sticking to a specific aspect ratio. Find a crop that's optimal for your image and don't feel the pressure to stick to a given aspect ratio.

Camera Raw cropping

Cropping in Camera Raw is pretty similar to cropping in Lightroom, except the crop moves and rotates, not the image. Kind of old school, but it works. There is a slight difference in the Crop tool drop-down menu layout and functionality: Camera Raw can do a custom crop, but that crop isn't saved as a preset.

You also have the ability, when making a custom crop, to change the units in the Custom Crop dialog box, which means you can enter specific sizes, unlike in Lightroom. If you specify the crop size in pixels, you can enter a maximum amount of 65,000 in either direction. This will have the effect of upsampling if you enter a larger

FIGURE 3.44 The Camera Raw drop-down menu.

◀ CUSTOM CROP DIALOG BOX

▲ CUSTOM CROP DIALOG BOX DROP-DOWN MENU

▲ CAMERA RAW CROP TOOL DROP-DOWN MENU

size than your native pixel dimension, up to the maximum size of 512MP (which is the maximum for both Camera Raw and Lightroom). If you try to enter more than 65,000, you'll get a warning that the max is 65,000.

The Straighten tool has its own button but is actually a semimodal state of the Crop tool. You can access it while in the main Crop tool by holding down the Command key (Mac) or Ctrl key (Windows). I find this keyboard-shortcut use of the Straighten tool to be more efficient than selecting the Straighten tool with a button and having to reselect it again to modify the rotation. **Figure 3.44** shows the Camera Raw Crop tool drop-down menu and the Custom Crop dialog box.

There is a menu item in the drop-down menu for toggling the crop overlay. There are two built-in overlays: Thirds (the same as Lightroom) and Grid. The Grid overlay shows up only when you're doing a manual rotation.

LIGHTROOM AND CAMERA RAW SPOT REMOVAL TOOLS

The Spot Removal tool is based on Photoshop's Spot Healing Brush tool. The Spot Removal tool is designed to do just that: remove sensor spots caused by dust. It's really not intended for or very good at traditional retouching like Photoshop's Clone Stamp tool or the Healing Brush tool. Trying to use it for heavy-duty retouching will drive you nuts. But for what it was designed for, it works well.

Lightroom Spot Removal tool

Figure 3.45 shows an image in severe need of spot removal and the Spot Removal panel.

The Spot Removal tool's panel offers the ability to use a clone- or healing-based algorithm. Personally, I would ignore the Clone option because you can't control

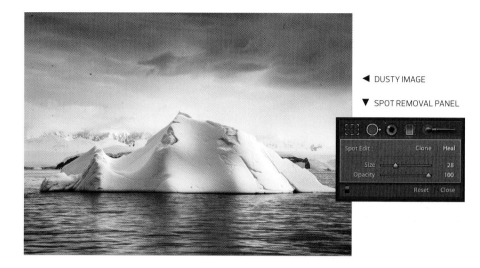

FIGURE 3.45 The Spot Removal panel and a really dusty image.

◀ DUSTY IMAGE

▼ SPOT REMOVAL PANEL

the Clone Brush feather and it rarely does what you need. I also wouldn't bother with trying to adjust the Opacity slider. Again, this isn't like Photoshop's retouching capabilities. The Healing option is good at preserving the source and destination texture and blending in the healing. But if you reduce the opacity, it tends to soften whatever texture ends up in the destination spot area.

The image I'm using was shot in Antarctica, the driest, dustiest, and windiest place on earth (so they say), and the images I shot there show a tremendous amount of dust. It got worse every time I changed lenses. I really learned how to use the Spot Removal tool because of my Antarctic images!

The fundamentals of using the Spot Removal tool are pretty simple: you click the brush on a spot and Lightroom places the designation spot and tries to auto-detect a useful target spot of the same size. Much of the time, the tool guesses pretty well, but not always. If you don't like what the tool suggests as the source, you can retarget the source spot by dragging it. Lightroom offers a quick preview of the destination spot while moving the source spot. You also can resize the destination spot by dragging along the outer perimeter of the spot. Before placing the spot, you can change the brush size either in the panel by adjusting the Size slider or by using the keyboard shortcut of right bracket (]) to make it bigger or left bracket ([) to make it smaller. Alternatively, you can size the brush directly on your image by holding down the Command key (Mac) or Ctrl key (Windows) and dragging the brush larger or smaller. Normally, you would drag from the upper left to the lower right to size the brush, but you can size it from the center of the cursor if you press the Option key (Mac) or Alt key (Windows). **Figure 3.46** shows the Spot Removal tool cursors for Lightroom.

FIGURE 3.46 Using the Spot Removal tool.

▲ STARTING A BRUSH SIZE

▲ DRAGGING THE BRUSH LARGER

▲ DESTINATION BRUSH BEFORE CLICKING

▲ DESTINATION SPOT AND SOURCE SPOT AUTO-DETECTED

▲ GRABBING AND MOVING THE SOURCE SPOT

▲ RESIZING THE DESTINATION SPOT

FIGURE 3.47 Placing multiple healing spots to remove a noncircular object.

▲ PLACING A SECOND SPOT

▲ ADJUSTING THE SIZE OF THE SECOND SPOT

▲ PLACING THE THIRD SPOT

▲ PLACING THE FINAL SPOT

Ideally, you want to use the smallest brush size you can to fully cover the spot. But not all spots are round. Because Lightroom doesn't (yet) have a noncircular healing spot, you can get around this by putting a series of overlapping smaller brushes in a group. As long as the center of the brush is outside the perimeter of the previous spot, you can keep adding additional spots until you remove the object. **Figure 3.47** shows adding multiple Spot Removal spots to remove a noncircular object.

I won't try to kid you, retouching out power lines in Lightroom isn't easy. You can do a lot of fairly basic retouching, but at some point you'll be better off punting the image over to Photoshop for heavy lifting. There is, however, one thing Lightroom can do that Photoshop can't do: sync a bunch of healing spots across multiple digital negatives. Because most dust spots won't move a lot between captures, the odds are pretty good that if you have a spot on your sensor in one frame, the next frame will have those same spots. The ability to do the spotting on one image and sync those spots to multiple images is a great time-saving feature! **Figure 3.48** shows the steps needed to sync the spot removal from one image to multiple images in a series.

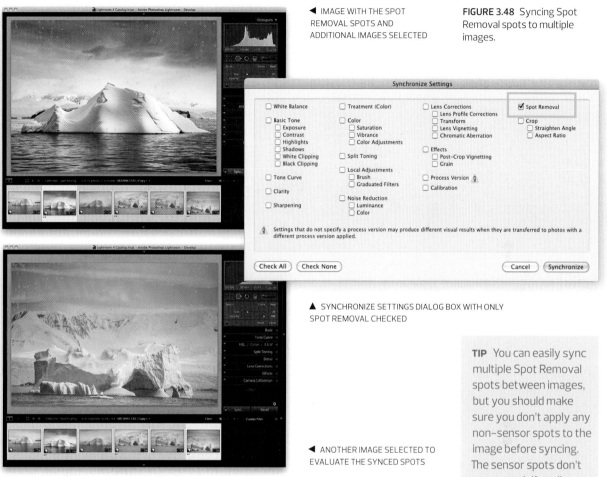

◀ IMAGE WITH THE SPOT REMOVAL SPOTS AND ADDITIONAL IMAGES SELECTED

FIGURE 3.48 Syncing Spot Removal spots to multiple images.

▲ SYNCHRONIZE SETTINGS DIALOG BOX WITH ONLY SPOT REMOVAL CHECKED

◀ ANOTHER IMAGE SELECTED TO EVALUATE THE SYNCED SPOTS

The first figure shows the original image with all the spots placed (there were a *lot* of spots placed). The additional images in the series also are selected (with the main image being "most selected"). To sync, click the Sync button at the bottom of the right-side panels. The Synchronize Settings dialog box shows all other settings unchecked and only the Spot Removal box checked. The final image shows the results of syncing the Spot Removal spots to a new image.

There are a couple things you need to understand regarding syncing:

■ If you have a spot where Lightroom auto-detected the source, upon syncing, Lightroom will again auto-detect the source in the new image. Often, this works well, but you'll need to double-check those spots to be sure the new source works.

TIP You can easily sync multiple Spot Removal spots between images, but you should make sure you don't apply any non–sensor spots to the image before syncing. The sensor spots don't move much if at all, unless your camera is locked down on a tripod and the subject isn't moving frame to frame, but retouching spots likely won't be able to be synced. Do all sensor spot removal first, sync the spots, and then go back and retouch on an image-by-image basis.

FIGURE 3.49 Adjusting synced Spot Removal spots.

▲ FINDING A MISPLACED SPOT

▲ MOVING THE DESTINATION SPOT

▲ RESULT OF MOVING THE SPOT

- ◼ If you manually moved a source spot, Lightroom will respect the manual move and not auto-detect for that spot in the new image. Again, this is something you'll need to inspect to confirm that the location of the spot in the new image is correct.

- ◼ Although dust doesn't move around a lot between frames, it's quite possible that the dust has migrated. Again, this is something you'll need to check out. **Figure 3.49** shows one spec of dust that moved a bit between frames, and the step required to relocate the destination spot.

Camera Raw Spot Removal tool

The Spot Removal tool in Camera Raw works essentially the same as the same tool in Lightroom. The main difference in Camera Raw is that when you click and drag on a spot to size the brush, it begins in the middle and goes out from the center. There is no way of dragging from the top left and sizing by dragging to the lower right. You can resize the spot with the left and right brackets and click and drag the source spot to relocate it. Unlike in Lightroom, you can resize *either* the source spot or the destination spot in Camera Raw. When moving a source spot or destination spot in Camera Raw, you don't get a live preview; you have to wait until after the spots are moved to see an updated preview. The brush in Camera Raw is more visible than the one in Lightroom; the destination spot has alternating red and white stripes, while the source spot is alternating green and white.

You can sync Spot Removal spots in Camera Raw as you can in Lightroom, but to do so you'll need to open multiple images at once and use the filmstrip of Camera Raw to select the images you want to sync. Camera Raw has the same behavior regarding the auto-detected and manually moved spots as Lightroom does.

In fact, there's really not much difference between the Spot Removal tool in Lightroom and Camera Raw, with the possible exception that the process in Camera Raw is faster than in Lightroom. The addition of lots of spots in Camera Raw doesn't seem to slow things down the way it does in Lightroom.

LOCAL ADJUSTMENTS IN LIGHTROOM AND CAMERA RAW

The Graduated Filter and Adjustment Brush tools in Lightroom and Camera Raw allow you to apply a localized tone or color adjustment by using a mask. The mask is applied as a gradient with the Graduated Filter and with a brush in the Adjustment Brush. If you're using Process Version 2012, the image adjustments are the same as those in the Basic panel. With Process Version 2010 and earlier, they're modified control channels that work similarly, but they aren't exactly the same adjustments as the previous Process Version Basic panel counterparts. This was one of the reasons the engineers wanted to make modifications to the Basic panel algorithms so that the local adjustments shared behaviors. The Lightroom and Camera Raw local adjustment share the same basic functionality, except for the fact that Lightroom has a drop-down menu to select the adjustment control parameters and comes with presets, whereas Camera Raw has buttons to quickly adjust parameters and comes with no default presets.

The Graduated Filter and the Adjustment Brush share the same local controls with adjustments in +/−100 units:

- **Temp** adjusts between cooler or warmer colors. This is similar to the Basic panel adjustment, but it isn't calculated in Kelvin degrees. The units are +/−100. They don't match the units in Basic for raw files, but they do match units for JPEG and TIFF files.

- **Tint** is similar to the Basic panel Tint but not an exact match for raw files. It does have the same settings with JPEG and TIFF files.

- **Exposure** has essentially the same range and units as the Basic panel. So, a −0.25 setting in the local adjustments can neutralize a +0.25 Exposure in the Basic panel.

- **Contrast** locally is the same plus or minus Contrast range and units found in the Basic panel.

- **Highlights** in the local adjustments has the same highlight recovery with minus settings and the same effect on the highlights with a plus adjustment as you find in the Basic panel.

- **Shadows** in the local adjustments has the same adjustment behavior found in Shadows in the Basic panel.

- **Clarity** in the local adjustments has the same adjustment behavior found in Clarity in the Basic panel.

TIP It's often better to apply Clarity locally rather than globally because of the greater control offered when applied by a gradient or a brush.

- **Saturation** in the local adjustments is a bit different from the Basic panel. In a plus adjustment, the local Saturation adjustments behave more like the Vibrance adjustment in the Basic panel. In a minus setting it behaves like a minus Saturation adjustment of the Basic panel.

- **Sharpness** when used with a plus adjustment Sharpness used locally essentially increases the relative Amount setting from the Detail panel. A setting of –1 through –49 reduces the Detail panel Amount. A setting of –50 through –100 actually adds a blur similar to Photoshop's Lens Blur filter.

- **Noise** also can modify the global Luminance Noise Reduction amount locally. A plus setting effectively increases the Luminance Amount setting. A minus setting reduces the Luminance Amount setting but has no actual effect unless there is a plus amount set in the Detail panel or a plus setting in a previous local adjustment.

- **Moiré** reduces color moiré very effectively and does a decent job of mitigating luminance-based moiré patterns. A plus setting reduces the moiré patterns, but a minus moiré setting will have no effect unless you have a plus moiré setting in a previous local adjustment.

- **Defringe** applied as a local adjustment is similar to, but not exactly the same as, the global Defringe adjustment. A minus Defringe local adjustment can reduce the global Defringe amount and can reduce or eliminate unwanted global Defringe adjustments. Adding a –100 setting locally can completely protect areas of the image from the global Defringe adjustments. A local plus adjustment adds a color defringe adjustment of all color fringe, not just the Purple and Green fringe colors found in the global adjustment.

- **Color** allows you to add a color tint based on the selected hue and saturation.

Lightroom Graduated Filter

The Lightroom Graduated Filter has a series of individual control channels that can be adjusted singly or in multiples. At the top, in the Effect drop-down menu, you can select the parameter you want to adjust. **Figure 3.50** shows the Graduated Filter panel and the drop-down menu. If you select the Save Current Settings as New Preset option, you can make your own preset that will show up in the drop-down menu. Figure 3.50 also shows the New Preset dialog box, as well as the drop-down menu showing the newly created preset and the limited controls when the Process Version is set to 2010 or earlier.

There are two basic approaches to using the Graduated Filter: you either select one or more parameters to adjust and then draw out the gradient, or you draw out the

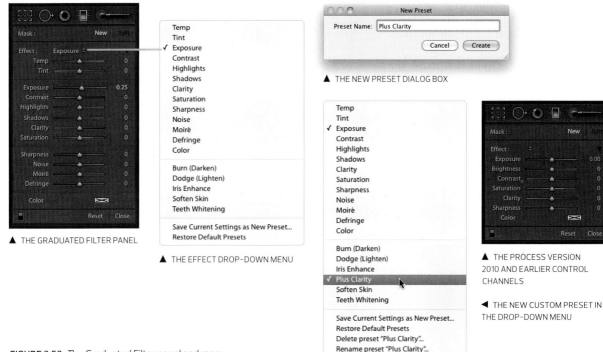

▲ THE GRADUATED FILTER PANEL

▲ THE NEW PRESET DIALOG BOX

▲ THE EFFECT DROP-DOWN MENU

▲ THE PROCESS VERSION
2010 AND EARLIER CONTROL
CHANNELS

◀ THE NEW CUSTOM PRESET IN
THE DROP-DOWN MENU

FIGURE 3.50 The Graduated Filter panel and menu.

gradient and then apply adjustments. I find it easier to apply some basic adjustment before drawing the gradient to give a visual guide on how and where to place the gradient. But it doesn't really matter because you can re-edit both the start and end points of the gradient, as well as the rotation and the adjustment parameters later.

Figure 3.51 shows drawing out a basic gradient mask.

When you're dragging out a gradient, you can hold the Shift key to constrain the gradient to exactly horizontal or vertical. There is no 45-degree angle constraint (unfortunately). The adjustments you make for tone in the Graduated Filter directly relate to the Basic panel units (if you're using Process Version 2012), so you can make a global adjustment and then come to the Graduated Filter to modify the global adjustment locally. It's the same for the Adjustment Brush tool. So, a –0.50 Exposure in the Graduated Filter parameter can offset, over the gradient, a +0.50 Exposure from the Basic panel adjustment. Having the units and the adjustments match up for global and local adjustments makes Process Version 2012 easier to work with.

Because you can't alter the midpoint of the gradient, you may need to apply more than a single gradient to achieve the tonal change you want. **Figure 3.52** shows adding

FIGURE 3.51 Drawing and adjusting a Graduated Filter.

▲ CLICKING TO BEGIN THE GRADIENT

▲ DRAGGING THE GRADIENT DOWN

▲ ROTATING THE GRADIENT

▲ ADJUSTING THE LENGTH OF THE GRADIENT

▲ ADDING A SECOND GRADUATED FILTER

▲ ADDING A THIRD GRADUATED FILTER

FIGURE 3.52 Combining multiple Graduated Filter adjustments.

a second −0.50 Exposure gradation at the top, as well as a single +0.25 Exposure gradation at the bottom. By combining the multiple gradations, you can achieve an overall gradient adjustment that isn't possible with a single gradient. Also, note that when starting a gradient, the beginning of the gradient application always extends off the image. That's a limitation of the tool. To start a new Graduated Filter, click the New button in the Mask section.

If you need to adjust the color of an image with a Graduated Filter, you can. Clicking the Color swatch brings up the Lightroom Color Picker. The Color Picker allows you to select a color hue and saturation to apply in the color spectrum or click a saved color preset. You can add a selected color to the color preset by clicking and hovering over the Color swatch. You can drag the Color Picker eyedropper from within the Color Picker and select a color directly from your image. The trick is to

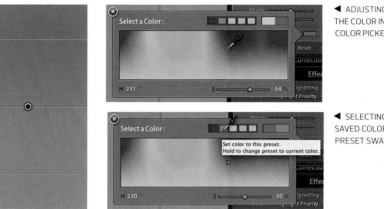

◀ ADJUSTING THE COLOR IN THE COLOR PICKER

◀ SELECTING A SAVED COLOR PRESET SWATCH

▲ APPLYING A COLOR GRADUATED FILTER

FIGURE 3.53 Using and adjusting a color Graduated Filter.

NOTE You can add color with a minus Exposure adjustment in conjunction with a color gradient. You don't need two separate gradient masks.

first click inside the spectrum and then drag the eyedropper into the image while holding down the mouse button. **Figure 3.53** shows the addition of a color Graduated Filter and selecting or saving a color in the Color Picker.

There is a limitation in the way the color Graduated Filter behaves: you can't blend a color into a clipped white or total black. The color is blended into whatever tone and color is under the gradient using a color blend. So, although it's useful to tint the image that's underneath, the blend won't act as a solid color fill. If you want to add a bit of color into a blown-out sky, you'll first need to add tone into the sky by darkening it with a suitable tone gradient.

Wherever possible, it's optimal to do as many individual control channel adjustments in a single Graduated Filter application. For example, adding tone and color at the same time is more efficient (and will bog down Lightroom less) than two separate gradients, each controlling a single parameter. This really comes into play when you start adding many Graduated Filters combined with a lot of Adjustment Brush corrections. So, as long as the gradient length and position of the midpoint is suitable, add additional adjustments to a single gradient when possible.

Once a Graduated Filter is applied, a pin is placed on the image to indicate whether a given gradient is the active gradient for editing either the gradient or the parameters. **Figure 3.54** shows the appearance of an active pin and an inactive pin.

TIP There is no way to "erase" a portion of a Graduated Filter. You can go from the Graduated Filter panel to the Adjustment Brush panel and paint in an inverted adjustment to cancel out areas affected by the Graduated Filter. It would be useful to adjust the gradient mask for both the midpoint of the gradient or erasing portions of the mask but, alas, that's a "feature request," so it may or may not happen in the future.

FIGURE 3.54 Active and inactive pins indicating the ability to edit the gradient or adjustment parameters.

▲ ACTIVE PIN ▲ INACTIVE PIN

Camera Raw Graduated Filter

The main differences between Lightroom and Camera Raw are UI differences and the way controls are adjusted. In Camera Raw, there are no presets built in for the different control parameters. Instead, Camera Raw gives you buttons to click to activate a particular adjustment, while at the same time clearing any other parameters. The Camera Raw Adjustment Filter also has a flyout menu for saving or selecting saved custom presets. **Figure 3.55** shows the main Adjustment Filter panel and the flyout menu, as well as the New Local Correction Preset dialog box.

If you select the New Local Correction Preset menu option, a dialog box appears where you can enter a custom name. The preset will retain all the currently active parameters and then be added to the flyout menu.

The Camera Raw Color Picker is a bit different, but it allows all the functionality of the Lightroom Color Picker short of being able to select a color directly from your image (something I wish were possible). When you click the Color swatch, the dialog box shown in **Figure 3.56** appears. Also, note that adding a new color to the saved color presets is a bit different. Instead of clicking and holding, you need to Option+click (Mac) or Alt+click (Windows) to add a new color.

FIGURE 3.55 The Camera Raw Adjustment Filter panel and flyout menu.

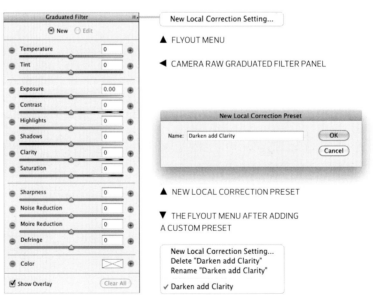

▲ FLYOUT MENU

◀ CAMERA RAW GRADUATED FILTER PANEL

▲ NEW LOCAL CORRECTION PRESET

▼ THE FLYOUT MENU AFTER ADDING A CUSTOM PRESET

◀ COLOR PICKER DIALOG BOX

▼ ADDING A COLOR PRESET

FIGURE 3.56 The Camera Raw Color Picker.

Lightroom Adjustment Brush

The Adjustment Brush in Lightroom has the same set of controls as the Graduated Filter. Whereas the Graduated Filter creates a mask based on a gradient, the Adjustment Brush builds masks based on paint strokes. The Brush settings allow you to change the Size, Feather, and Flow of the stroke, as well as the overall Density. Pressing the Option key (Mac) or Alt key (Windows) turns the brush into an eraser to remove or reduce painted areas. The Erase function has its own, separate settings for Size, Feather, and Flow, while the Density is dimmed and unavailable when erasing. Lightroom has two brush settings—Brush A and Brush B—which allow you to quickly switch between two very different settings. For example, one of the brushes can be large and very feathered with a low flow, and the other can be much smaller with a harder feather and higher flow.

Like the Graduated Filter, you can launch into making brushstrokes without making any adjustment settings. I find that more difficult than starting off with some sort of image adjustment that will aid in visually seeing the effect of the adjustments.

The key to using the Adjustment Brush is to understand the relationship between global adjustments and their local counterparts. It's highly likely you may never find the right combinations of global image adjustments to satisfy the image's needs. I see many people get fixated on trying to get just the right balance of tone and color adjustments globally; they get frustrated and waste time doing so. It's a far better approach to use the global adjustments to get the best overall image appearance and resort to the local controls, particularly the Adjustment Brush, to fine-tune the little areas in order to get the best image adjustments. This is particularly true for some of the adjustments such as Clarity, Sharpness, and Noise that can play a major role in image quality. **Figure 3.57** shows the Lightroom Adjustment Brush panel for Process Version 2012 and Process Version 2010 and earlier.

TIP Ideally, you should minimize the number of individual masks you make and apply multiple adjustments for performance reasons. But do what you need to do to get your image to look the way you want.

NOTE The drop–down menu for the Adjustment Brush and the Graduated Filter are the same as those shown in Figure 3.50.

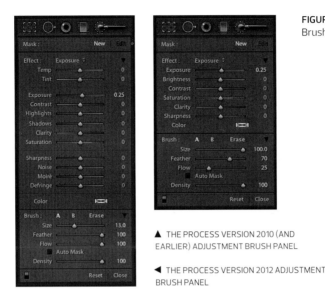

FIGURE 3.57 The Adjustment Brush panel in Lightroom.

▲ THE PROCESS VERSION 2010 (AND EARLIER) ADJUSTMENT BRUSH PANEL

◀ THE PROCESS VERSION 2012 ADJUSTMENT BRUSH PANEL

The ways you use the Adjustment Brush in Lightroom and Camera Raw are pretty much the same. You set the parameters and then brush to create a mask—you aren't painting the adjustments, you're painting a mask through which the adjustments are applied. You can adjust the following:

▓ **Size** controls the dimension of the brush to paint with. The brush size isn't tied to your image size or to pixels; it's an arbitrary size setting. The physical size of the brush is independent of the screen zoom. So, a brush at a given size at 1:1 will remain the same size when you zoom out to Fit or Fill. This is important to remember because often you'll need to zoom into the image to do detailed work. Because the brush display remains the same size, you can quickly zoom in for more precision. The right bracket key (]) increases the brush size and the left bracket key ([) reduces the size.

▓ **Feather** controls how hard and soft the brush application will be. I rarely use a brush with 0 hardness because it's simply not effective and leaves a poor edge. I often use a really large highly feathered brush to softly paint in adjustments—often instead of doing a gradient. *Remember:* Because you can zoom out, you can have a huge brush to do very gentle gradations of adjustments. Holding down the Shift key while clicking the left bracket key ([) reduces the feather, while Shift plus the right bracket key (]) increases the feather. **Figure 3.58** shows examples of the display of various brush hardness.

FIGURE 3.58 Brush feathering.

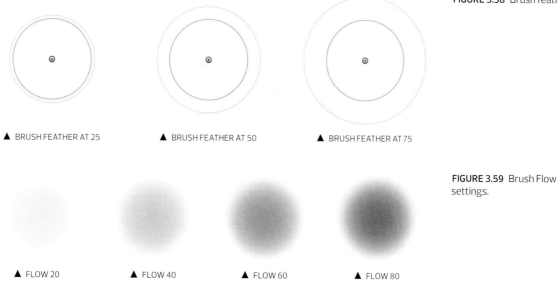

▲ BRUSH FEATHER AT 25 ▲ BRUSH FEATHER AT 50 ▲ BRUSH FEATHER AT 75

FIGURE 3.59 Brush Flow settings.

▲ FLOW 20 ▲ FLOW 40 ▲ FLOW 60 ▲ FLOW 80

- **Flow** controls how much buildup occurs with each brushstroke. Generally, it's advisable to start off with a lower Flow so you can build up an effect rather than overwhelm the resulting adjustments. You have to fiddle with it to arrive at the best flow and strength of the adjustment parameter. I tend to use a slightly stronger adjustment parameter and a lower flow rate to sneak up on the result I need. You can always increase or lower the adjustment parameter, but modifying the mask by erasing becomes a more difficult proposition. You can set the flow rate in units of ten by clicking the number keys. Clicking two numbers quickly sets the flow to that specific rate. **Figure 3.59** shows an example of various flow rates.

- **Density** sets a maximum threshold of opacity for strokes. Although both Density and Flow modify the opacity of the resulting painted mask, they do so in a different manner. **Figure 3.60** shows the difference. A reduced Flow at full Density will result in a buildup in those areas where the strokes overlap. With a Density setting of 50, the maximum density of the resulting strokes will be limited to 50. So, in use, when you're trying to build up an effect, and you want the overlap to build up, you should use a higher Density with a lower Flow. When you want to paint in an area that needs specific mask opacity, the Flow matters less than the threshold set in Density.

FIGURE 3.60 Density versus Flow.

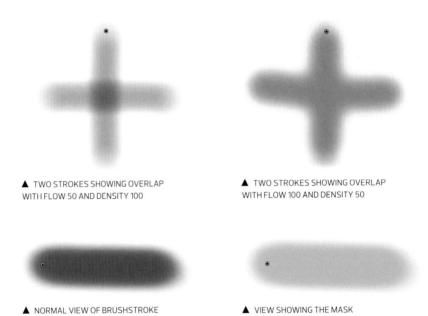

▲ TWO STROKES SHOWING OVERLAP WITH FLOW 50 AND DENSITY 100

▲ TWO STROKES SHOWING OVERLAP WITH FLOW 100 AND DENSITY 50

FIGURE 3.61 Brushstroke and mask view.

▲ NORMAL VIEW OF BRUSHSTROKE

▲ VIEW SHOWING THE MASK

After you start painting, the mask will have a pin. The pin shows whether the specific mask is active. You can toggle the visibility of the pins in the Show Edit Pins menu in the toolbar. Sometimes it's difficult to know where you have and have not painted. To find out, hover the brush cursor over the pin. You also can click the Show Selected Mask Overlay option in the toolbar or press the O key to toggle the mask on or off. You can change the color displayed in the mask by pressing Shift+O. The color options are red, green, white, and black. **Figure 3.61** shows the normal view of the brushstroke and a view with the mask toggled on.

After painting into a mask, you can hold down the Option key (Mac) or Alt key (Windows) to erase or "unpaint" a portion of the mask. When you're erasing, the center of the brush cursor changes from a + sign to a – sign. **Figure 3.62** shows erasing a portion of the mask.

When you select the Auto Mask option, the mask is generated based on the color and tone of the image area under the center of the cursor when painting is started. This allows you to paint in an area and automatically have the mask set to the shape of the object you paint into. The key is to make sure the center mark of the brush cursor remains inside the area where you want the mask to be painted. If you go outside the color area, additional colors or tone will be added to the mask. The Auto Mask option also works when erasing a mask, so if you go over an area a bit, you can

TIP I find it's often easier to paint with a larger, softer brush and then erase using a smaller, sharper brush for more precision.

▲ ERASING A PORTION OF A MASK

▲ VIEWING THE MASK AFTER THE ERASE STROKE

FIGURE 3.62 Erasing a portion of a mask.

▲ IMAGE BEFORE MASKING

▲ PAINTING WITH AUTO MASK

FIGURE 3.63 Using the Auto Mask option.

use it to help erase the overpaint. Simply hold down the Option key (Mac) or Alt key (Windows) when erasing with the Auto Mask option selected. **Figure 3.63** shows using the Auto Mask to select the orange color of the King Penguin's head.

As long as you are good about keeping the exact center of the brush in the area you want to mask, Auto Mask works well. If you accidentally extend outside of the color or tone area, the mask will be expanded to include those colors or tones as well. If that happens, you can use Auto Mask to eliminate the additional tone or colors from the mask. **Figure 3.64** shows painting outside the line and then erasing the unwanted addition to the mask.

The Auto Mask seems to get a bad rap from some users, which is due to trying to use it for something it wasn't designed to do. If you have an understanding of the behavior and the fundamentals of using the tool, Auto Mask can be very useful. The design of the functionality is based on the Background Eraser from Photoshop. Auto Mask doesn't have some of the useful functionality found in Background Eraser, such as a tolerance setting or various limits, Auto Mask (when used correctly) works for subtle or gentle tone and color adjustments. Really strong adjustments simply don't have enough precision in the mask edges to keep edges from being visually obvious.

TIP You don't have to draw a line when using Auto Mask, you can simply click the mouse button along an area you want to mask. By making sure the center cursor is always in the correct target tone and color, you can use a larger brush with a stronger Flow setting and then reduce the strength of the image adjustment settings.

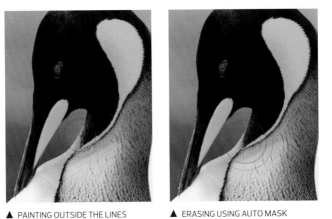

FIGURE 3.64 Erasing using Auto Mask.

▲ PAINTING OUTSIDE THE LINES ▲ ERASING USING AUTO MASK

I often use Auto Mask not to paint in to create a mask but to erase areas I don't want in the existing mask. Using it as subtractive brush often works better than as an additive brush.

Camera Raw Adjustment Brush

There's really very little difference between the Adjustment Brush in Lightroom and Camera Raw. The Camera Raw version has the same button-based ability to control parameter adjustments and can make, but doesn't come with, presets. **Figure 3.65** shows the Camera Raw Adjustment Brush panel and flyout menu.

There is one nice little addition to the Camera Raw version of this tool. When you want to check the mask in Camera Raw (keyboard shortcut: Y), you can have complete control over the color of the mask overlay rather than be limited to the colors shown in Lightroom. You also have what I think is a pretty big thing: the ability to control whether the mask preview is of the affected areas or the unaffected areas in the image. **Figure 3.66** shows the Camera Raw mask Color Picker and the ability to change how the mask is displayed.

Adjustment Brush

New Add Erase

Temperature 0
Tint 0
Exposure 0.00
Contrast 0
Highlights 0
Shadows 0
Clarity 0
Saturation 0
Sharpness 0
Noise Reduction 0
Moire Reduction 0
Defringe 0
Color
Size 7
Feather 100
Flow 30
Density 100
Auto Mask Show Mask
Show Pins Clear All

✓ Separate Eraser Size

New Local Correction Setting...

▲ FLYOUT MENU

◄ CAMERA RAW ADJUSTMENT BRUSH PANEL

FIGURE 3.65 The Camera Raw Adjustment Brush and menu.

Color Picker

Select mask overlay color:

OK
Cancel

Brightness:
Opacity:
Color Indicates: Affected Areas Unaffected Areas

▲ MASK COLOR PICKER DIALOG BOX

▲ MASK SET TO DISPLAY AFFECTED AREAS

▲ MASK SET TO DISPLAY UNAFFECTED AREAS

FIGURE 3.66 Mask Color Picker and display options.

View from the ship while sailing through the Lamaire Channel
in the Antarctic Peninsula. Captured with a Canon EOS 1Ds M II
camera with a 24–70mm f/2.8 lens at ISO 400.

ADVANCED RAW PROCESSING USING LIGHTROOM OR CAMERA RAW

The previous chapter was about how the individual adjustments and tools work. This chapter is about combining the various image adjustments and tools capable of being deployed in Lightroom or Camera Raw to arrive at an optimized "master digital negative." The final images shown in this chapter are the result of just raw processing. I used Photoshop only to size, output sharpen, and make final CMYK separations for reproduction. (Sorry, Photoshop, I only needed you for the grunt work.) Some of the images needed more help than others and some of the original captures were, uh, less-than-ideal exposures or photographic conditions. But that's why I'm here—to teach you how to make a silk purse out of a sow's ear.

Yeah, I know, it would be ideal if photographers could just point the camera and magically end up with perfectly cropped, well-exposed images with the proper tone and color. Sometimes that happens—although I'm often shocked when it does, because I'm so used to the raw capture being less than ideal straight from the camera. The following examples will guide you through correcting typical problem images due either to the photographic conditions or poor technique by yours truly. I've never said I was perfect, but I am pretty darn good at fixing things.

TONE MAPPING

NOTE Don't get too wrapped up in the exact numbers I use in these examples. Image adjustments need to be made on an image-by-image basis—the numbers I use for my images won't be all that useful to you on your images. Pay more attention to how and why I made the moves rather than the actual numbers. I've included them only to provide documention of the settings.

When shooting conditions are suboptimal, the best you can do is make sure you get the shot and then massage the image in post-production. The images in this section are generally the result of poor lighting conditions, although I threw a few "mistakes" in the bunch for good measure. These solutions rely on adjusting the tone mapping by adjusting how the sensor captured the scene.

FLAT LIGHTING

The image for this example was shot though the window of a Cessna 172 four-seat high-wing aircraft flying over the Palouse region of southeastern Washington State. It was shot with a Phase One 645DF camera with a P65+ camera back and 75–150mm lens. Yes, I stuck a $45,000 camera out the window of a small plane while making absolutely sure the camera strap was secure around my neck. Because this image was chosen for the cover of this book, I thought it would be appropriate as the first example. It combines two problems really: flat lighting and trying to shoot out of an airplane.

As you can see from the "before" histogram in **Figure 4.1**, the image was well exposed and gently to the right with no clipping. The primary adjustments made to the image were to adjust the white balance, increase Contrast, and adjust the Whites and Blacks sliders. Those adjustments really modified the overall Tone Curve and added a lot of contrast to the image but with the advantage of controlling the ¼ and ¾ toning asymmetrically. A simple Contrast adjustment alone wouldn't have provided the strength in the shadows, and reducing the Shadows slider was too gentle—it really needed the Blacks adjustment to push down the deep tones.

In the Presence adjustments, I really got heavy-handed. I set Clarity and Vibrance and added a touch of Saturation. The strong Clarity setting also had a major impact on the tone mapping, substantially reduced the flat lighting, and enhanced the midtones contrast.

◀ HISTOGRAM BEFORE ADJUSTMENTS

▲ IMAGE BEFORE ADJUSTMENTS: WB TEMP 4800 K, TINT −17

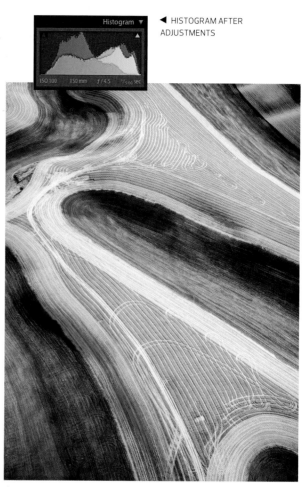

◀ HISTOGRAM AFTER ADJUSTMENTS

▲ IMAGE AFTER ADJUSTMENTS: WB TEMP 5667 K, TINT −7; CONTRAST +18; WHITES +29; BLACKS −36; CLARITY +60; VIBRANCE +49; SATURATION +9

FIGURE 4.1 Cover image and histograms before and after adjustments.

The other issue I had to deal with was image sharpness. In preparing for the shoot, I had decided not to bother with autofocus and taped the lens at just shy of infinity. I also preset the f-stop to 4.5 (just down a bit from wide open) and set the shutter speed to 1/500 second, thinking (hoping) that would be fast enough to freeze the shaking effect of being in an airplane with the camera halfway out the window. I was close, but 1/1000 second would've been better, even if I'd had to raise the ISO from 100 to 200. I didn't have an issue with shots at the wider 75mm focal length, but this

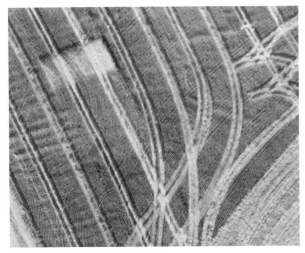

▲ IMAGE BEFORE ADJUSTMENTS

FIGURE 4.2 Before and after comparison at 1:1 zoom.

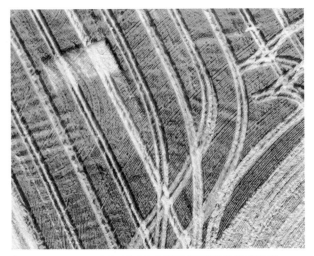

▲ IMAGE AFTER ADJUSTMENTS: SHARPENING AMOUNT 47, RADIUS 0.8, DETAIL 100, MASKING +20; NOISE REDUCTION LUMINANCE +30

shot was at 150mm and camera shake shows when zoomed to 1:1. **Figure 4.2** shows the "before" image with default tone, color, and sharpening and after substantial adjustments in the Detail panel.

You can see that the "before" image is flat and lacks detail. The tone mapping has helped the apparent sharpening, but the Detail panel settings I used were rather aggressive. The Detail slider was set all the way to 100 to maximize the deconvolution aspect of the sharpening. I also adjusted the Luminance Noise Reduction, which helped dampen down the really aggressive Detail slider adjustment. I don't think the final image detail is great at 1:1 (there's still a softness and lack of texture in places), but the final cropped image size was 6722 x 8714 pixels. A print could be made at about 22.5 x 29 inches at 300 PPI (although I suspect I could see the lack of detail in a print that size). In Chapter 5, I'll show an example of a sharpening routine called *progressive sharpening,* which can get even more texture from this image.

HIGH-CONTRAST LIGHTING

When you find yourself in a midday lighting situation and the primary subject is in a cave, you kind of know the lighting is going to suck. This example shows how you can adjust for it.

This image of the Cliff Palace in Mesa Verde National Park in southwestern Colorado was shot with a Canon EOS Digital Rebel camera with the 18–55mm kit lens. The

FIGURE 4.3 Cliff Palace before image adjustments.

◄ IMAGE BEFORE ADJUSTMENTS

▼ HISTOGRAM AT DEFAULT

time was early afternoon. Because I was on a motorcycle trip and planning on staying the night in Gunnison, Colorado, which was still over four hours down the road, I couldn't wait around for the light to get better. **Figure 4.3** shows the "before" image.

The exposure was about as good as I could get without any clipping. You can see a lot of levels in the ¼ and ¾ tones but not a lot in the middle. The sunlit portions of the image are very bright, and the shadows under the cliff are rather dark. The primary global image adjustments were made in the Basic panel. I didn't touch the white balance, but I did a lot of substantial tone mapping in the Tone section. I increased Exposure and reduced Contrast to open up the whole image and reduce the current heavy contrast. I reduced Highlights all the way down and increased Shadows. This modified the Tone Curve, but the image still needed some additional work. I increased the Whites to fine-tune the upper-white detail and reduced the Blacks to clamp down on the deepest areas after substantial lightening in the Shadows and overall Exposure. I set Clarity rather high and increased Vibrance. The increased saturation in the blues didn't look right, so I did an adjustment of saturation in the HSL/Color/B&W panel for a –3 Aqua and –15 Blue. I adjusted the Detail panel settings to taste at a screen zoom of 1:1 but didn't need to go wild. I also applied a Lens Corrections adjustment for the EF-S 18–55mm lens, which has barrel distortion and

FIGURE 4.4 Image after all global image adjustments.

▲ BASIC PANEL ADJUSTMENTS: EXPOSURE +0.20, CONTRAST −24, HIGHLIGHTS −100, SHADOWS +71, WHITES +41, BLACKS −41, CLARITY +84, VIBRANCE +41

FIGURE 4.5 The highlight and shadow areas that the Adjustment Brush masks.

▲ MASK SHOWING THE HIGHLIGHT AREAS ADJUSTED: EXPOSURE −0.60, HIGHLIGHTS −39

▲ MASK SHOWING THE SHADOW AREAS ADJUSTED: EXPOSURE −0.42, CONTRAST −74, HIGHLIGHTS +13, SHADOWS +34, CLARITY +86

turned on the chromatic aberration (CA) removal. **Figure 4.4** shows the result of the global image adjustments.

Compared with the "before" image, you can see that the overall tone mapping has improved with the reduction in highlights and opening up of the shadows. A few areas still needed additional work. I added a slight Graduated Filter on the left third of the image that reduced Exposure and Highlights. That darkened down the left side of the image a touch. But the remaining adjustments would need to be made using

FIGURE 4.6 Additional Adjustment Brush masks.

▲ ADJUSTING THE LIGHTEST PORTION OF THE WALKWAY: HIGHLIGHTS −44

▲ ADJUSTING THE AREA UNDER THE CLIFF: EXPOSURE −0.52, CONTRAST −25, HIGHLIGHTS −20, CONTRAST −20

the Adjustment Brush. The goal was to locally darken the areas that were still too bright, particularly along the path, and then adjust the tone and color under the cliff face. **Figure 4.5** shows the two main Adjustment Brush pins with the masks visible.

The areas in the highlights mask were created using Auto Mask to concentrate the adjustments in the area of the cliff side and walkway. Some areas were painted without Auto Mask. I also added a slight taupe color with a Hue of 27 and a Saturation of 30. You can see the results in the shadow areas figure. For the shadow areas, I used the Adjustment Brush with Auto Mask on along the edges but painted without Auto Mask in the center. Ironically, some areas were too bright, so I used a minus Exposure setting and reduced the Contrast. The Highlights and Shadows were increased and Clarity was increased a lot. Why these numbers? I really don't go by the numbers—I prefer to look at the image on-screen and twiddle the areas to arrive at what I want.

I also added a darker color tint with a higher saturation. The Hue was 39 and Saturation was 70. The single highlight area adjustment wasn't sufficient, and the area under the cliff also needed further adjustments. **Figure 4.6** shows two additional image adjustment area masks.

The brightest portion of the walkway looked too "white," so I applied an additional mask using Auto Mask, reduced the Highlights further, and added a stronger Color tint with a Hue of 29 and a Saturation of 37. This gave the walkway a more rock-colored look instead of a gravel-covered look. For the area under the cliff, I wanted to darken the area and desaturate the rock color. I used a minus Exposure setting while reducing Contrast, Highlights, and Saturation. The second pin under the highest pin was an additional area to add further desaturation; the last pin on the far left was just to darken the tree a bit further. **Figure 4.7** shows the final adjusted image and resulting histogram. You can see that the lack of midtones has been fixed and the histogram peaks have been rounded over.

TIP Exposure is overall brightness (more or less), Highlights and Shadows are modifications altering contrast, and Clarity is a midtones contrast adjustment. As you adjust one parameter, you'll typically see that a different parameter ends up needing to be tweaked.

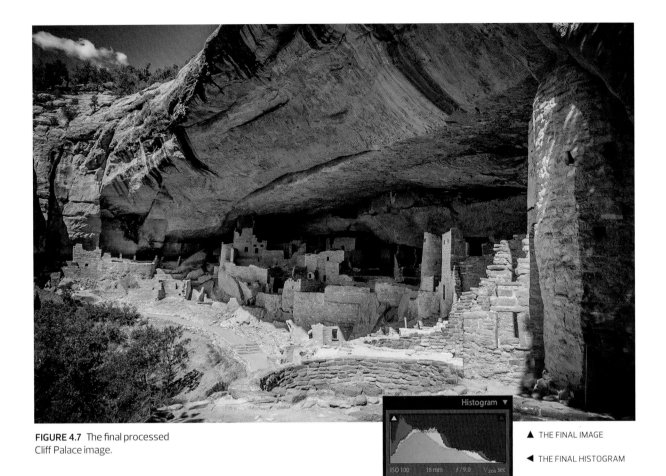

FIGURE 4.7 The final processed
Cliff Palace image.

▲ THE FINAL IMAGE

◀ THE FINAL HISTOGRAM

BLOWN SKIES

When you go to an exotic location far, far away and you're faced with overcast skies, fret not and keep shooting—you may just end up with something "interesting" (although, truth be told, I didn't really expect to get anything out of this location). This shot is of the Glenfinnan Monument, situated at the head of Loch Shiel in the Highlands of Scotland. It was erected in 1815 to mark the place where Prince Charles Edward Stuart ("Bonnie Prince Charlie," also known as "The Young Pretender") raised his standard at the beginning of the 1745 Jacobite Rising, which ended in failure with Charlie fleeing to France, making a dramatic if humiliating escape disguised as a "lady's maid" to Flora MacDonald. Did I mention that Scotland has a lot of weather like

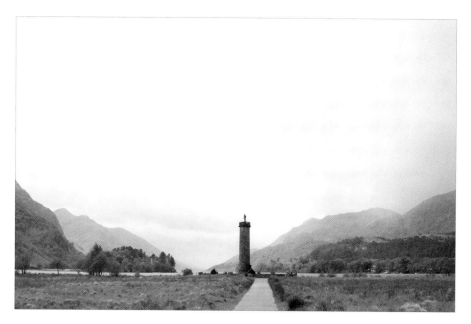

this that results in wide expanses of blown-out skies? **Figure 4.8** shows the original capture and histogram showing a lot of blown skies that look like they're clipped.

I cooled the white balance down a tad from the original As Shot setting. I reduced the overall Exposure and didn't touch the Contrast setting. I reduced the Highlights setting and increased the Shadows setting. No changes to Whites or Blacks. I added Clarity and increased Vibrance. (Are you seeing a trend here?) The other main adjustment was to turn on the Lens Corrections using the lens profile for a Canon Powershot S90 and enable the auto CA corrections. I adjusted the Saturation in the HSL panel to increase the Yellow +12 and Green +19. The capture sharpening was done to taste, leaving everything at default except raising Amount to 50 and adding a +17 Luminance Noise Reduction. The global adjustments helped but weren't enough, so I used a Graduated Filter for further fine-tuning, as shown in **Figure 4.9**.

The global adjustments weren't enough to bring back the detail in the sky, and the histogram still showed clipping. I used a Graduated Filter to further darken the sky and bring out additional detail. The gradient had a minus Exposure along with a minus Highlight. I added Clarity and increased Saturation. One additional adjustment was made: I increased the Noise Reduction setting to cut down on some of the noise that showed up during the gradient adjustment. Where possible, I like to adjust multiple parameters in a single Graduated Filter instead of spawning off a bunch of single-parameter local adjustments. The final image in **Figure 4.10** shows

▲ IMAGE AFTER GLOBAL ADJUSTMENTS: WB TEMP 4778 K, EXPOSURE −0.90, HIGHLIGHTS −67, SHADOWS +58, CLARITY +27, VIBRANCE +40

▲ IMAGE AFTER GRADUATED FILTER: EXPOSURE −1.27, HIGHLIGHTS −76, CLARITY +20, SATURATION +20, NOISE +20

FIGURE 4.9 Image after global and Graduated Filter adjustments.

◄ FINAL ADJUSTED HISTOGRAM ▼ FINAL ADJUSTED IMAGE

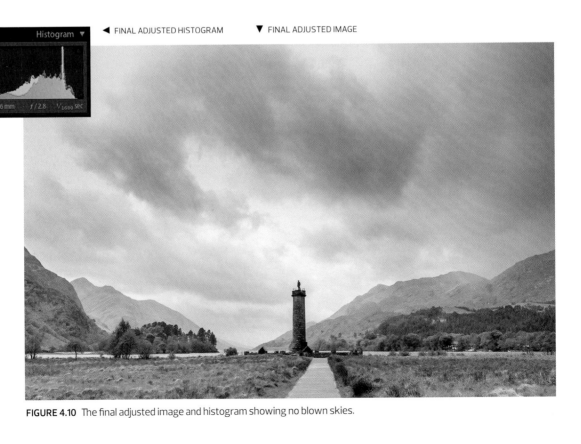

FIGURE 4.10 The final adjusted image and histogram showing no blown skies.

no clipping in the histogram and an interesting cloud arrangement above Charlie's monument—a testament to how much detail can be extracted from what might seem to be a blown sky. I hope that Charlie would approve (although from what I've read, he was a bit of a putz, so who cares?).

INCLEMENT WEATHER

When you've spent about 24 hours in airports and two and half days in really rough seas crossing the Drake Passage to Antarctica, you're not going to let a little "inclement weather" stop you from shooting (as long as the cameras keep firing). Such was the case with this shot. I'm not 100 percent sure where we were, but I think it was shortly after a shore cruise near Prince Olav Harbor in South Georgia Island in the Scotia Sea, just a bit north of the Antarctica Peninsula. We were on our way to Grytviken, where Ernest Shackleton was buried.

The shore cruise was pretty wet, sodden, and miserable. I had lost a lens and a camera LCD due to rain on the cruise, but I returned to the deck of the ship to keep shooting, even though it was still raining and very foggy. It was either shoot or take a nap (or hang out in the bar), so I kept shooting. We saw a "blue ice" iceberg off in the distance and I framed it with a 400mm lens, even though everything was very flatly lit. **Figure 4.11** shows the image before adjustments and the histogram.

NOTE Blue ice occurs when snow falls on a glacier, is compressed, and becomes part of a glacier that winds its way toward a body of water. During its travels, air bubbles that are trapped in the ice are squeezed out, and the size of the ice crystals increases, making it clear. The blue color is often wrongly attributed to light scattering. Instead, ice is blue for the same reason water is blue: H_2O absorbs light at the red end of the visible spectrum, resulting in a strong blue color. The purer the ice is with no air trapped in, the bluer the ice will appear.

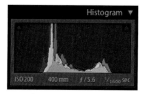

▲ HISTOGRAM AT DEFAULT

◄ THE IMAGE BEFORE ADJUSTMENTS

FIGURE 4.11 The iceberg in inclement weather and the histogram at default.

I suppose I could've done a bit more ETTR for this image, but as it turns out, it wasn't really necessary because the image was pretty easy to tone-map into something useful. The major global adjustments were in the Basic panel, where I increased Exposure and Contrast. This started the tone mapping that continued with a minus Highlights adjustment and a plus Whites adjustment to extract more highlight textual detail. The biggest adjustment was a strong minus Blacks to spread out the shadows and get a decent black. This did a decent job of expanding the image levels but needed a bit of tweaking using the Parametric Tone Curve. The Highlights were set to +32 and the Darks to +38. This had the effect of lightening the brighter portions of the image, as well as retaining some of the shadow detail that had been crunched by the strong minus Blacks adjustment. I added Clarity and a small amount of Vibrance. I didn't change the As Shot WB Temp of 6000 K and Tint of +5.

I also decided to throw in a minus Exposure with the Adjustment Brush to knock down the coast visible beyond the iceberg. **Figure 4.12** shows the global adjustments and the brush mask.

For the final image I did do a bit of spotting to eliminate some distracting items and, of course, the sensor dust spots (typical of being down there—lots of dust to spot!). Because I was shooting with a long lens, little rain actually showed up in the

FIGURE 4.12 The image with global adjustments and the local adjustment mask.

▲ IMAGE WITH GLOBAL ADJUSTMENTS: EXPOSURE +0.55, CONTRAST +56, HIGHLIGHTS −64, WHITES +13, BLACKS −71, CLARITY +49, VIBRANCE +13

▲ IMAGE WITH ADJUSTMENT BRUSH MASK: EXPOSURE −0.42

final capture, so I didn't have to spot out hardly any raindrops. I did add some Noise Reduction (+40), set the Amount for Sharpening to +68, and set the Radius to 1.4. With a shutter speed of 1/1600 second and using an image-stabilized lens, the image ended up very crisp. **Figure 4.13** shows the final adjusted image and the histogram. You can see the histogram shows the levels of the image redistributed. Even though it's showing some Red channel shadow clipping, I really don't care about that. I go for the way the image looks instead of avoiding clipping.

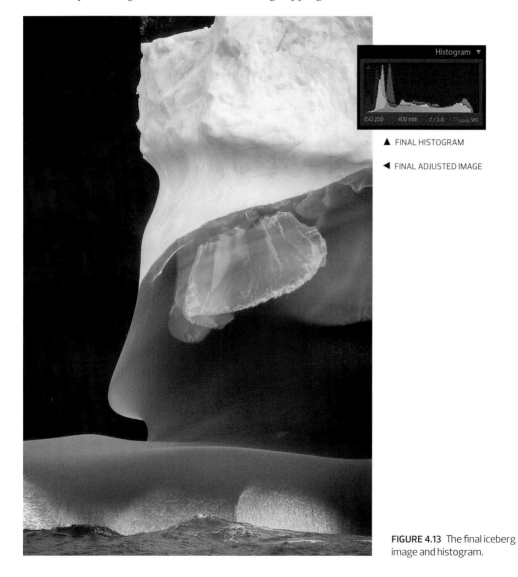

▲ FINAL HISTOGRAM

◀ FINAL ADJUSTED IMAGE

FIGURE 4.13 The final iceberg image and histogram.

UNDEREXPOSURE

Did I mention I'm not perfect? We all make mistakes. The question then becomes, "What do you do about your mistakes?" I like to fix them if I think an image may be worthy of the effort. For this particular shot of a sign from a neighborhood restaurant, I thought it was worth the effort. The histogram tells the story, about two stops underexposed, which resulted in a pretty flat and ugly capture. **Figure 4.14** shows the image before adjustments and the sadly underexposed histogram.

Obviously, the Exposure setting needed a strong adjustment to fix the underexposed capture. I increased the Exposure a lot and raised the Contrast because underexposed images are rather flat. I also adjusted the white balance from the As Shot settings. Whether you adjust the white balance or exposure first is really a toss-up, but in this case, the image was so dark that it didn't make sense to even try to adjust the white balance first. The only other tone adjustment used was a plus Shadows setting to open up the darker areas and a plus Blacks setting. This was required because, with such a severe underexposure, the deep shadows were truncated and needed extending to extract the detail.

Once I had a basic global adjustment of tones, I cropped the image and applied a lens profile correction for the Canon EF 17–40mm lens. With the strong horizontal lines in the image, it was important to remove any obvious barrel distortion and use the Straighten tool to get the image level. I increased the green and blue saturation settings in the HSL panel, while also increasing the blue luminance to punch up the greens and blues and try to lighten the blue lamp, which only went partway. **Figure 4.15** shows the result of the global image adjustments.

FIGURE 4.14 The underexposed sign image and default histogram.

▲ HISTOGRAM AT DEFAULT

▲ THE IMAGE BEFORE ADJUSTMENTS: WB TEMP 5200 K, TINT +28

FIGURE 4.15 The global image adjustments result.

▲ GLOBAL ADJUSTMENTS: WB TEMP 6900 K, TINT +23; EXPOSURE +2.00; CONTRAST +96; SHADOWS +22; BLACKS +25

I added a Graduated Filter for the top bricks that decreased Exposure and increased Contrast. I also added a strong Clarity adjustment to increase the textural detail in the painted bricks. Then I moved to the Adjustment Brush and made five separate local adjustments using the Auto Mask option to locally brush in corrections. The most visually important of the adjustments was to lighten up the blue lamp. I increased the Adjustment Brush Exposure, Shadows, and Saturation. I also added Noise Reduction because the noise in the blue increased due to the high exposure increases. This helped pop the blue color and acted as a color counterpoint to the strong overall orange color of the scene.

Because of the increase in the overall image brightness, I also wanted to darken some of the areas. I painted in a minus Exposure adjustment to darken the trees, the beer bottle, and parts of the cowboy. I also lightly touched the shadow areas of the green hills. **Figure 4.16** shows the blue lamp and tree darkening masks.

You can see three additional Adjustment Brush pins in Figure 4.16. The pin to the far left was a color tint to add additional blue tone to the strip along the top of the sign. The pin on the bottle was an adjustment of +34 in the Highlights to lighten the lighter portions of the beer bottle. The pin just to the right of the bottle was a +0.80 Exposure adjustment on the highlight areas of the painted hills. This adjustment was very lightly painted in with Auto Mask but a very low flow to the brush. The results are very subtle.

FIGURE 4.16 The two main Adjustment Brush masks.

▲ BLUE LAMP
MASK: EXPOSURE
+0.80, SHADOWS +53,
SATURATION +34,
NOISE +53

▲ TREE DARKENING MASK: EXPOSURE −0.90

FIGURE 4.17 The final adjusted sign.

▶ FINAL ADJUSTED IMAGE

▼ FINAL HISTOGRAM

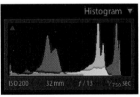

For the final image, I debated cropping into the strong dark line at the bottom of the sign to eliminate the small strip of orange at the bottom. In the end, I decided to keep it in. Without the small strip, the bottom of the image seemed too heavily dark weighted. If you want to see for yourself, take a small piece of white paper and cover the bottom orange line and see if you agree. **Figure 4.17** shows the final adjusted image and histogram showing the redistribution of the levels in the image upward.

BACKLIT SUBJECTS

When you're in the field and you can't control the lighting, about all you *can* do is take the shot and see if you can do something with it. I encountered this problem while shooting at Arches National Park just outside Moab, Utah. While waiting to shoot a sunset shot of the South Window arch, I set up this shot of Turret Arch with the Phase One 645FD camera with the P65+ back and 28mm lens. I tried to position the sun so it just barely showed through the arch. I had planned on (and did shoot) a full HDR bracket. But in several tests, there were problems with the rather fast-moving clouds and I couldn't get a natural-looking sun flare. Instead of trying to do a full-blown HDR, I worked on a single image to see how much shadow detail could be obtained with Process Version 2012. As it turns out, a lot! **Figure 4.18** shows the original capture and histogram before adjustments.

There was a big problem with the overall exposure, so I adjusted the Exposure up almost two stops and applied a minus Highlights and plus Shadows to modify the overall tone mapping. However, I needed to add a substantial minus Whites adjustment (to preserve the detail around the sun) and a plus Blacks adjustment to further open up the shadows. Working on an image like this is an iterative process. Clearly, a strong Exposure adjustment has an impact on highlights even though the adjustment rolls off the extreme brightest levels. The aim was to get a compromise of the conflicting needs of the image. I also added Clarity and Vibrance (don't I always?).

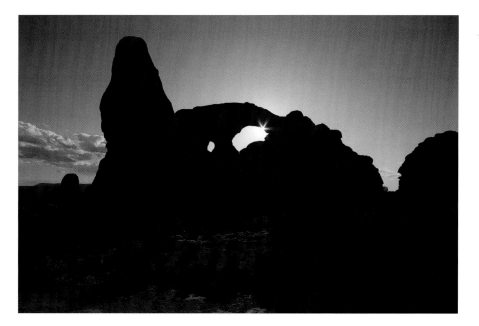

FIGURE 4.18 Turret Arch before adjustments and histogram.

◀ THE IMAGE BEFORE ADJUSTMENTS

▼ HISTOGRAM AT DEFAULT

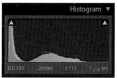

FIGURE 4.19 Results of the global tone-mapping adjustments.

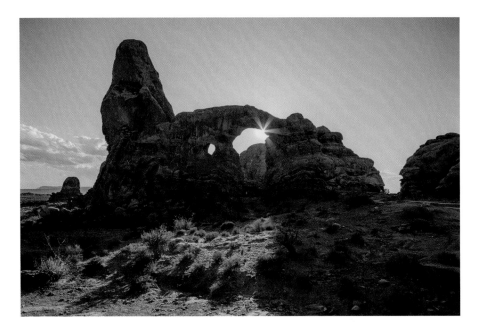

▶ BASIC PANEL ADJUSTMENTS: EXPOSURE +1.80, HIGHLIGHTS −49, SHADOWS +69, WHITES −69, BLACKS +16, CLARITY +38, VIBRANCE +18

▶ PARAMETRIC CURVE: HIGHLIGHTS −58, LIGHTS 0, DARKS +31, SHADOWS −23

In addition to the Basic panel adjustments, I also used the parametric curve portion of the Tone Curve panel. I adjusted the Highlights down, the Darks up, and the Shadows down to take down the overly lightened darkest portions of the image. **Figure 4.19** shows the results of the global tone-mapping adjustments.

Because of the severe underexposure in the front face of the arch in shadow, lightening the shadows made the noise much more visible and objectionable. I used a rather strong amount of Luminance Noise Reduction and made additional Detail panel settings to get the best image detail possible. **Figure 4.20** shows the default settings and the optimized settings as a screen zoom of 2:1.

The Sharpening settings are shown in Figure 4.20. I used a higher Radius and the default Detail settings to avoid oversharpening the noise. I increased the Luminance and the Detail sliders in the Noise Reduction settings to prevent too much of the image detail from being treated as noise. The result of the settings was the best compromise between squashing the noise and preserving useful image detail.

I decided to add three additional Adjustment Brush adjustments to further refine the tone mapping. **Figure 4.21** shows the mask used to lighten the arch itself. The adjustments lightened the whole area but tended to lighten the brighter portions more than the shadows. Also, adding the local Clarity strengthened the midtones contrast.

I needed two additional small fixes. One was to lighten the areas around the sun because the global highlight reductions made the sun too dark. The other area of

FIGURE 4.20 Comparing default and optimized Detail panel settings at 2:1 zoom.

▲ DETAIL SETTINGS AT DEFAULT

▲ DETAIL SETTINGS OPTIMIZED: SHARPENING AMOUNT 70, RADIUS 1.2, DETAIL 25, MASKING 0; NOISE REDUCTION LUMINANCE 50, DETAIL 100, COLOR 50

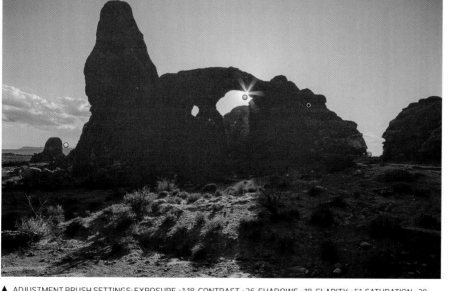

FIGURE 4.21 Adjustment Brush mask for the front of the arch.

▲ ADJUSTMENT BRUSH SETTINGS: EXPOSURE +1.18, CONTRAST +36, SHADOWS +18, CLARITY +51, SATURATION +29

NOTE I didn't notice the guy climbing the arch until I started working on the book. I left him in to give you a sense of scale, but for my use (outside the book) I would retouch him out in Photoshop. It's not so much the fact that somebody is there that bothers me—I just really hate his shirt.

the distant hills suffered from too much global Clarity being applied. **Figure 4.22** shows the mask areas for the smaller tweaks.

For the sun area, I added a plus Highlights adjustment to lighten the area around the sun and a plus Saturation to bring back some color. For the hill area, I added a minus Clarity to overpower the global Clarity (+38) and to add an effective negative clarity. These two additional adjustments capped off the final image adjustments, shown in **Figure 4.23**.

FIGURE 4.22 Additional Adjustment Brush masked areas.

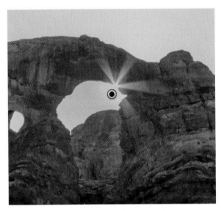

▲ MASK TO ADJUST SUN: HIGHLIGHTS +18, SATURATION +20

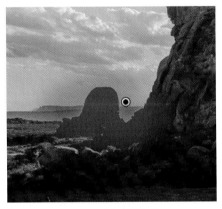

▲ MASK TO ADJUST HILLS: CLARITY −51

FIGURE 4.23 The final Turret Arch image and histogram.

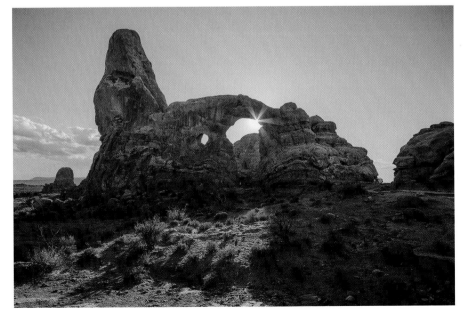

▶ FINAL ADJUSTED IMAGE

▼ FINAL HISTOGRAM

COLOR CORRECTION

It can be pretty difficult to separate tone adjustments from color-correction techniques. The tone-mapping examples all resulted in changes to color, but instead of altering the color itself, they altered the tone of the color. The following color-correction examples dwell on substantial changes to the chromatic nature of the images. Yes, some tone mapping is involved, but it's the subtle or not-so-subtle changes in color that are emphasized.

WHITE BALANCE (GLOBAL)

Unless you want to run around with a color temperature meter to accurately measure the actual white balance, you'll just have to rely on your camera . . . which can sometimes be a bit of a problem. Most of my cameras record reasonable white balance information in the EXIF metadata that Lightroom and Camera Raw can make use of reasonably well. However, my Phase One 645DF camera and back are less good. I generally set WB to the standard Daylight on the camera back and just roll with it, knowing I'll be spending time adjusting after the fact. Yes, if accuracy is needed, I'll use the ColorChecker Passport to make the adjustments both more technically correct and easier to accomplish, but that's a bit of a pain in the field.

The example I'm showing here is of an Icelandic horse shot in, well, Iceland. I had the camera back set to Auto White Balance (my bad). The lighting was overcast with a touch of volcanic ash in the air from the eruption of the Eyjafjallajökull volcano. **Figure 4.24** shows the original As Shot WB and the Lightroom default Daylight WB.

From the Daylight preset, I felt more warmth was needed (which is often the case unless you're looking for a cold effect). I adjusted the WB to 6500 K and a +17 Tint,

FIGURE 4.24 The As Shot and Daylight WB settings.

▲ AS SHOT WB TEMP 4900 K, TINT −17

▲ DAYLIGHT WB TEMP 5500 K, TINT +10

▲ WB ADJUSTED: TEMP 6500 K, TINT +17

▲ GLOBAL TONE ADJUSTMENTS: EXPOSURE +0.40, CONTRAST +40, HIGHLIGHTS −32, SHADOWS +10, WHITES −58, BLACKS −9, CLARITY +64, VIBRANCE +45

as shown in **Figure 4.25**. The results of the white balance were fine, but the overall tone mapping was off, so the second figure in Figure 4.25 shows the global tone and color corrections applied.

The tone mapping consisted of adjusting Exposure and Contrast higher, Highlights lower, Shadows up, and Whites and Blacks down. I also added a healthy dose of Clarity and Vibrance. In the HSL panel, I adjusted the Yellow Hue to +17 and adjusted the Orange and Yellow Saturation both to +9.

You might have noticed that I flipped the image horizontally. I decided I didn't really like the horse looking off to the right because I thought it drew the viewer's eyes off to the right and off the image. You can decide for yourself if you agree. (My wife and daughter disagree, but I'm the one who makes the final decisions—at least when it comes to my photographs!)

The image still needed some additional local adjustments. I used three Graduated Filters to darken the top and left edge of the image. The top gradient was a simple −0.50 Exposure adjustment. The second was an additional −0.75 Exposure adjustment. I used two separate gradients to vary the gradient slope. (It would be nice to be able to do that in a single gradient, but there's no way to edit the gradient slope in a single Graduated Filter.) The gradient on the left was a minus Exposure and a plus Highlights to flatten down and darken the left side of the image.

Because the overall Graduated Filters darkened down the mane of the horse too much, I came back with an Adjustment Brush to relighten areas of the mane. The mask in **Figure 4.26** shows the Graduated Filter and the Adjustment Brush mask.

I like this image in color a lot. However, later in this chapter, you'll see that I also experimented with the image in a toned black-and-white image (see the "Color to Black-and-White Conversion" section). The final color image is shown in **Figure 4.27**.

▲ GRADUATED FILTER ADJUSTMENTS

▲ ADJUSTMENT BRUSH ADJUSTMENT MASK:
EXPOSURE +50, HIGHLIGHTS +29

FIGURE 4.26 The local tone adjustments.

FIGURE 4.27 Final Icelandic horse adjusted image.

WHITE BALANCE (LOCAL)

A global white balance correction may be fine most of the time, but sometimes you may need to modify the white balance locally. There are several ways, but I find the most direct way is to paint in a local adjustment with the Adjustment Brush. For this image of a man walking with his burros in San Miguel de Allende, Mexico, the default white balance was too cool. I wanted a very warm look. **Figure 4.28** shows the default white balance and the adjusted result. The image was captured with a Panasonic LUMIX HG2 camera with a 14–140mm lens at ISO 400.

In the default white balance, you can see the street in shadows looks cool. Making a strong warm adjustment had a global impact on the street that I didn't like. I made two Adjustment Brush adjustments aimed at cooling down the shadows and lightening the reflections in the wet part of the street. The adjustments cooled down the street color, and I added a plus Shadows adjustment to lighten the areas a touch. Since I used a strong lightening effect on the Shadows, I also included a plus Noise Reduction. To lighten the wet area, I added a strong plus Exposure and a milder plus Shadows and a plus Clarity adjustment. **Figure 4.29** shows the two Adjustment Brush masks.

The result of the local white balance cooled the shadows on the street a bit more than the original As Shot WB, but it gave me the warm/cool lighting I was looking for. For the final image, I added some additional Adjustment Brush adjustments. I added a mask to darken the white top of the building in the background primarily using a minus Highlights adjustment. I also painted in a pretty substantial tone adjustment on the front of the walking man. I also added a +51 Noise Reduction Luminance. I had already dialed in a +38 Noise Reduction Luminance globally, so the local adjustments added additional Noise Reduction strength. **Figure 4.30** shows the final result.

FIGURE 4.28 Comparing the default As Shot and adjusted WB.

▲ DEFAULT AS SHOT WB: TEMP 5750 K, TINT +7

▲ WB ADJUSTED: TEMP 7000 K, TINT +9

▲ GLOBAL TONE ADJUSTMENTS: EXPOSURE +0.10, HIGHLIGHTS −42, SHADOWS +62, WHITES −20, BLACKS −20, CLARITY +60, VIBRANCE +40

FIGURE 4.29 Local adjustments for white balance cooling and lightening.

▲ MASK FOR THE SHADOW COOLING: WB TEMP −70, TINT −11; SHADOWS +46; NOISE REDUCTION LUMINANCE +29

▲ MASK FOR THE WET AREA LIGHTENING: EXPOSURE +2.49, SHADOWS +20, CLARITY +39

FIGURE 4.30 The final image of a man walking his burros.

NOTE The length of the sunset shooting times in the Lamaire Channel are what led my friend and colleague Seth Resnick to coin the term major gigage, because of the vast number of captures shot by everybody on the ship.

COLOR CURVES

The new addition to the Tone Curve panel provides the ability to use per-channel color curves for color correction. You can use it for cross-curve correction or creatively. I'll show you how I use it creatively. The image shown in **Figure 4.31** was captured with a Canon EOS 1Ds Mark II camera with a 24–70mm f/2.8 lens. It was shot during my first trip to Antarctica while sailing into the Lamaire Channel (which is often referred to by its nickname "Kodak Gap," because it's a frequently visited destination on cruises). I took this photograph before sunset, which lasts about four hours that far south.

I adjusted the WB from the As Shot setting and increased the global Exposure, Contrast, Highlights, and Shadows to adjust the tone mapping. I added Clarity and Vibrance. Finally, I added an Adjustment Brush mask with adjustments for the center of the island and increased Exposure, Contrast, Highlights, and Shadows to bring out the tonality of the hill. The strong Clarity was to really bring out the textural detail. **Figure 4.32** shows the mask and the locally adjusted results.

I wanted to warm up the highlights while cooling down the shadows. To do this, I used the channel curve in the Point Curve of the Tone Curve panel. Instead of trying to write down the curves I adjusted, I've resorted to showing you the channel curve adjustments that were made and the result of the changes to the image. **Figure 4.33** shows the four points I adjusted.

FIGURE 4.31 The default rendering of the Lemaire Channel at 12:28 a.m., just before sunset.

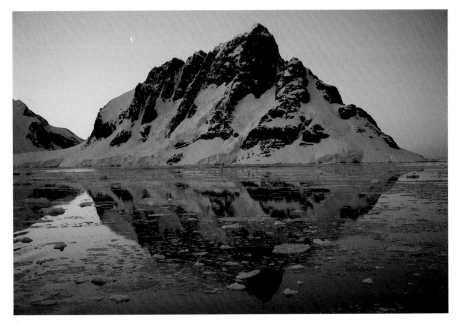

▲ DEFAULT AS SHOT WB TEMP 6100 K, TINT −1

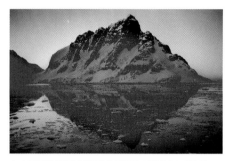

▲ ADJUSTMENT BRUSH MASK FOR LIGHTENING THE HILL: EXPOSURE +0.14, CONTRAST +13, HIGHLIGHTS +25, SHADOWS +25, CLARITY +60

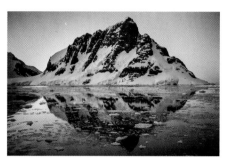

▲ RESULTS OF THE LOCAL AND GLOBAL ADJUSTMENTS: WB TEMP 5500 K, TINT +10; EXPOSURE +0.45; CONTRAST +20; HIGHLIGHTS +11; SHADOWS +16; CLARITY +30; VIBRANCE +20

FIGURE 4.32 The adjustment mask with the global adjustments result.

▲ RED CHANNEL HIGHLIGHT POINT

▲ RED CHANNEL MIDPOINT

▲ BLUE CHANNEL HIGHLIGHT POINT

▲ BLUE CHANNEL MIDPOINT

FIGURE 4.33 The color channel points adjustments.

To achieve the results I wanted, I placed a point at about the ¼ position in the Red channel and raised it to make the highlight gain red. You can see the input/output levels in the figures. The midpoint in the Red channel wasn't so much to change the color but to hold it. You may need to add a "blocking point" to keep the Bézier curve behavior from impacting additional levels. I added ¼ tone and midpoints to the Blue channel as well. The addition of red and yellow made the highlights warmer. You'll note that in the blue midpoint, I did allow some yellow to extend down into the midtones.

The final results are actually more along the lines of what I *think* I remember from being there. This is one of my favorite images from all three of my Antarctic trips—in large part because of the light and the experience of getting to engage in the act of producing major gigage! **Figure 4.34** shows the final result.

COLOR SPLIT TONING

Given my druthers, I would rather shoot a sunset than a sunrise. Why? Well, for one, you don't have to get up early to shoot a sunset. Plus, shooting a sunset allows you to set up in the light. A sunset also gives you plenty of warning regarding weather—if the light is going to suck, you know it in plenty of time to go to dinner.

However, if you fly to London and then drive to Edinburgh to do some shooting with a friend, you aren't going to be sleeping in late in your hotel room, are you? I didn't. I went to Scotland with my good friend and colleague Martin Evening. Martin wanted to do a dawn shot from Calton Hill in central Edinburgh. We woke up around dawn and found that the weather wasn't ideal. But in for a penny, in for a pound, we went to shoot.

We didn't really have a spectacular sunrise. Clouds to the east made sure of that. But there's an old saying in Scotland: if you don't like the weather, wait five minutes— it'll change. I later found that isn't *always* true, but the clouds did break and we got some shots. The image I'll be using to show color split toning is of the Dugald Stewart Monument, a memorial to the Scottish philosopher and mathematician Dugald Stewart. The capture shows that a tiny bit of sun was peaking out of the clouds and, although it was okay, I thought I could make it better in post. **Figure 4.35** shows the image at default and with global tone and white balance adjustments.

I adjusted the WB from the As Shot setting to warm the image. The main change in the tone was to increase Contrast and add a plus Shadows and minus Blacks to modify the tone mapping. Yeah, I added Clarity and Vibrance—big shock, huh? I also applied the Lens Correction to get rid of barrel distortion found on my Canon EF 28–135 lens. Because I had set up the camera level, I didn't need to worry about keystone correction.

The image needed some local "enhancements." I used the Graduated Filter to darken down the sky (a –0.89 Exposure) and the Adjustment Brush to lighten the center of the monument and darken some of the bright building in the background. I painted in a plus Exposure adjustment on the monument to lighten the columns and a minus Exposure and Highlights adjustment on the background using the Auto Mask to darken the bright buildings. **Figure 4.36** shows the two Adjustment Brush masks.

FIGURE 4.35 The default and global image adjustments.

▲ DEFAULT RENDERING WITH WB AS SHOT TEMP 5400 K, TINT –2

▲ GLOBAL IMAGE ADJUSTMENTS: CONTRAST +35, SHADOWS +42, BLACKS –13, CLARITY +32, VIBRANCE +33

▲ MONUMENT LIGHTENING MASK: EXPOSURE +0.99

▲ BUILDING DARKENING MASK: EXPOSURE –0.89, HIGHLIGHTS –48

FIGURE 4.36 Adjustment Brush masks.

To finish off the color adjustments, I used a Split Toning panel adjustment to warm up the highlights and cool down the shadows. I could have done this using color curves, but to be honest, split toning is easier and quicker if you don't need to have specific color adjustments (and it gives me a useful example of using split toning). I selected a warm color for the highlights and a cool color for the shadows. In this case, I didn't need to modify the Balance split point. **Figure 4.37** shows the separate highlights and shadows color adjustments.

When you combine the global and local tone corrections with the split-toning effect, the end result seems like a glowing sun was lighting up the Dugald Stewart Monument that morning in Edinburgh. It was … I just sort of *helped* the shot along. **Figure 4.38** shows the final image.

FIGURE 4.37 Comparing the color effect of the highlights and shadows regions of the Split Toning panel.

▲ WARM COLOR FOR THE HIGHLIGHTS: HUE 48, SATURATION 48

▲ COOL COLOR FOR THE SHADOWS: HUE 228, SATURATION 30

FIGURE 4.38 Early morning light (enhanced) from Calton Hill overlooking Edinburgh.

COLOR GRADIENTS

The Graduated Filter is a useful correction tool, but not just for tone adjustments. You also can use it to alter and adjust the existing colors of an image. For this particular shot at Arches National Monument, taken well after sunset, I wanted to bring out the warmth of the glow on the horizon while deepening the blue color of the sky. I took this on the same day I shot the Turret Arch image. Martin and I had started driving back to the motel and came upon this scene. We grabbed our cameras and flashlights (it was really dark by then) and set up to shoot a few frames. This image was shot at ISO 50 with a shutter speed of 3 seconds with the P65+ camera back. Nice, but not what I remember seeing (or thought I saw). **Figure 4.39** shows the image before the color corrections. Oh, and if you're wondering, I didn't bother to use any Clarity—I tried, but it didn't do anything (although Vibrance was set to +28).

I decided to use two color gradients: a warming one to help the glow and a cooling one to cool down the sky. The gradients were applied as a color tint, but the saturation of the colors I used also strongly increased the overall saturation of the colors. **Figure 4.40** shows the two gradients applied individually to show the unblended adjustments. **Figure 4.41** shows the results of both gradients applied together.

Once the two gradients were combined as shown in Figure 4.41, the dark blue sky and golden horizon were more to my liking. But I've never been one to leave well

FIGURE 4.39 Moon setting in Arches with post–sunset glow.

FIGURE 4.40 Applying a warm and a cool Graduated Filter.

▲ WARM SELECT A COLOR DIALOG BOX

◀ WARM GRADUATED FILTER APPLIED

▲ COOL SELECT A COLOR DIALOG BOX

◀ COOL GRADUATED FILTER APPLIED

FIGURE 4.41 The combined warm and cool gradients applied.

enough alone, so I wanted to see what it would be like to combine a Split Toning panel adjustment on top of the Graduated Filter adjustments. **Figure 4.42** shows the separate warm and cool hues and saturations applied and the Split Toning Highlights and Shadows color pickers.

I'll admit that adding Split Toning on top of the Graduated Filters may be just a tiny bit over the top, but nobody has ever accused me of being subtle. **Figure 4.43** shows the results. You decide what you think, but I like it!

FIGURE 4.42 The Split Toning settings applied individually.

▲ HIGHLIGHTS COLOR PICKER

◀ HIGHLIGHTS WARM COLOR APPLIED

▲ SHADOWS COLOR PICKER

◀ SHADOWS COOL COLOR APPLIED

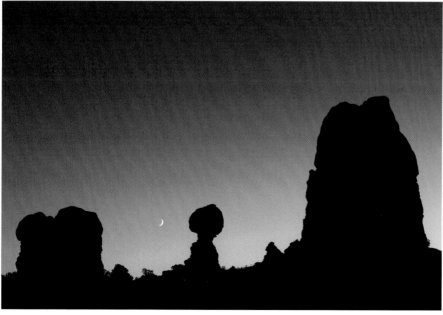

FIGURE 4.43 Final post–sunset glow using both Graduated Filters and Split Toning.

HSL COLOR CORRECTION

NOTE The reality is that most "greens" are actually more yellow than green. This was one of the reasons the engineers altered the normal additive and subtractive color primaries of red, green, blue, cyan, magenta, and yellow in lieu of the eight colors in the HSL panel.

As a general rule, I don't recommend walking up to a wild American buffalo to photograph it. Although I shot this image with a 24mm lens, I didn't actually walk up to the buffalo (I'm not that stupid). Instead, I sat down on the ground when it was much farther away and waited for it to come to me. Of course, once I was done photographing the buffalo, the situation was a bit dicey ... I slowly walked away and quickly got on my motorcycle and beat feet out of there. Truth be told, I doubt the buffalo was paying any attention to me—it was chowing down, and buffalo are pretty used to people in Yellowstone National Park. **Figure 4.44** shows the image before color correcting.

The primary color corrections I wanted to accomplish were to change the Hue of the green grass; punch up the Saturation of the oranges, yellows, and greens; reduce the blue-sky Saturation; and adjust the Luminance value of some of the colors. **Figure 4.45** shows the three sub-panels I used in the HSL/Color/B&W panel.

FIGURE 4.44 An American buffalo in Yellowstone before color correction.

FIGURE 4.45 The HSL color adjustments with the slider adjustments.

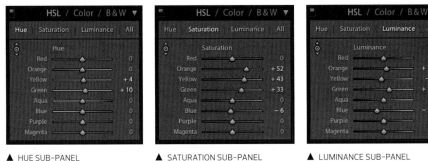

▲ HUE SUB-PANEL ▲ SATURATION SUB-PANEL ▲ LUMINANCE SUB-PANEL

FIGURE 4.46 An American buffalo in Yellowstone after color correction.

In the Hue sub-panel, I wanted to move green from more yellow to less yellow. I moved green toward a more green color and moved yellow a bit more toward green. In the Saturation sub-panel, I wanted to punch up the color of the buffalo (orange), as well as yellow and green, but I wanted to desaturate the blue. In the Luminance sub-panel, I lightened the orange and green while slightly darkening the yellow and more strongly darkening the blue. The new result would be to have the green of the grass greener, the yellows more colorful, the buffalo more saturated and lighter, and the sky reduced in saturation and luminance.

Figure 4.46 shows the final result of the HSL color correction. Oh, if you're curious, I didn't use any Vibrance in this image (although I did add some Clarity).

LENS COLORCAST CORRECTION

The lens you shoot with can cause a lens colorcast that can be very difficult to correct in Lightroom. When the light passing through the lens strikes the sensor at a more oblique angle, you can get uneven colorcasts generally of a green or magenta color. A single WB adjustment will fail to correct this problem. If you balance for the green,

TIP In my experience, if you pump up Vibrance too much and then try to use HSL, the precision of the adjustments suffers (in other words, it becomes harder to use HSL after a really strong Vibrance adjustment). If you want better precision when making HSL adjustments, don't adjust the Vibrance or Saturation in the Basic panel.

the neutral becomes magenta. If you correct the magenta, the cast becomes green. Then there are uneven light falloffs. If you're using a tilt/shift lens even on a DSLR, you may encounter asymmetrical lens falloff (vignetting) that, when combined with the colorcast, can become an even more difficult problem to address because the lens corrections can't deal with asymmetrical lens falloff.

To really fix this problem, you need to shoot a sample image as a calibration image with the lens in the exact position regarding tilt/shift, f-stop, and focus distance of your normal shot. Use the calibration image as a basis to correct for colorcast and falloff. To shoot this, place a diffuser disk (often translucent Plexiglas) over the lens and shoot essentially just the colorcast and falloff caused by the lens.

Up to now, you couldn't do this in Lightroom—even though the DNG specification allows for making the corrections. So, even though the DNG *can* do it, there was no way of selecting the calibration image, extracting the colorcast and falloff data, and applying it to other images in Lightroom. That's about to change. Starting in late 2012, Adobe will be releasing a DNG Flat Field plug-in for Lightroom. The plug-in will be provided as a free download from the DNG product page (www.adobe.com/dng). As of this writing, I'm using a beta version of the plug-in, so it's subject to change when the release is final. **Figure 4.47** shows an image shot with the Phase One IQ 180 camera back on a Sinar 4x5 camera with a 120mm lens with a forward standard tilt to alter the focus plane and a front standard shift up for composition. The colorcast and light falloff aren't terrible, but they're noticeable at the top of this high key shot (which is why I shot it).

The plug-in can identify a calibration image, calculate the required corrections, and apply the corrections to real images. The only catch: you must convert the raw

FIGURE 4.47 Image before flat field corrections.

▲ STEP 1: IN THE LIGHTROOM LIBRARY, SELECT THE IMAGE AND THE COLORCAST CALIBRATION IMAGE.

FIGURE 4.48 Steps to correct colorcast and light falloff using the DNG Flat-Field plug-in.

▲ STEP 2: IN THE LIBRARY MODULE, UNDER THE LIBRARY MENU, SELECT PLUG-IN EXTRAS AND THEN APPLY INTERLEAVED CORRECTION.

▲ STEP 3: WHEN THE DIALOG BOX APPEARS, SELECT YOUR CORRECTION OPTION.

▲ STEP 4: THE PLUG-IN RUNS AND CREATES A NEW DNG FILE STACKED WITH THE ORIGINAL WITH THE CORRECTIONS APPLIED.

files to DNG before using the plug-in. You can convert raw images to DNG directly in Lightroom by choosing Convert Photo to DNG from the Library menu. **Figure 4.48** shows the steps for applying the corrections.

Under the DNG Flat Field plug-in menu, there are two options: Apply interleaved correction and Apply external correction. I used the interleaved option because both the main image and the colorcast calibration image were interleaved in the same folder—as would happen when shooting in the field or studio. If you have a fixed shooting setup (as you might have for shooting copy shots of artwork), you may prefer to store your colorcast sample image in a different location. Note that the

NOTE A special note of thanks to Tom Hogarty, the Lightroom product manager, for letting me put the beta plug–in in the book. Also, an extra–special note of appreciation to Eric Chan, Camera Raw engineer, for writing the plug–in.

calibration image must use the exact same lens, f-stop, focus distance, and lighting as the images you want to correct. If you choose the external option, you'll be given a dialog box to navigate to and select the external sample.

When shooting the colorcast calibration images, it doesn't matter whether you shoot them before or after the real image. The plug-in is capable of finding the calibration image or images if you have multiple shots and calibration images. Shooting in the field with a tech camera, you may end up with a variety of different shots—just be sure you shoot a calibration image before making any lens changes. The plug-in is capable of determining which calibration images are intended for which real images. If you're doing an exposure bracket for HDR blending, odds are, you won't be changing your f-stop, so a single calibration image would work for all captures in a bracket. The same is true for shooting a panoramic series—as long as you don't change the lens settings, a single calibration image will suffice.

The DNG Flat Field plug-in works only in Lightroom. You can't use Camera Raw to select calibration images (although Camera Raw can process a DNG with the corrections already embedded in the DNG). **Figure 4.49** shows the final image after the colorcast and falloff corrections have been applied. You'll note the removal of the green colorcast and light falloff from the top of the image.

FIGURE 4.49 The result of removing the colorcast and light falloff from the image.

COLOR TO BLACK–AND–WHITE CONVERSION

I have a fond place in my heart for black-and-white photography. Processing film and making prints in the darkroom is how my love of photography took root. The first time I saw a print developing in the developer tray, I got so excited that I immediately turned on the white lights to look at it. Yes, of course, the print turned black before my eyes, because I skipped the stop bath and fixer. Silly me.

I mention this because my love of black and white is what got me into photography, and now shooting digital has breathed new life into that love. Just to be clear, except for a few raw sensors and cameras like the recently announced Leica M-Monochrom camera, all sensors capture color when shooting raw. Some cameras allow you to set the in-camera settings to shoot black-and-white JPEGs, but the raw files are in color (well, more or less, as I discussed in Chapter 1).

In the old black-and-white film days, you could control the exposure and processing to adjust the contrast of the negative. In the digital age, this is done in Lightroom and Camera Raw when converting color to black and white—and you don't need to mix any fixer!

It's important to understand that black and white is a monochromatic representation of colored light. How that color is converted to black and white is fundamental to getting optimal conversions. Ansel Adams could develop his early film by inspection, because the film was *orthochromatic* (sensitive only to blue light) and he could use a bright red light as a safelight to see what was happening in development. Modern black-and-white film and digital sensors are sensitive to all colors of visible light (and, in the case of digital, very sensitive to infrared). The term for that is *panchromatic* (across all colors).

In the old days, photographers generally shot film using color-contrast filters to alter the panchromatic response of the film. They used yellow to lightly darken blue skies, red to really darken blue skies, green to lighten foliage and darken skin, and orange to lighten skin. With digital cameras, we don't need to do that because we're capturing full-color images and we can modify the panchromatic response of the sensor in post-processing (which, to an old dog like me, is pretty cool). In this section, I'll talk about various methods of controlling the color contrast of the black-and-white conversions and also delve into the concept of color toning the monochromatic black-and-white conversion.

ADJUSTING THE PANCHROMATIC RESPONSE

When shooting digital, we end up with a digital negative that has color information: red, green, and blue color channels in the RGB image. If you look at an RGB file in Photoshop channel by channel, you'll see that each channel has a different tonality based on the color of the light passing through the tricolor RGB sensor filters. **Figure 4.50** shows the original color image and each of the color channels, as shown in Photoshop when selecting a single color channel. The dolls were shot at a flea market in Buenos Aires—I hope you don't find them too scary (my wife thinks they're really creepy).

The key to converting from RGB color to black and white lies in understanding the relationships of color to grayscale tone. In the Red channel figure, you see the doll's red bow tie is very light, while the same bow tie is darker in the Blue channel. Conversely, in the Blue channel, the blue hat is much lighter than the same color in the Red and Green channels. The Green channel, which contains the largest amount of luminance data (because of the RGGB Bayer pattern of the sensor; see Chapter 1), looks like a more general color to black-and-white conversion. As a result, when

NOTE When converting from color to black and white in Camera Raw, you can choose to process the resulting image as a grayscale image with a selected gamma instead of a monochromatic RGB image. You choose that option in the Camera Raw Workflow Options dialog box. In Lightroom, black–and–white images must be output as monochromatic RGB images. If you need a grayscale image, you'll need to use Photoshop to do the RGB to grayscale conversion.

▲ COLOR IMAGE

▲ RED CHANNEL

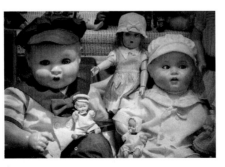
▲ GREEN CHANNEL

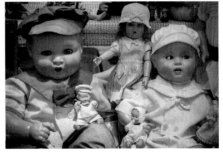
▲ BLUE CHANNEL

FIGURE 4.50 Color image and red, green, and blue channels.

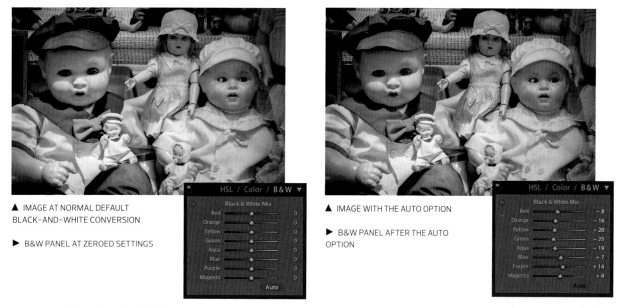

▲ IMAGE AT NORMAL DEFAULT
BLACK–AND–WHITE CONVERSION

▶ B&W PANEL AT ZEROED SETTINGS

▲ IMAGE WITH THE AUTO OPTION

▶ B&W PANEL AFTER THE AUTO
OPTION

FIGURE 4.51 Comparing the default color to black–and–white conversion to the Auto option.

getting the optimal blend of the color-channel information to the single-channel grayscale image, you need to blend the various amounts of each channel to get a final result that maintains a good color contrast–to–grayscale conversion. It's not at all unusual to have two different colors whose RGB appearance show substantial differences converge and appear much closer to a single grayscale value. That's why we need to "twiddle" with the conversion. **Figure 4.51** shows the result of a default conversion from color to black and white in the HSL/Color/B&W panel of Lightroom or the HSL/Grayscale panel of Camera Raw.

The Auto option does a fairly good job of maintaining good color-contrast separation in the grayscale tonality. You can see it's pretty close to the Green channel in Figure 4.50. The Auto option is very image- and color-sensitive, but it's often a better starting point than the zeroed default. That's why I have my preferences set in the Lightroom and Camera Raw defaults to use Auto. Tuning the colors is an easy task if you click the Targeted Adjustment tool and use the cursor directly over the image to target specific colors to lighten or darken tonality. Increasing a color will lighten the tone, while numbers below zero darken the tone. Once you click the B&W button on the panel, you won't be able to see the color image, but you can click the HSL or Color button to bounce back to the color version of the image. Upon returning to

TIP When converting from color to black and white, don't overlook a useful additional tool for adjusting the black–and–white rendering of the color image: the WB adjustment in the Basic panel. By changing the WB setting, you can further alter the color to black–and–white conversion after tweaking the B&W panel adjustments.

the B&W panel, your last-used settings will be remembered. I wanted to darken the blue tonality of the hat and lighten the red bow tie. **Figure 4.52** shows the adjusted black-and-white color mix.

To finish off the image, I added some local adjustments to soften the corners of the image. The mask in **Figure 4.53** shows the areas I modified using the Adjustment Brush. I used two settings: Clarity was set to –100 to soften the contrast of the corners, and Sharpness was set to –100 to add a blur effect. **Figure 4.54** shows the final adjusted image.

> **NOTE** If you've made local color–tinting adjustments in the Graduated Filter or Adjustment Brush, converting from color to black and white won't remove those adjustments. This is something to be aware of if the resulting black–and–white conversion still has some areas of color in the image. This is as designed and can be a useful creative tool.

FIGURE 4.52 The final color to black–and–white mix.

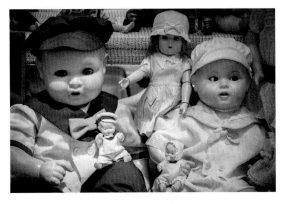

▲ FINAL B&W SLIDER ADJUSTMENTS

FIGURE 4.53 A mask that was created to adjust the reduced contrast and blurring in the corners.

FIGURE 4.54 The final image of the scary dolls!

WARM TONING

There's black and white, and then there's black and white with a color tone. The concept goes back to the days of the darkroom, where a normal, neutral, black-and-white print would be processed in a chemical treatment bath after development and fixing—or simply printing on a warm-tone paper such as Agfa Portriga. When I was darkroom printing, the only time I didn't used a chem-tone was when delivering commercial prints for reproduction. Normally, I would tone the prints in a KODAK Brown Toner, a KODAK Sepia Toner, or a combination of KODAK Rapid Selenium Toner and any of the above. The intent was to add a subtle color tone to the image and enhance the maximum density of the print. If the previous sentence is just gobbledygook, let me condense it: photographers like to add a subtle (or not-so-subtle) color tint to neutral black-and-white prints.

This warm toning example is of a boring color image shot of the steam engine of the Swangage Railway, which is a heritage railway running between the town of Swangage in the English county of Dorset to the ruins of Corfe Castle. **Figure 4.55** shows the original color images.

FIGURE 4.55 The color image of the steam engine while facing facing south on the Corfe to Swangage leg of the trip.

▲ COLOR TO BLACK-AND-WHITE CONVERSION WITH ORANGE, YELLOW, AND GREEN SET TO –25 AND BLUE SET TO –50.

▲ WARM TONING SET TO A HUE OF 50 AND SATURATION OF 25

I tried an Auto conversion to black and white in the HSL/Color/B&W panel and made some adjustments. The final settings were to darken the orange, yellow, and green colors and really darken the blue colors to enhance color contrast. I also added a Graduated Filter to darken the sky and Adjustment Brushes to lighten the steam. Local blurring was added to make the top and bottom of the frame softer. The initial warm toning was done with the Split Toning panel only adjusting the Highlights. **Figure 4.56** shows the grayscale conversion and the initial warm toning.

I liked the vintage look the warm toning gave the image, but I decided to back down the saturation a bit and modify the Split Toning panel's Balance to keep the warm tone from going too far into the shadows. For the final image (shown in **Figure 4.57**), I reduced the Saturation to 20 and moved the Balance slider to –50. This had the effect of not only reducing the overall warm tone but also making the shadows in the image more neutral. It's always a temptation to overdo effects. Although I liked the warmer tone, I think I prefer the reduced warm-toning result. What do you think?

FIGURE 4.57 The final warm–toning result.

SPLIT TONING

I mentioned that I used to do a kind of split toning in the darkroom. The typical toning would be a combination of sepia and selenium toning. The sepia toning was a bleach and redevelopment to warm up the highlights and midtones while not impacting the shadows, which remained neutral. After the sepia toning, I would run the print through selenium toning, which added a deepening of the blacks and a cool purplish tone. I used to do this in a chemical darkroom, but you're no longer constrained by chemicals, so you can use whatever split-toning colors and saturation you want in Lightroom or Camera Raw. This example is very close to the sepia/selenium-toned prints I used to produce. **Figure 4.58** shows the original color image of some trimmed flowers I photographed with a Phase One 645FD camera with a P65+ back and a 120mm macro lens. It was shot at the Reykjavík botanical gardens in Iceland in between rain showers. The black-and-white conversion is also shown in Figure 4.58.

I wanted to darken the yellows in the image a lot (remember, green is mostly yellow), as well as darken the actual green color. As a neutral black-and-white image, I like it, but I wanted to push it a bit by adding a warm color to the highlights and a cooler color to the shadows to achieve a split-toned effect. **Figure 4.59** shows the warm toning and the cool toning separately.

When the two color tints were combined, the result produced a split-toned image that looked a lot like a sepia/selenium-toned silver print. For the final image, I changed the Balance slider to −20 to keep some of the warm tint out of the deeper midtones. **Figure 4.60** shows the final split-toned effect.

FIGURE 4.58 The color image and black–and–white conversion with the custom B&W mix.

▲ THE COLOR IMAGE

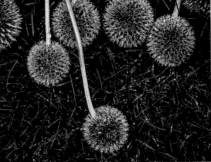

▲ THE BLACK–AND–WHITE CONVERSION WITH THE FOLLOWING SETTINGS: −50 YELLOW AND −20 GREEN IN THE B&W PANEL MIX

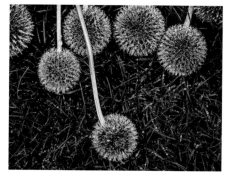

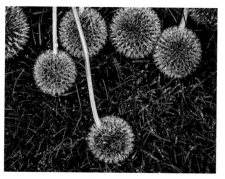

FIGURE 4.59 The warm and cool Split Toning adjustments.

▲ WARM TONING WITH A HUE OF 52 AND A
SATURATION OF 25

▲ COOL TONING WITH A HUE OF 236 AND A SATURATION
OF 25

FIGURE 4.60 The final result from the Split Toning panel adjustment in Lightroom or Camera Raw.

COLD TONING AND SPOT OF COLOR

This example is actually a two-for-one deal; it shows not only cold toning the shadows but also locally converting to black and white while preserving a portion of the image as color. For this image of a matador before a bullfight in San Miguel de Allende, I decided to locally convert to black and white using the Adjustment Brush set to a –100 Saturation setting. This allowed me to keep the red door and convert everything else to grayscale. You don't have to convert to black and white in the HSL/Color/B&W panel—there are other ways to skin a cat. **Figure 4.61** shows the original color image and the Adjustment Brush mask created using the Auto Mask and the resulting conversion retaining the red door.

To bring up the detail in the horses, I used a plus Exposure (+0.80) and a plus Shadows (+96) adjustment, as well as a plus Clarity (+60) in the Basic panel to bring out the shadow detail missing on the original color image. I liked the red door in the black-and-white converted image but thought the heat of the red needed a colder color to offset it. For the final Split Toning settings, I used a Hue of 228 and a Saturation of 43 to get the cold look I wanted. **Figure 4.62** shows the final result.

FIGURE 4.61 The original color image, the mask showing the desaturated areas, and the final black–and–white conversion.

▲ THE COLOR IMAGE

▲ THE IMAGE WITH THE AUTO MASK CREATED

▲ THE IMAGE CONVERTED TO BLACK AND WHITE USING DESATURATE AS A LOCAL ADJUSTMENT

OPTIMIZED BLACK–AND–WHITE TONE MAPPING

Simply converting a color image to black and white and adjusting the black-and-white color mix won't always produce an optimized black-and-white conversion. Often, you'll need to optimize the tone mapping to get a dramatic black-and-white image. This example of some sand dollars shot at a roadside attraction in the Florida Keys is just such an image. **Figure 4.63** shows the original color image at defaults.

FIGURE 4.63 The original color image of sand dollars.

▲ THE COLOR IMAGE TONED WITH THE FOLLOWING BASIC PANEL ADJUSTMENTS: EXPOSURE −0.65, CONTRAST +67, HIGHLIGHTS −100, SHADOWS +18, WHITES +29, BLACKS −6, AND CLARITY +100

▲ THE DEFAULT ZEROED BLACK-AND-WHITE CONVERSION

FIGURE 4.64 The toned color image and the conversion to black and white.

The original color image was properly exposed—no clipping in Process Version 2012. I didn't like the variation in the color of certain tonal regions, so I decided to convert to black and white pretty early after a global tone-mapping adjustment. **Figure 4.64** shows the tone-mapped color image and the conversion to black and white with the default zeroed black-and-white conversion in the HSL/Color/B&W panel.

I wanted to darken the image, increase the contrast, and really darken the highlights, while lightening the Shadows a bit and the Whites a bit more. Reducing Blacks helped pin the deepest tones to black. Changing Clarity to +100 was a strong move, but I've found that such strong tonal moves can work very well when converting to black and white. The color version of the image suffers, but the black-and-white conversion is improved. The converted black-and-white image looks better after the Basic panel tone mapping, but the image still needs curves work to extract the proper amount of tonality (at least from my point of view). Instead of trying to finesse the Tone Curve using the Point Curve Editor, I resorted to the Parametric Curve Editor to massage the final Tone Curve.

Figure 4.65 shows the final image with the Parametric Curve Editor edits applied. You'll notice the nature of the curve—a sort of zigzag where Highlights are lightened while Lights are darkened. This is to more finely tune the ¼ tone areas and bring out the texture. The ¾ tone area also has been zigzagged by darkening the Darks a bit but substantially darkening the Shadows. All the adjustments were done by eye, based on what I wanted from the final Tone Curve.

FIGURE 4.65 The final tone–mapped black–and–white conversion.

COLOR TONING USING COLOR CURVES

The San Miguel Chapel in Santa Fe, New Mexico, is reputed to be the oldest church in the United States. It was reportedly built between 1610 and 1626, but rebuilt in 1710 because of damage. It's a U.S. National Historic Landmark that still has a Sunday Mass.

This example shows a nontraditional approach of color to black-and-white conversion and colorizing not by using the Split Toning panel but by using the per-channel color curves function of the Tone Curve panel. The original color image and the black-and-white conversion made by desaturating with a –100 Saturation adjustment in the Basic panel is shown in **Figure 4.66**. This black-and-white conversion also included an Adjustment Brush correction to substantially lighten the belfry to bring out the detail.

FIGURE 4.66 The original color image and the adjusted black-and-white conversion, including local tone corrections.

▲ THE ORIGINAL COLOR IMAGE

▲ THE BLACK–AND–WHITE CONVERSION USING A −100 SATURATION ADJUSTMENT IN THE BASIC PANEL AND THE LOCAL ADJUSTMENT BRUSH TO LIGHTEN THE BELFRY: EXPOSURE +1.84, CONTRAST 29, HIGHLIGHTS 55, SHADOWS 29, AND CLARITY 44

FIGURE 4.67 Adjusting the Red and Blue channels.

▲ RED CHANNEL ¼ TONE POINT

▲ RED CHANNEL ¾ TONE POINT

▲ BLUE CHANNEL ¼ TONE POINT

▲ BLUE CHANNEL ¾ TONE POINT

Instead of trying to adjust the color using the Split Toning panel, I used the per-channel adjustments in the Point Curve Editor of the Tone Curve panel. I added a plus Yellow and Red ¼ Tone Curve while adjusting the ¾ tones to be plus Blue and plus Cyan. **Figure 4.67** shows the Red and Blue channel adjustments.

The final image is a more graphic, nonrepresentational rendering of the church. Although it isn't suitable for a lot of images, in this case, the strong graphic color works (at least for me). You can adjust the color in a more precise manner using color curves rather than the Split Toning panel. **Figure 4.68** shows the final color curve-toned result.

FIGURE 4.68 The final color curve-toned black-and-white conversion.

MAXIMIZING IMAGE DETAIL

Getting the most detail from your images is a complicated subject—heck, somebody could write a whole book on it. Wait, somebody already has! I co-authored the revision to Bruce Fraser's image-sharpening book: *Real World Image Sharpening with Adobe Photoshop, Camera Raw, and Lightroom* (Peachpit Press). I can't stuff the 360 or so pages of that book in this section, but I'll try to give you the most salient points when adjusting the Sharpening and Noise Reduction settings in Lightroom or Camera Raw.

You want to apply sharpening that enhances image detail but doesn't do harm. Oversharpening is a bigger problem than undersharpening. You can always add additional sharpening down the road, but it's very difficult to undo the undesirable effects of overly crunchy sharpening. Add the complications of sharpening to noise reduction, and you're attempting a balancing act between getting the most image detail while reducing visible noise. Trying to arrive at optimal settings for both is difficult and requires experience and knowledge of the tools.

The reason for image sharpening in Lightroom and Camera Raw is to recover and improve the image detail lost when converting the continuous tone light of a scene into pixels captured by the sensor. The act of demosaicing introduces softness due to interpolation. The sensor itself can cause softness because of the use of aliasing filters. Lenses may have defects and can suffer from diffraction at small apertures. As a result, you'll need to apply sharpening to improve the apparent sharpness or *acutance* (edge contrast). That edge part is important to understand. You want to sharpen the edges and not the non-edge surfaces in the image. Edge frequency is the determining factor of what Sharpening Radius you want to apply to your image—and arguably one of the more difficult things to determine. I'll break down sharpening for three common edge type images: high-frequency, low-frequency, and mixed-frequency edges.

HIGH-FREQUENCY EDGE SHARPENING

To show an example of high-frequency edge sharpening, I chose this image from Bryce Point in Bryce Canyon National Park. It was shot with a Phase One P65+ camera back using a 45mm lens, which has excellent performance. At the final cropped size, the image is 29.6 x 18.8 inches at 300 PPI. **Figure 4.69** shows the entire image (only cropped top and bottom a bit). You see the tiny green rectangle? That's the area of the image I'll be showing zoomed to 4:1 in Lightroom.

I would normally use a screen zoom of 1:1 in Lightroom (100 percent in Camera Raw) while adjusting the sliders, but I'm showing you this portion at 4:1 so detail

FIGURE 4.69 The full Bryce Point image as cropped, showing the zoomed area.

will show in the halftone reproduction of the book. The aim of the Sharpening and Noise Reduction is to extract as much usable detail in the image while avoiding any oversharpened artifacts. **Figure 4.70** shows the image with four sets of Sharpening and Noise Reduction settings.

Obviously, with Sharpening of 0 the image appears very soft at 4:1 zoom, but at the default settings there's little improvement in the apparent sharpness. Once the Sharpening settings have been optimized, you can clearly see the improvement in the image detail. Yes, there are visible halos—but remember, we're at 4:1 zoom so it's overenhanced; viewed at 1:1, those halos are invisible. The issue with the settings in the third optimized image is that increasing the Detail setting to 90 and Amount to 60 has done some undesirable work on the Luminance. The last image has a Noise Reduction Luminance setting of 25 to help mitigate that noise bloom.

So, how did I arrive at those settings? I worked out of order. Yes, generally, you should work from the top down, but I think a case could be made that the first adjustment for Sharpening should be setting the Radius. This image obviously has a lot of small edges, and the Radius should be set to under the 1.0 default. **Figure 4.71** shows the default Radius of 1.0 and adjusted to 0.7 while previewing the settings holding the Option key (Mac) or Alt key (Windows).

Reducing the Radius setting reduced the width of the halos and tightened up the sharpening of the edges. You might be tempted to simply use the lowest Radius of

FIGURE 4.70 Comparing various Detail panel settings at a 4:1 screen zoom.

▲ IMAGE WITH SHARPENING AND NOISE REDUCTION TURNED OFF

▲ IMAGE WITH THE DEFAULT SETTINGS: SHARPENING AMOUNT 25, RADIUS 1.0, DETAIL 25, MASKING 0; NOISE REDUCTION LUMINANCE 0

▲ IMAGE WITH OPTIMIZED SETTINGS: SHARPENING AMOUNT 60, RADIUS 0.7, DETAIL 90, MASKING 20; NOISE REDUCTION LUMINANCE 0

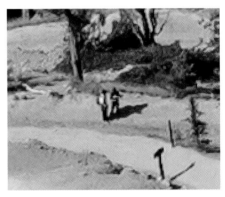

▲ IMAGE WITH OPTIMIZED SETTINGS AND NOISE REDUCTION LUMINANCE 25

FIGURE 4.71 Adjusting the Radius setting.

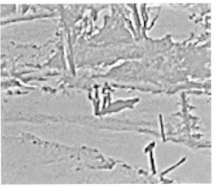

▲ DEFAULT RADIUS SETTING OF 1.0

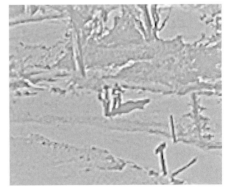

▲ ADJUSTED RADIUS SETTING OF 0.7

0.5 in a case such as this, but that isn't really optimal—it would undersharpen the edges because the Radius would be too small. There isn't a lot of difference between 0.5 and 0.7, but the impact will be visible when adjusting the Amount and the Detail sliders. This is the part of fine-tuning that requires experience. Setting the optimal Radius is critical. The next setting to adjust is the Detail slider, shown in **Figure 4.72**.

The default setting of 25 has very little deconvolution sharpening and a lot of halo suppression. For high-frequency images, I always increase the Detail slider to reduce the suppression and enhance the fine detail. The setting of 90 is pretty high, but this image could withstand the strong setting. You can see the inevitable increase in the sharpening of the noise, which will be addressed with the Noise Reduction Luminance setting (this preview is before the addition of the Noise Reduction). The next step will be to fine-tune the Amount and Masking settings, as shown in **Figure 4.73**.

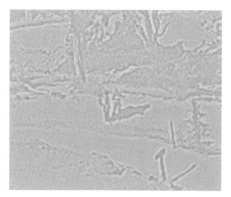

▲ DETAIL SETTING AT DEFAULT OF 25

▲ DETAIL SETTING ADJUSTED TO 90

FIGURE 4.72 Adjusting the Detail slider.

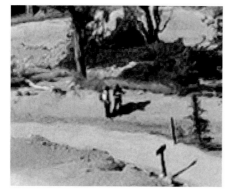

▲ ADJUSTING THE AMOUNT TO 60

▲ ADJUSTING THE MASKING TO 20

FIGURE 4.73 Adjusting the Amount and Masking settings.

After setting the Radius and Detail sliders, I went back to the top to adjust the Amount. The Amount is a simple "volume" control, and it's pretty easy to see how far you can go up to the point you're doing harm by oversharpening. Also, remember that if the overall Amount setting is good for the majority of the image but produces some suboptimal areas of oversharpening, you can use the local minus Sharpening settings in the Graduated Filter or Adjustment Brush to locally reduce the global settings made in the Detail panel. This ability to mitigate oversharpening is an important consideration, because it can change your global sharpening strategy. The Masking was adjusted so that surface areas (non-edge) didn't receive the full sharpening. Where the mask is white, the full sharpening is applied; where it's black, the sharpening is substantially reduced. If you use a very high mask setting, the sharpening in the black areas is almost eliminated. Be careful not to use a really high Masking setting when applying strong sharpening to an image with a lot of noise. You can get an unfortunate rippling effect, where no sharpening is applied to the surfaces and high sharpening is applied to the edges.

The Detail panel adjustments would normally be judged at 1:1. **Figure 4.74** is a screen zoom at 1:1 (100 percent). However, due to the halftone screen, you won't

FIGURE 4.74 The optimized Detail panel settings at a 1:1 screen zoom.

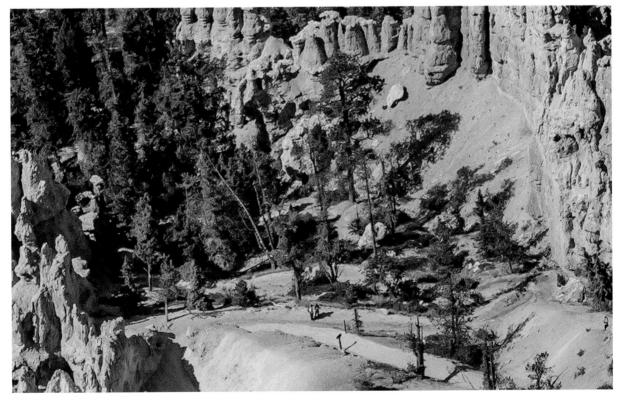

see what I saw in Lightroom when I made the adjustments. But it should give you an idea of what things should look like when optimally adjusted.

You might think that would wrap up this section, but no. I mentioned that optimal Detail panel settings might not be optimal for the entire image. In this case, the Sharpening and Noise Reduction were fine for most of the image but not for the sky. To adjust the global settings in the Detail panel, I used a local adjustment brushed in with the Adjustment Brush to modify the settings being applied in the sky. **Figure 4.75** shows the masked image area and "before" and "after" detail figures at a 4:1 screen zoom.

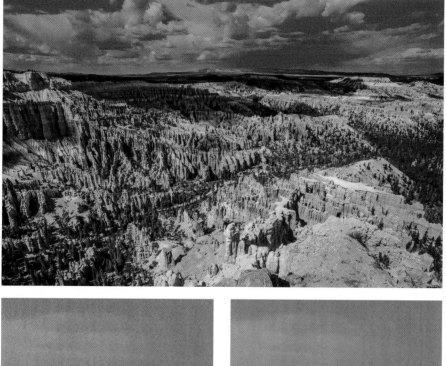

FIGURE 4.75 The masked area with local settings and a 4:1 zoomed view of the image before and after adjustment.

◀ THE ADJUSTMENT BRUSH MASK WITH SETTINGS: SHARPNESS −30, NOISE +50

▲ 4:1 ZOOMED VIEW BEFORE

▲ 4:1 ZOOMED VIEW AFTER

The differences are subtle but relevant if the maximum image detail and image quality are the goal (which they always are for me). This sort of local modification doesn't need to be extreme precision with the creation of the mask. Unlike making tone and color adjustments, locally fine-tuning the Sharpening and Noise Reduction settings only requires moderate accuracy of the mask. Since the full-size image is way too large to be reproduced in the book without substantial downsampling (which would make the image detail adjustments invisible), go back and take a look at Figure 4.69 to see the entire image and Figure 4.74 to see the results of the Sharpening and Noise Reduction at 1:1.

LOW-FREQUENCY EDGE SHARPENING

When sharpening an image with low edge frequency, you want to increase the Radius so small areas of texture and noise don't get overly sharpened. For example, on a person's face, you want to sharpen the eyes and lips but avoid oversharpening the skin (unless you want to go for that "weathered" look). The image I'm using as an example is a shot of my friend Daniel Ortize's wife, Roxana Chåzaro, in San Miguel de Allende, Mexico. Daniel is an avid photographer, so I asked his permission to photograph his wife. **Figure 4.76** shows the full frame of the image and a 2:1 zoom detail image of Roxana's eye. The image was captured with a Canon EOS REBEL T1i with an 18–135mm zoom lens at 113mm zoom. The ISO was set to 800 to get a fast enough shutter speed (1/60 second with image stabilization) to avoid camera shake.

FIGURE 4.76 Low-frequency example image.

▲ FULL IMAGE

▶ DETAIL AT 2:1 ZOOM WITH TH DEFAULT SHARPENING APPLIED

The Radius is again the first slider I adjusted. I knew I wanted to increase the Radius to avoid sharpening her skin and the sensor noise visible at ISO 800. I moved from the default 1.0 Radius setting to a setting of 2.0. **Figure 4.77** shows the preview of both Radius settings.

By increasing the Radius, I increased the sharpening on the strong edges in the eye while mitigating the noise and skin texture. The preview shows a slightly increased sharpening of the noise, but that will be adjusted later when adjusting the edge masking and adding noise reduction. The next adjustment was to adjust the Detail slider (**Figure 4.78**).

FIGURE 4.77 Adjusting the Radius setting.

▲ PREVIEW OF RADIUS 1.0 SETTING AT 2:1 ZOOM

▲ PREVIEW OF RADIUS 2.0 SETTING AT 2:1 ZOOM

FIGURE 4.78 Adjusting the Detail slider.

▲ PREVIEW OF DEFAULT DETAIL SETTING OF 25 AT 2:1 ZOOM

▲ PREVIEW OF ADJUSTED DETAIL SETTING OF 10 AT 2:1 ZOOM

FIGURE 4.79 Adjusting Masking and Amount settings.

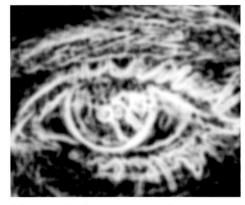 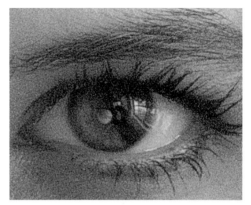

▲ PREVIEW SHOWING MASKING SET TO 68 ▲ PREVIEW SHOWING AMOUNT SETTING TO 88

Adjusting the Detail slider is probably going to be difficult to see in the book's half-tone reproduction, but let me explain what you're looking at (even if it's hard to see). At the default Detail setting of 25, there is still a touch of deconvolution sharpening being blended in, which means the high-frequency texture of skin and noise is getting hit too hard. By reducing the Detail slider to 10, much less of the noise is getting sharpened. The next adjustment, Masking, will cut down on the surface sharpening even further. **Figure 4.79** shows adjusting the Masking and Amount adjustments.

The Amount of 88 may seem high, but consider that the Radius is 2.0 while Detail is down to 10 and the edge Masking is up to 68—all of which alters the overall impact of the Sharpening. The Sharpening amount needed to be pretty high, and I actually increased the Sharpening around the eyes and lips with a local adjustment. After adjusting the final Sharpening settings, I adjusted the Noise Reduction Luminance setting to +50 to smooth out the noise. **Figure 4.80** shows a less-cropped version, still at 2:1 zoom. Yes, it does look a bit crunchy, but remember that you're seeing the results at two times the actual pixel size; it *should* look a bit crunchy.

In addition to the global Sharpening and Noise Reduction settings, I also did a little light-duty retouching and local Sharpening and skin adjustments. The spotting was very minimal—Roxana has good skin, but a little negative clarity never hurt anybody! I also wanted to increase the local Sharpening around the eyes and lighten up a bit under the eyes. **Figure 4.81** shows four of the local Adjustment Brush masks doing the majority of the touchup.

Using a local brush with minus Clarity has the effect of reducing the midtone contrast in the texture of the skin, which is really useful without actually blurring (and destroying skin texture). By adding additional Sharpening just around the eyes and lips, I avoided adding any additional global Sharpening. The +43 Sharpness with the Adjustment Brush is added to the global Detail panel settings. Lightening up the skin

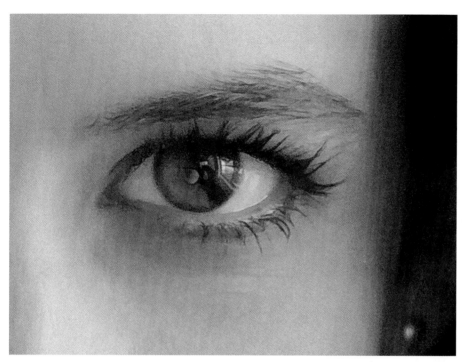

FIGURE 4.80 Final global Sharpening and Noise Reduction results.

▲ MASK FOR REDUCING CLARITY −36

▲ MASK FOR INCREASING SHARPNESS +43

▲ MASK FOR EXPOSURE +0.39, CONTRAST −31, SHADOWS +11, AND NOISE +22

▲ MASK FOR CLARITY −15 AND SHARPNESS −15

FIGURE 4.81 Local Adjustment Brush masks.

under the eyes and an additional touch of minus Sharpness and plus Noise with the Adjustment Brush finished things up. Well, okay, there were a couple more tweaks: I added a very gentle adjustment to lighten the whites of the eyes while darkening the round highlight over the pupils. I also lightened the teeth and added a touch of color and saturation to the lips. However, this isn't a heavy-duty fashion-magazine type of makeover. The goal was to maintain Roxana's good looks while keeping a natural appearance. **Figure 4.82** shows the final adjusted image at a screen zoom of 1:1 (100 percent).

FIGURE 4.82 Final portrait of Roxana at 1:1 zoom.

MIXED–FREQUENCY EDGE SHARPENING

Not every image can be lumped into just high-frequency or low-frequency categories. Using the wrong sharpening can adversely impact the final image quality. So, what do you do if you have an image that is predominantly in the low-frequency camp but has important image detail that needs high-frequency sharpening? You have to get smart! You need to take a slightly sneaky way around the issue. Lightroom and Camera Raw can apply only one type of sharpening at a time, so when faced with this problem, I turn to Photoshop and open digital negatives as Smart Objects. Yes, the image must be sent to Photoshop, but when it's a Smart Object, you retain the capability of editing raw image-processing parameters. **Figure 4.83** shows an example of an image with lots of low-frequency areas and some high-frequency areas in the center of the image. The iceberg image was shot at the northern tip of the Antarctic Peninsula near the Weddell Sea using a Canon EOS 1Ds Mark II and a 24–70mm lens.

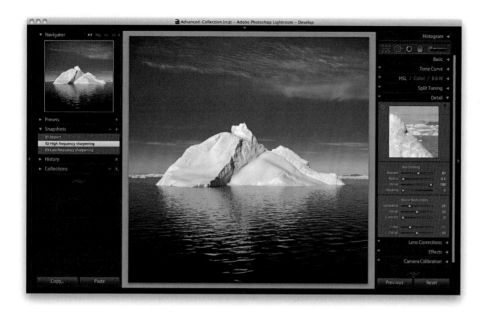

FIGURE 4.83 A mixed-frequency image.

The sky and the water are the low-frequency portions of the image, while the iceberg in the center really needs high-frequency sharpening. To apply a mixed-frequency edge sharpening while retaining the ability to edit raw parameters, I had to take a trip to Photoshop.

First, I'll point out a limitation of Smart Objects: once you take a raw image into Photoshop, you pretty much sever the relationship of the digital negative residing inside of Lightroom and the raw file that's embedded into a Photoshop file as a Smart Object. Any changes you make to the Smart Object using Camera Raw can't be easily changed back to your original negative inside of Lightroom. It's pretty much a one-way street from Lightroom to Photoshop. Yes, you can save the Photoshop file and import it into Lightroom, but then it's considered a rendered PSD or TIFF file. You can open the edited TIFF or PSD and re-edit the parameters from inside Camera Raw, but those settings aren't shared with Lightroom. Another slight hiccup regarding editing a Smart Object in Photoshop from Lightroom is that your Lightroom and Camera Raw versions need to be in sync (another good reason to keep Lightroom and Camera Raw up to date).

One way I work around the issue of severed settings from the digital neg and the Photoshop file is to make all the image adjustments in Lightroom and save Snapshots prior to editing the image as a Smart Object. Since Snapshots travel with the file, Snapshots made in Lightroom will show up in Camera Raw as well. **Figure 4.84** shows the two Snapshots I made and the sharpening settings I used for this image.

FIGURE 4.84 The Snapshots and the Detail panel settings.

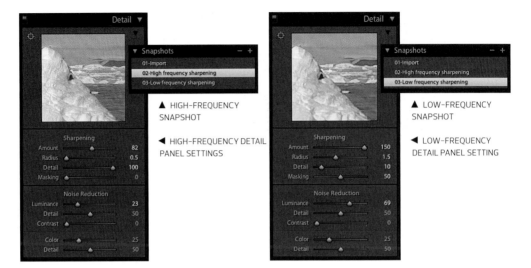

▲ HIGH-FREQUENCY SNAPSHOT

◄ HIGH-FREQUENCY DETAIL PANEL SETTINGS

▲ LOW-FREQUENCY SNAPSHOT

◄ LOW-FREQUENCY DETAIL PANEL SETTING

There are a couple things you'll notice about the different settings: For the high frequency, Detail is all the way up and the Radius is very small. I did this to really bite into the textural detail of the iceberg ice. For the low frequency, The Sharpening Amount slider is all the way up to 150 (that's rare, but it's sometimes useful), but the Detail slider is way down to +10 and the Masking slider is up to +50. I'll admit that I'm actually pushing this a little bit for the purposes of the example, but as you'll see, the results are very reasonable.

Once the settings are adjusted and the Snapshots are saved, it's time to open the digital negative as a Camera Raw Smart Object in Photoshop. From the Photo main menu in Lightroom, select Edit In and the Open as Smart Object in Photoshop option. This renders the image into Photoshop and the Smart Object is embedded into the Photoshop file and appears as a special Smart Object layer. **Figure 4.85** shows the single Camera Raw Smart Object layer, as well as the result of copying to a new layer and adding a Reveal All layer mask.

In order to copy the Smart Object layer, you need to do it in a special way: in Photoshop under the Layer menu is a flyout menu called Smart Objects. From the flyout menu, select New Smart Object via Copy. This creates a new Smart Object that can have different parametric adjustments from the original Smart Object layer. Simply duplicating the layer won't work; it needs to be a new Smart Object. Once the new Smart Object layer is in place, double-click the layer icon to open the Smart Object version of Camera Raw shown in **Figure 4.86**.

▲ THE SMART OBJECT LAYER IN
PHOTOSHOP

▲ COPYING THE SMART OBJECT
TO A NEW LAYER

FIGURE 4.85 The digital
negative opened in Photoshop
as a Smart Object.

◀ THE SMART OBJECT
VERSION OF CAMERA RAW

▼ SELECTING THE LOW–
FREQUENCY SHARPENING
SNAPSHOT

FIGURE 4.86 Opening the
Smart Object into Camera Raw.

Since I already saved Snapshots, I didn't need to fiddle in the Detail panel. I simply selected the low-frequency Sharpening Snapshot and clicked OK. Camera Raw renders the changes back into the Smart Object layer.

To blend the two edge-frequency sharpened layers, you need to create a layer mask. In this case, since the low-frequency image was on the top of the stack, the layer mask needed to reveal the high-frequency layer on the bottom. **Figure 4.87** shows the layer mask painted in and the resulting layer. Where the image is red, the low-frequency image will be hidden.

The payoff for this mixed-edge frequency sharpening is that it allows you to mix and match the optimal Sharpening and Noise Reduction settings while still retaining the raw editing capabilities of Camera Raw. It's a true blending of the strengths of combining Lightroom, Camera Raw, and Photoshop to optimize your image detail. **Figure 4.88** shows the high-frequency layer and the blended layers.

FIGURE 4.87 The layer mask for hiding the low-frequency sharpening layer.

▲ THE IMAGE WITH THE LAYER MASK TURNED VISIBLE

▲ THE LAYERS PANEL SHOWING THE LAYERS

▲ THE HIGH-FREQUENCY SHARPENED IMAGE

▲ THE MIXED-FREQUENCY SHARPENED IMAGE

FIGURE 4.88 Comparing the high-frequency sharpening to the mixed-frequency sharpening.

Corfe Castle in the county of Dorset in the southwest of England. The sky was composited into the image, a process I explain in the Compositing Multiple Images section later in this chapter. The camera I used was a Phase One 645DF with a P65+ back and a 75–150mm lens at ISO 100.

■ CHAPTER 5

DEPLOYING PHOTOSHOP TO PERFECT YOUR DIGITAL NEGATIVES

Do you know why Photoshop is such a huge success? Reality sucks! With Photoshop, you can alter reality by retouching, compositing, or using a host of computational manipulations, such as merging multiple panoramic shots, merging multiple exposures for HDR, or stacking images for focus blending. All these manipulations alter the reality of what you shoot—and that can be a good thing if you do it well (and for a good purpose).

This chapter is all about Photoshop, but it's not *everything* about Photoshop. I'm going to concentrate on the type of image manipulations I do to digital negatives on a regular basis. Lightroom and Camera Raw are excellent for getting images to a certain point, but past that you need to deploy Photoshop to perfect your master images. Fasten your seatbelts—it's going to be a fast ride!

GETTING IMAGES INTO PHOTOSHOP

If you're using Bridge and Camera Raw, it's pretty easy to get your images into Photoshop: just click the Open button in Camera Raw and your image ends up in Photoshop with attributes determined by the Camera Raw Workflow Options.

If you're using Lightroom, there are a couple ways of getting your images into Photoshop. One way is to export your images and have them opened for you in Photoshop, as shown in **Figure 5.1**.

The Export dialog box lets you control the particulars of how to render your digital negs into RGB images in Photoshop. You can control the file settings for format, color space, compression, and bit depth. You also can control the way files are named, their size, and what metadata will be included in the rendered files.

To make working more efficient, you can create a custom user preset with all the parameters stored. This is what I've done in Figure 5.1. You'll also see that I've turned on the option to Add to This Catalog and Add to Stack. This will ensure that the rendered images are imported back into Lightroom and stacked with the original digital negative—which is very useful for keeping your digital negs and rendered images well organized.

FIGURE 5.1 The Lightroom Export dialog box, showing the option to open the images directly into Photoshop.

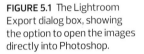

Once you click Export, Lightroom will render the files, save them to disk, and open them in Photoshop for further editing. This is useful if you want to open multiple images in Photoshop. If you simply want to open a single image or use one of the Edit In flyout menu options in the Lightroom Photo menu, there's a more efficient way. **Figure 5.2** shows the menu options found in the Edit In flyout menu.

The easiest way of opening an image from Lightroom into Photoshop is pressing Command+E (Mac) or Ctrl+E (Windows). ***Remember:*** The External Editing tab of the Lightroom Preferences dialog box dictates how the image is rendered. CS5.1 shows in my flyout menu because I've saved an Additional External Editor preset. **Figure 5.3** shows the External Editing settings.

If you have any third-party image editors, you can add them as a saved preset as I have for CS5.1. I have CS5.1 so I can test compatibility between Lightroom 4, Photoshop CS6, and Photoshop CS5. I normally only edit images in CS6.

FIGURE 5.2 The Edit In flyout menu with a single image and with multiple images selected.

▲ EDIT IN MENU WHEN A SINGLE IMAGE IS SELECTED

▲ EDIT IN MENU WHEN MULTIPLE IMAGES ARE SELECTED

FIGURE 5.3 The External Editing tab of the Preferences dialog box.

NOTE You need to understand the relationship of Camera Raw and Lightroom versions as outlined in Chapter 2. The ideal situation is to maintain a consistent compatibility between Camera Raw and Lightroom that provides the optimal integration between Lightroom and Photoshop.

A TYPICAL EDIT IN PHOTOSHOP

In this section, I'll show examples of a typical edit of an image from Lightroom into Photoshop and some of the steps I often use to optimize images using precision tools not available in Lightroom or Camera Raw. The image I use in this section was shot in Arches National Park; it's a photo of the Courthouse Towers at sunrise (yes, I went wandering around in the dark to set up) with the Phase One 645DF camera and a 45mm lens with the P65+ camera back. **Figure 5.4** shows the image before editing in Photoshop and the final layer stack showing the various correction layers.

There are a couple things I'd like to stress about using layers in Photoshop:

- Do yourself a favor and learn the discipline required to always name your layers (and channels and paths). The name Layer 1 won't mean much to you months or years down the road.

- Keep your pixel layers used for sharpening or retouching at the bottom, and put layers to adjust color or tone on top. This is more important when you're using adjustment layers, which I'll show later.

- Use layer groups to keep various layer types separate. In Figure 5.4, there's really only one type of layer being used, so I kept them all in a single layer group named Image Tweaks.

FIGURE 5.4 The beginning and the final layer stack after editing in Photoshop.

▲ THE IMAGE BEFORE PHOTOSHOP EDITING

▶ THE FINAL LAYERS PANEL SHOWING THE LAYER STACK

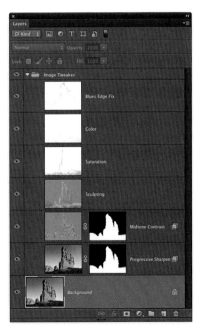

You'll note that I have a layer mask on two of the pixel layers that are masking the effect from being applied to the sky. I used the Color Range selection tool to create it.

COLOR RANGE SELECTION TOOL

The Color Range selection tool is found under the Select menu in Photoshop. To use Color Range, you move the cursor over your image and click to select a color in the image. You can use the plus and minus eyedroppers to add or subtract colors or use the keyboard shortcut of Shift+click to add color or Option+click (Mac) or Alt+click (Windows) to subtract colors. You can hold down the Option/Alt keys and click and drag the cursor over the image to add or subtract multiple colors at once.

The Fuzziness slider expands or contracts the selection sensitivity. I generally use a lower fuzziness setting when trying to select a more discrete color and tone. In Photoshop CS6, the engineers added the ability to try to detect faces, but that's only enabled when you turn on the option for Localized Color Cluster, which constrains the selection of a color to a localized region around the cursor when clicked. You also have an option to invert the selection, which is what I used. **Figure 5.5** shows the steps I used to create the Color Range selection.

I ended up using three Shift+clicks to arrive at the final color selection. Since I wanted to mask out the sky, I used the Invert option. Once the selection was made, I used the Save Selection command in the Select menu to save the selection as a channel. In this case, the sky was pretty easy to select. However, sometimes you won't be able to successfully select the area you need with Color Range and you'll need to modify the selection by working on the channel to paint areas in or out. I'll cover that in the "Compositing Multiple Images" section, later in this chapter.

TIP If you want to use Color Range on only a small portion of your image, you can preselect an area of the image using the Marquee or Lasso selection tool before using Color Range. The resulting selection will be of colors only inside the preselected area.

FIGURE 5.5 Using Color Range to create a selection.

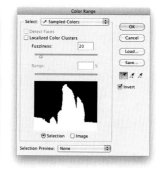

▲ FIRST CLICK IN THE SKY

▲ SECOND CLICK WITH SHIFT KEY TO ADD TO THE SELECTION

▲ THIRD CLICK WITH SHIFT KEY TO FINALIZE THE SELECTION

▲ TURNING ON THE INVERT OPTION

CREATIVE PROGRESSIVE SHARPENING

I had already adjusted the capture sharpening to the image in Lightroom, but I decided that the image needed some additional sharpening, so I did what I call "progressive sharpening": multiple applications of the Unsharp Mask plug-in followed by the Fade command in Photoshop. The first step is to make a copy of the Background layer to apply the sharpening to. You can do that either by using the Duplicate Layer command in the Layers panel flyout menu or by dragging the Background layer onto the Create a New Layer button on the Layers panel. **Figure 5.6** shows the copy layer, as well as the Unsharp Mask filter dialog box and the Fade command.

FIGURE 5.6 Starting the progessive sharpening procedure.

▲ THE BACKGROUND LAYER COPY

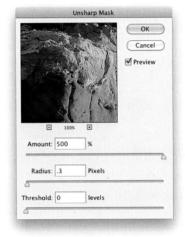

▲ THE UNSHARP MASK FILTER DIALOG BOX

▲ THE FADE DIALOG BOX

NOTE I discovered this process because I was trying to fix a friend's image that had been shot out of focus. He was desperate to get a usable image, so I started experimenting with various applications at various settings and hit upon the idea of accumulating multiple sharpening passes with each one faded to modify the results. Ideally, you should create a Photoshop action so you can apply the progressive sharpening at the push of a button.

I set the Background copy layer to a Luminosity blend mode to apply the sharpening only to the luminance image data and lowered the opacity to 50 percent. The resulting series of sharpening steps will produce a really sharpened image, so the odds are, you'll want to use a lowered opacity. Once the Unsharp Mask filter was applied the first time, I used the Fade command in the Edit menu to reduce the opacity of the actual filter application. This step is important because you want to build up the effect over multiple steps, and a 100 percent application of multiple sharpening rounds would pretty much destroy the image.

At this point, I had barely scratched the surface, so to speak. To build up the effect, I kept applying additional Unsharp Mask applications with gradually reduced amounts and increased radii. Here's what I used:

- Amount 500%, Radius 0.3, faded to 20% opacity (the first step shown)

- Amount 300%, Radius 0.6, faded to 20% opacity

- Amount 200%, Radius 1.0, faded to 20% opacity

- Amount 100%, Radius 5.0, faded to 20% opacity

- Amount 50%, Radius 10, faded to 20% opacity

- Amount 25%, Radius 25, faded to 20% opacity

By adding additional sharpening applications with varying amounts and radii, I built up the sharpening effect, producing a result that no single Unsharp Mask application can duplicate.

There's still one more step involved: applying the layer mask to the sharpened layer and making an adjustment to the range over which the sharpening is applied. **Figure 5.7** shows the renamed layer with layer mask and the Layer Style dialog box.

To keep the darks and lights of the image from getting oversharpened, I rolled off the highlights and shadows so the sharpening wouldn't be applied to those areas. The easiest way to do that is to use the Blend If adjustments in the Layer Style dialog box. To get this dialog box, select the Blending Options found in the Layer Style submenu of the main Layer menu in Photoshop. The easy way to bypass the menu navigation is simply to double-click the image icon in the Layers panel.

You can alter the General Blending options and adjust the blend mode and opacity, but what I wanted to adjust is how the progressive sharpening layer blended into the main Background layer. I accomplished this by adjusting the Blend If option at the bottom.

TIP If you've never done this before, rest easy— doing it a time or two will give you a better grasp of what's going on under the hood.

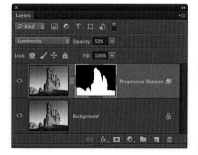

▲ THE RENAMED LAYER WITH LAYER MASK

▶ THE LAYER STYLE DIALOG BOX

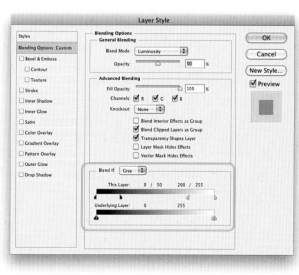

FIGURE 5.7 Modifying the layer and Layer Style options.

▲ BEFORE

▲ AFTER

FIGURE 5.8 Before and after application of the progressive sharpening.

The Blend If settings tell Photoshop what levels of the upper layer will blend into the lower layer. In the This Layer section, I've adjusted the slider so that the sharpening will be fully applied between level 50 (on the left) and level 200 (on the right). Accomplishing this takes a keyboard command to split the level indicators. You split the indicators by holding down the Option key (Mac) or Alt key (Windows) and dragging one-half of the level indicator right or left, respectively. This tells Photoshop to roll off the blending between level 50 and level 0 and between level 200 and level 255. This fades off the blending so extreme highlights and shadows don't get the full amount of the progressive sharpening layer. **Figure 5.8** shows the before/after application of the progressive sharpening layer at a 100 percent zoom in Photoshop.

The progressive sharpening can actually add texture and detail to your image, but it also can result in areas of substantial oversharpening. That's why I suggest always using a reduced layer opacity and modulating where the sharpening is applied using a layer mask. If you find areas where your image is hurting, simply paint it away on the layer mask.

MIDTONE CONTRAST

I use Clarity in Lightroom and Camera Raw, but the application of a midtone contrast using Clarity is limited to a single adjustment parameter: Amount. In Photoshop, you have a lot more control over the parameters. To make a midtones contrast adjustment in Photoshop, you first have to make your image look bad before you make it look better. The process is similar to doing a progressive sharpening: you make a

copy of the Background layer and change the blend mode to Overlay. Overlay is a procedural blend where levels above middle gray are blended using Screen mode, while levels below middle gray are blended using Multiply (see the "Blend mode magic" sidebar for more info). **Figure 5.9** shows the duplicated Background layer set to Overlay. You'll note that the contrast has jumped up a lot. Don't worry—I'll show you how to localize that!

You end up getting your image looking better by applying the High Pass filter found in the Filter menu in the Other flyout menu. The High Pass filter looks for edges in your image. The name High Pass actually comes from electronics—it's a filter that passes high-frequency singles but attenuates lower frequencies. The Photoshop version preserves the edges while making non-edges (surfaces) into a flat middle gray. The radius controls how far on either side of the edge the attenuation occurs. When applied to a layer that's set to Overlay, it acts as a sharpening filter; when used with a small radius, it's a sharpening filter. I use it with higher radius settings. **Figure 5.10** shows three radius settings in the High Pass filter.

FIGURE 5.9 Background copy set to Overlay blend mode.

FIGURE 5.10 Adjusting the High Pass filter.

▲ RADIUS SET TO 10 PIXELS ▲ RADIUS SET TO 100 PIXELS ▲ RADIUS SET TO 30 PIXELS

Set at 10 pixels, only areas within 10 pixels on either side of an edge remain. The low-frequency areas are turned to gray. The 10-pixel setting was too attenuated and resulted in more of a sharpening effect than a localized contrast adjustment. At 100 pixels, the effect was too broad and wouldn't bring up the midtones contrast details, as well as the 30 pixels I actually used on the image. The 100-pixel radius is similar to the basis of the Lightroom and Camera Raw Clarity adjustment. The range I generally use is between 20 and 80 pixels, but the value depends on the image's needs. This is one reason that midtones contrast in Photoshop is more flexible than Clarity in Lightroom or Camera Raw.

Since the layer that is on top is set to Overlay, the low-frequency areas of the image turn gray and the blend mode simply passes them through and has no effect. Where there are edges, the light side of the edge gets lighter and the dark side gets darker, which is a classic Unsharp Masking type of filtration. The key to having the midtones increase in contrast is to set the Blend If options to only be applied in the middle range of levels in the image. I'll use the Layer Style dialog box to adjust the Blend If sliders. **Figure 5.11** shows the blending options.

Getting the exact numbers isn't overly critical. The important thing is to roll off the level's impact so you don't plug up the shadows and blow out highlights. The settings I used fully blended the results between level 100 and level 150 (slightly biased toward the upper midtones). Nothing below 50 or above 200 will be blended in.

I'll show you the results of the midtones contrast in a moment, but I wanted to show a variation of midtones contrast accomplished by freehand painting instead of using a filter. My good friend and colleague Mac Holbert (who taught it to me) calls it "sculpting."

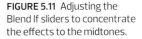

FIGURE 5.11 Adjusting the Blend If sliders to concentrate the effects to the midtones.

SCULPTING

Sculpting is similar to midtones contrast in that the blending mode is Overlay where anything lighter than middle gray blends using Screen and anything darker blends using Multiply. Rather than applying it to a copy of your image, you apply it to a gray-filled layer by painting in white or black with the Brush tool.

To start, create a new blank layer, fill it with a 50 percent gray, and set the blend mode to Overlay. Once set, the layer is essentially a null layer that does nothing...yet. When you paint into the gray with white, you lighten the image; paint with black, and you darken. If you want to tone down either effect, you can paint in with a 50 percent gray. It's a pretty high-tech way of doing localized dodging and burning (lightening and darkening) à la the old chemical darkroom. **Figure 5.12** shows the Sculpting layer I painted and a detail of the area near the base of the right tower.

The Layer Style blending options I used were the same as shown in Figure 5.7. Figure 5.12 shows the areas of middle gray (which does nothing), as well as areas that are lighter and areas that are darker than middle gray. Where the area is lighter than middle gray, the Overlay blending will use the Screen logic and lighten the area in the image. Where it's darker, the image will get darker because of the Multiple blend. (See the "Blending mode magic" sidebar for more information on layer blends.)

I used this Sculpting layer to enhance the tone and texture of certain image features while adding a sense of depth and dimensionality. **Figure 5.13** shows the image before midtones contrast, with midtones contrast and with sculpting. The effects are accumulative and build up.

FIGURE 5.12 The Sculpting layer and detail.

▲ FULL SCULPTING LAYER

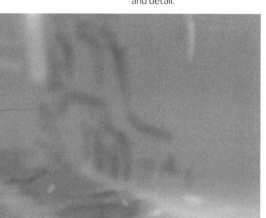

▲ DETAIL OF SCULPTING LAYER

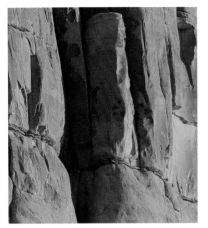

▲ BEFORE

▲ AFTER MIDTONE CONTRAST

▲ AFTER SCULPTING

FIGURE 5.13 Comparing before and after at a 100 percent screen zoom in Photoshop.

SATURATION AND COLOR LAYER MODIFICATIONS

I'm going to combine these two adjustments made via layer blending modes because they're the same in concept and differ only in the way the adjustments are applied and blended. If you refer back to Figure 5.4, you'll see two layers: one called Saturation and, above it, Color. The names reflect the blending modes each layer is set to and what aspects of the image I'm adjusting. **Figure 5.14** shows larger versions of the Layers panel thumbnails.

To better understand what the Saturation-based adjustments are doing, I chose a vivid green color to show where the layer increases the saturation of the colors in the image. It can be any fully saturated color because the layer is blending only the saturation information, not the color. You can just see some areas where there's a gray color. Gray, because it's a totally unsaturated color, will reduce the saturation in the image. For clarity, I have my Photoshop Preferences setting in Transparency & Gamut set to Grid Size: None. Seeing the transparency grid would confuse the visual and potentially cause printing problems, so wherever you see white, think transparent.

Being able to blend back and forth between more or less saturation in a single layer is useful. To accomplish the same effect using adjustment layers, you would need to use two separate adjustment layers and have to bounce back and forth to modify the layer masks to make the same plus and minus saturation adjustments.

For the Color layer, the blend mode alters only the color (the hue and saturation) of the image. For this example, I wanted to paint in a cooler color to cool down the

FIGURE 5.14 The Saturation-and Color-based corrections.

▲ SATURATION-BASED CORRECTIONS

▲ COLOR-BASED CORRECTIONS

▲ THE IMAGE BEFORE ADJUSTMENTS

▲ THE IMAGE AFTER THE SATURATION ADJUSTMENTS

▲ THE IMAGE AFTER THE SATURATION AND COLOR ADJUSTMENTS

FIGURE 5.15 Comparing the image before and after the Saturation and Color adjustments.

shadow areas of the image. **Figure 5.15** shows the results of the Saturation and Color layers compared to the image before.

The differences are subtle but visually important. In the "before" image, some of the areas needed more saturation, so I painted it in. However, I wanted to cool down the shadows so I painted in a cooling color in those areas. The net result was to increase the saturation in some areas and cool down the colors in others, increasing the sunrise feeling I wanted to achieve.

BLENDING MODE MAGIC

The blending modes in Photoshop are ways of modifying how color and tone are blended together when painting with a brush-based tool or blending two or more layers. To understand how the blending works, you need to understand the following terms:

- **Base color:** The original unblended color (and tone) in the image

- **Blend color (and tone):** The color being blended

- **Result color:** The color (and tone) that results from the blend

There are a lot of blending modes, many of which I neither understand nor use. I'm going to concentrate on the blending modes that are the most useful for working on digital negatives in Photoshop. **Figure 5.16** shows the entire list of blending modes available in the Layer Style dialog box, as well as painting-based tools such as the Brush and Clone Stamp tool. A smaller subset is available in the Healing Brush tool.

FIGURE 5.16 The Layers panel blending drop-down menu.

These are the blend modes I understand and use regularly:

- **Normal:** Edits or paints each pixel to make it the result color. This is the default mode.

- **Darken:** Looks at the color in each channel and selects the base or blend color—whichever is darker—as the result color. Pixels lighter than the blend color are replaced, and pixels darker than the blend color don't change.

- **Multiply:** Looks at the color information in each channel and multiplies the base color by the blend color. The result color is always a darker color. Multiplying any color with black produces black. Multiplying any color with white leaves the color unchanged.

- **Color Burn:** Looks at the color information in each channel and darkens the base color to reflect the blend color by increasing the contrast between the two. Blending with white produces no change.

- **Lighten:** Looks at the color information in each channel and selects the base or blend color—whichever is lighter—as the result color. Pixels darker than the blend color are replaced, and pixels lighter than the blend color don't change.

- **Screen:** Looks at each channel's color information and multiplies the inverse of the blend and base colors. The result color is always a lighter color. Screening with black leaves the color unchanged; screening with white produces white. The effect is similar to projecting multiple photographic slides on top of each other.

- **Color Dodge:** Looks at the color information in each channel and brightens the base color to reflect the blend color by decreasing contrast between the two. Blending with black produces no change.

- **Overlay:** Multiplies or screens the colors, depending on the base color. Patterns or colors overlay the existing pixels while preserving the highlights and shadows of the base color. The base color isn't replaced, but it's mixed with the blend color to reflect the lightness or darkness of the original color.

- **Soft Light:** A variant of Overlay that also darkens or lightens the colors, depending on the blend color. If the blend color is lighter than 50 percent gray, the image is lightened; if the blend color is darker than 50 percent gray, the image is darkened. The effect is more subdued than Overlay.

- **Hard Light:** A variant of Overlay that also multiplies or screens the colors, depending on the blend color. If the blend color is lighter than 50 percent gray, the image is lightened, as if it were screened; if the blend color is darker than 50 percent gray, the image is darkened, as if it were multiplied. This effect is stronger and more pronounced than Overlay.

- **Vivid Light:** Burns or dodges the colors by increasing or decreasing the contrast, depending on the blend color. If the blend color is lighter than 50 percent gray, the image is lightened by decreasing the contrast; if the blend color is darker than 50 percent gray, the image is darkened by increasing the contrast.

- **Linear Light:** Burns or dodges the colors by decreasing or increasing the brightness, depending on the blend color. If the blend color is lighter than 50 percent gray, the image is lightened by increasing the brightness; if the blend color is darker than 50 percent gray, the image is darkened by decreasing the brightness.

- **Pin Light:** Replaces the colors, depending on the blend color. If the blend color is lighter than 50 percent gray, pixels darker than the blend color are replaced, and pixels lighter than the blend color don't change; if the blend color is darker than 50 percent gray, pixels lighter than the blend color are replaced, and pixels darker than the blend color don't change.

- **Hue:** Creates a result color with the luminance and saturation of the base color and the hue of the blend color.

- **Saturation:** Creates a result color with the luminance and hue of the base color and the saturation of the blend color. Painting with this mode in an area with no saturation (gray) causes no change.

- **Color:** Creates a result color with the luminance of the base color and the hue and saturation of the blend color.

- **Luminosity:** Creates a result color with the hue and saturation of the base color and the luminance of the blend color. This mode is the inverse effect of Color mode.

The easiest way to learn how to use the blending modes is by actually using them. If you don't want to experiment with all the modes, these are the ones I suggest you concentrate on: Multiply, Screen, Overlay, Soft Light, Hue, Saturation, Color, and Luminosity.

BLUE EDGE FIX

One of the common problems in photography is the way the complementary colors tend to blend into white when mixed by the lens. This isn't just a digital problem, but it can be made worse because of the application of edge-based image sharpening. (We had the same problem with film, but it tended to be less noticeable.) Even though my Lightroom Detail panel settings were correctly set and the progressive sharpening was masked away from the edges between the blue sky and the orange rocks, there appears to be a white halo along the edges of the rocks and sky. The only way to really fix this problem is to manually remove them using the Clone Stamp tool. **Figure 5.17** shows the image before and after fixing the edges.

I figured you might be a bit skeptical that the white edges weren't a byproduct of oversharpening, so I've included a screenshot of the image in Lightroom with no

FIGURE 5.17 Before and after the blue edge fix at a screen zoom of 4:1.

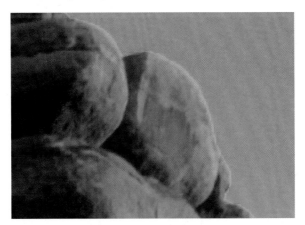

▲ IMAGE IN LIGHTROOM AT A 4:1 ZOOM WITH ALL SHARPENING OFF

▲ IMAGE WITH SELECTION ACTIVE AND THE CLONE STAMP TOOL

▲ IMAGE AFTER BLUE EDGE FIX

sharpening applied at all. You can see the edge along the perimeter of the rocks show-ing a white color where the blue and orange colors mix. This is a problem whenever two complementary colors form a border. You'll see a similar white edge between magenta and green or red and cyan. Although neither of the colors in my image are pure additive or subtractive primary colors, the white edge appears.

To eliminate the line, I used the sky channel inverted so the sky was actively se-lected and the rocks protected. I used the Clone Stamp tool to paint along the edges of the rock to eliminate the white line. Yes, I had to do this manually throughout the entire image. Yes, it was tedious. But the final image was worth the effort. (Nobody ever said this Photoshop stuff was easy.) **Figure 5.18** shows the final adjusted image.

FIGURE 5.18 The final image of the Courthouse Towers.

You might wonder if I always do all these things to all my images? More or less, yes, but it depends on the image. Any image that's worthy of some quality time in Photoshop gets my full attention and my whole bag of tricks. Clearly, some images don't need all these manipulations and adjustments, and I let the images dictate what they need. However, I honestly do all this and more on a regular basis.

RETOUCHING

I started my career as an advertising photographer whose skills and talent to make a product look "perfect" were in high demand. But that was well before the introduction of Photoshop, which completely changed the nature of photography. These days, photographers don't need to spend hours or days prepping products or making perfect model comps to be able to shoot the perfect shot. Now you just shoot what you have and fix it in Photoshop—and I'm okay with that.

Photoshop has a lot of powerful tools that make the process of retouching images pretty darn easy. The big question is: how far do you take your retouching? I guess that depends on who's paying the bill. If you're doing commercial work, you retouch to satisfy the client. Fortunately, I no longer have to satisfy a client—I only need to satisfy myself—so my approach to retouching is to eliminate blemishes while preserving the character of the image. I remove distracting details and enhance the natural appearance of whatever I'm retouching, but I'm not necessarily trying to achieve an artificial "ultimate perfection," just a natural improvement of reality.

The image I'll use as an example of retouching is one of my daughter's rental cello. It's a rental, so there were a lot of nicks and scratches, and the finish was less than perfect. (Ironically, I did sort of have an art director: my daughter, who oversaw my work and offered plenty of criticism. When I was done, she finally admitted I did "all right.") **Figure 5.19** shows a screenshot of the image in Lightroom with the spot healing points, the image opened in Photoshop before retouching, and the final layer stack showing the retouching and tone and color adjustments. There was a lot of work to be done!

I started the retouching in Lightroom with a bunch of spot healing for those things that Lightroom can easily do, such as sensor spots, smaller dust spots, and small imperfections. But there was no way I was going to be able to do everything in Lightroom. In Photoshop, I had to fix some scratches and dings, fix an unraveled string, remove a lightstand, and then tone down parts of the cello and adjust the background—a lot of work.

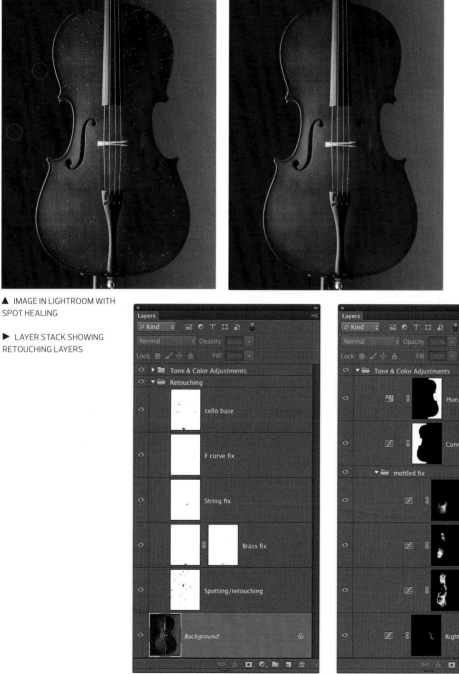

FIGURE 5.19 The image before retouching and the final retouched layer stacks.

▲ IMAGE IN LIGHTROOM WITH SPOT HEALING

▶ LAYER STACK SHOWING RETOUCHING LAYERS

◀ IMAGE IN PHOTOSHOP BEFORE RETOUCHING

▼ LAYER STACK SHOWING TONE AND COLOR ADJUSTMENTS

I'm showing you the final layer stack here in the beginning to explain why I organize layers the way I do. When pixel retouching, I always place those layers at the bottom and never intermix retouching layers with tone and color adjustment layers. When using the Healing Brush or the Clone Stamp tools, I usually use the tool option sample mode of Current & Below so I can build up the retouching from the bottom to the top. If you intermix any adjustment layers in between the retouching layers, they'll get picked up by the Healing Brush or Clone Stamp tools and be added to the retouched spot. Yes, there is an option to ignore adjustment layers, but that's a relatively new addition and I've built my habits over time. Plus, you have to remember to turn that option on and then off when you don't need it. I find it easier to simply do the retouching on the bottom layers.

I like to keep specific fixes on their own layers. I usually put the basic retouching and spotting on the bottom followed by additional area retouching above to be able to take advantage of the things I've already retouched.

HEALING BRUSH AND CLONE STAMP TOOLS

I tend to work with both the Healing Brush and Clone Stamp tools somewhat interchangeably, except for specific cases. The Healing Brush is wonderful at fixing the area under the brush cursor while retaining good textural detail, except for working near areas of high-contrast edges. Because the Healing Brush looks outside the brush cursor to determine the area to be healed, working up next to dark or light areas will fool the healing logic and deliver poor results. For those areas, I tend to use the Clone Stamp tool. However, using a large and soft Clone Stamp brush tends to mush up the underlying texture. So, I'll often use both—first, the Clone Stamp tool to fix the areas that the Healing Brush isn't good at, and then the Healing Brush to fix the textural problems caused by the Clone Stamp tool. **Figure 5.20** shows the area at the bottom of the cello where I retouched to remove a lightstand that was holding up the cello. The zoom view is at 100 percent in Photoshop.

First, I retouched the areas immediately under the cello with the Clone Stamp tool to fix the edge of the cello. The Healing Brush would've had problems here. Once I cleared the area around the cello edge, I came back with the Healing Brush to eliminate the remainder of the lightstand. It was a pretty quick and easy fix.

I also needed to fix an area on the fingerboard of the cello. I zoomed to 200 percent to work closely. I used the Healing Brush and picked a source area using Option+click (Mac) or Alt+click (Windows) and then moved the brush down the bias of the string. Photoshop offers a preview of the way the source lines up with the destination area. I find it useful to select an area of an object that's easy to line up and then extend the brush over the area that needs healing. **Figure 5.21** shows selecting the source, seeing a misaligned preview, and then the aligned preview and the final healed stroke.

TIP Working zoomed in allows a greater level of precision when retouching. I often zoom to 200 percent or more when working on small details.

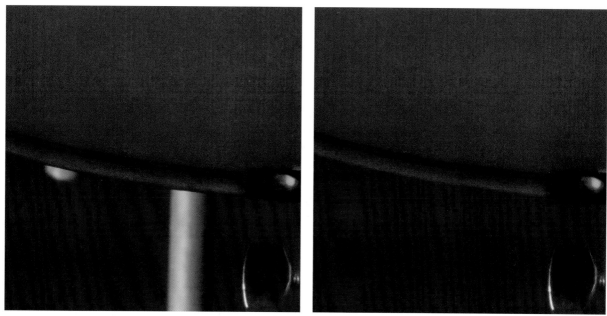

▲ BEFORE RETOUCHING

▲ AFTER RETOUCHING

FIGURE 5.20 Before and after Clone Stamp and Healing Brush retouching.

▲ SETTING THE SOURCE OF THE HEALING BRUSH

▲ SEEING THE MISALIGNMENT OF THE BRUSH PREVIEW

▲ SEEING THE BRUSH PREVIEW ALIGNED

▲ COMPLETING THE HEALING BRUSH STROKE

FIGURE 5.21 Setting the source of the Healing Brush and previewing the alignment and final healed area.

COPY-AND-PASTE PATCHING

Sometimes using the Clone Stamp or Healing Brush isn't very efficient. In the case of the string fix, it was easiest to simply copy a portion of the image, paste it to a new layer, and then move that layer into the required position. **Figure 5.22** shows the before and after of the string fix.

In the "before" figure, I used the Marquee tool to select the area I wanted to move over the unraveled string. In the "after" figure, I've pasted the patch and then moved the patch over the unraveled string. I did need the Healing Brush to catch a bit of the stray red fibers, but the patch did a fine job. The key to making this fix was to select an area large enough so that string wrapping matched up. Sometimes you'll need to feather the selection before copying to make sure the resulting paste can blend in. Don't overfeather! In this case, I used a 0.8-pixel feather to keep the copy-and-paste lines from being too sharp.

The next thing I wanted to fix was the blown-out brass of the endpin holder at the bottom of the cello. Truth be told, I should've fixed this with a local Adjustment Brush while the image was still in Lightroom, but I didn't. I didn't really notice how

FIGURE 5.22 Before and After the String fix using copy and paste.

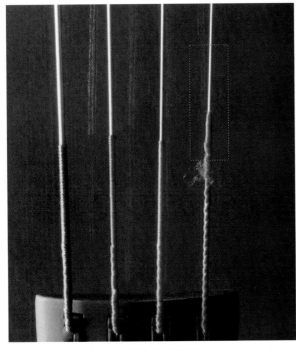

▲ BEFORE FIX WITH AREA SELECTED FOR COPYING

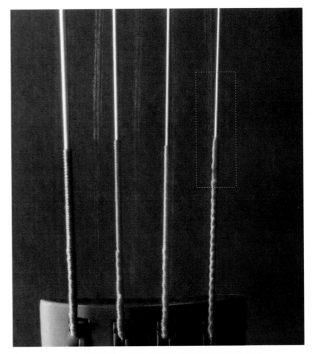

▲ AFTER WITH THE PASTED LAYER MOVED OVER THE PATCH AREA

FIGURE 5.23 Copy and paste from a second processed image version.

▲ BEFORE THE COPY AND PASTE

▲ AFTER THE COPY AND PASTE

bright and blown out the brass looked until retouching the lightstand out of the image. That's when I noticed that the brass was clipped of color. Since I had already started work on the image, the prospect of starting over again wasn't appealing. However, I knew I could go back and fix this small area in Lightroom and then open the adjusted image in Photoshop and copy and paste the toned portion of the endpin holder into the retouched image. **Figure 5.23** shows the image before and after the copy-and-paste patch.

The primary adjustments I made back in Lightroom were to reduce the Highlights and Whites sliders to regain texture detail in the brass highlights. This also darkened the wood a bit, which I had deemed too bright as well. I opened the image a second time in Photoshop and selected the newly processed image area down near the bottom with the Marquee tool and, using the Move tool, dragged the selected area to the original image while holding down the Shift key to place the new image in exact registration with the underlying image. I used a layer mask to blend the new area with the older area. Okay, so I did a drag and drop not a copy and paste—same difference—although there is actually a slight difference in behaviors between copy and paste and drag and drop (see the nearby sidebar).

RETOUCHING USING PAINTING

Some types of retouching fixes are really hard to accomplish using the Clone Stamp and Healing Brush tools or using copy and paste. Curved areas can be very challenging. In many cases, the easiest way to fix these kinds of defects is to simply use the Paint Brush tool and paint them in. On the right F-hole of the cello, there was a

highlight along the edge that didn't look good. I'm not sure if it was due to a defect in the finish or something causing a break in the highlight, but it was painfully obvious. Fixing this with the Healing Brush or Clone Stamp tool would've been very difficult, but it was easy to paint in the fix. To accomplish the fix, I created a new blank layer and drew a path with the Pen tool along the highlight I wanted to paint in. Then I used the Stroke path with brush option. **Figure 5.24** shows the steps.

Once I had drawn out the path segment (I didn't need to do a completed path), I selected a very tiny brush size of 2 pixels and sampled the area of the highlight that was good as the paint color. With the path active, I clicked on the Stroke path with the brush icon on the Path panel. You also can use the Stroke Path command in the Path panel flyout menu. The key to re-creating the highlight on the F-hole was to build up the tone and color gently.

When using the Paint Brush tool, I often use a very low opacity and multiple strokes to arrive at the final result. In this case, I used 10 percent opacity, and I increased the brush size incrementally to gently expand the width of the highlight. Once done, I

COPY-AND-PASTE AND DRAG-AND-DROP BEHAVIORS

When using copy and paste or drag and drop, Photoshop has a specific set of behaviors that can be useful. By default, if both the source and destination documents are exactly the same pixel dimensions, copy and paste and drag and drop will exactly register the object in the destination when holding down the Shift key.

If the source and destination are different dimensions, a copy and paste follows the following rules:

- If the entire image is visible, the pasted object will be in the exact center of the destination.

- If the image is zoomed in, the paste will be in the center of the visible window.

- If you have an active selection in the destination, the paste will end up in the center of the active selection.

With drag and drop between different-sized documents, the following behaviors are observed:

- If the Shift key is held down, the dropped object will land in the exact center of the destination.

- If the Shift key is not held down, the dropped object will land in the destination document wherever the cursor was when you released the mouse button.

▲ IMAGE BEFORE PAINT RETOUCHING ▲ IMAGE SHOWING ACTIVE PATH ▲ IMAGE AFTER PAINTED STROKES

FIGURE 5.24 Retouching using painting.

used the Eraser tool to gently taper off the bottom end of the painted highlight. The last step was to add a very tiny amount of noise to the paint layer. If you don't add noise, the resulting painted areas (even this small) will look overly smooth. I used the Add Noise filter with an Amount of 4 percent with Uniform Distribution with the Monochromatic option.

USING PATHS TO MAKE SELECTIONS

Many photographers shy away from using paths to make selections, which is too bad really because a path is the most accurate way of creating a selection. I'll tell you why I first started using paths to make selections: Back in early versions of Photoshop, the amount of RAM a computer could hold was very, very small. My first Mac Quadra 950 could hold only 64 MB of RAM. So, in the early days, we all tried to keep our file sizes as small as possible. Each channel you create adds to the overall file size, while each path you add is negligible. So, to save on file size, I used to use a lot of paths to make selections.

Another important aspect of paths is their accuracy and precision. Paths have sub-pixel accuracy. So, if you very carefully draw a path with the Pen tool, you can determine exactly where a selection will end up. I usually draw paths when zoomed to at least 200 percent in Photoshop. If you don't really know how to use paths, I suggest you learn. It takes practice and learning how to control the Bézier nature of the way path curves are controlled.

The basics are simple, you click and drag to draw out a path curve and then click again to start the next segment. At any time, you can adjust the curve handles by

FIGURE 5.25 The Rubber Band option for the Pen tool.

holding down the Command key (Mac) or Ctrl key (Windows). This allows you to adjust the curve handles. Both handles move with Bézier behavior; however, if you add the Option key (Mac) or Alt key (Windows) to the Command/Ctrl key, you can break the handle and move each curve handle separately. Once you've completed the path, you can always go back and edit the individual path point, and if you have the Auto Add/Delete option turned on in the Path tool options, you can add or delete a point by clicking.

If you don't have the Rubber Band option for the Path tool turned on, do so. It makes drawing a path a lot easier because, as you draw the path, a line segment is added, greatly helping you to figure out where to place the next path point. **Figure 5.25** shows where the Rubber Band option lives. It's actually rather obscure, and I don't for the life of me understand why it's not checked by default—it makes using the Pen tool a lot easier.

The final series of adjustments I needed to make involved using adjustment layers to make tone and color corrections. The biggest involved darkening the background on the left of the cello and completely removing any color saturation on the right. I started by creating a path around the entire perimeter of the cello. Then I made a selection based on the cello outline and modified copies of the cello outline channel. **Figure 5.26** shows the series of steps going from the outline path of the cello to the cello channel and the two modified channels to select the left and right background areas.

If you refer back to Figure 5.19, you'll see the two adjustment layers I created to adjust the background. On the left I used a Curves adjustment layer to darken the left background. I had tried to scrim the light to darken the background when I captured the shot, but it was tough to get the background full black and I knew that would be easy to do in Photoshop. I also created a Hue/Saturation layer to remove any color

FIGURE 5.26 Making a path into a channel and modified for use as adjustment layer masks.

▲ THE CELLO OUTLINE PATH

▲ THE PATH TURNED INTO A SELECTION AND SAVED AS A CHANNEL

▲ A COPY OF THE OUTLINE CHANNEL MODIFIED FOR THE LEFT BACKGROUND

▲ A COPY OF THE OUTLINE CHANNEL MODIFIED FOR THE RIGHT BACKGROUND

from the right side of the background. The white balance I set in Lightroom left a slight yellow cast to the background—an easy fix in Photoshop.

I also made a few other tone adjustments. I used adjustment layers to smooth out the mottling of the cello tone. I darkened some of the lighter tones and lightened some of the darker tones. My art director daughter didn't want me to completely eliminate the mottling because she thought it gave the cello "character" (I didn't disagree). I also used a path around the right F-hole to darken it. The final retouched cello image is shown in **Figure 5.27**.

FIGURE 5.27 The final retouched cello image.

COMPOSITING MULTIPLE IMAGES

I've been using Photoshop for image manipulation and compositing since August 15, 1992. How do I know it was that day? I actually found the first image I did on a backup tape and the creation date on the file was 08-15-1992. I have to tell you, it was garbage, literally. It was an image done for Waste Management depicting a waste cleanup effort that I shot in my studio. I did the Photoshop imaging on a rental Mac IIci with 32 MB of ram and an 80 MB hard drive. I worked on a 24 MB scan and it was painfully slow—saving the image took about 30 minutes (and it didn't even have layers). It was done using Photoshop 2.0.1. I started on a Friday evening, and my wife woke me up on Monday morning—I had fallen asleep on my keyboard. **Figure 5.28** shows the final manipulated and composited image. See, I told you it was garbage.

That first job was enough to get me hooked on digital imaging. Throughout the 1990s, I continued to do digital imaging and compositing commercially. If you want to see more, you can visit my website (www.schewephoto.com).

Enough nostalgia—let's get back to the here and now. The images I'm going to composite are two shots I captured in the county of Dorset in the southwest of England. The first image is a shot of Corfe Castle in a village of the same name. It was shot in late afternoon light with my Phase One camera and back with a 75–150mm

FIGURE 5.28 My first Photoshop job, from August 15, 1992.

▲ CORFE CASTLE

▲ PORTLAND BILL LIGHTHOUSE

FIGURE 5.29 The two images to be composited.

lens. It's a nice enough shot, but there were no clouds in the sky (unusual for that locale), so I decided to add some. Ironically, I had taken a shot of the Portland Bill Lighthouse on the Isle of Portland the previous morning in very early light that had some very nice clouds. That was also shot with the Phase camera so the resolutions would match up pretty well. **Figure 5.29** shows the original shots (the Corfe Castle shot is cropped a bit from the sides and bottom).

CREATING THE COMPOSITE MASK

I used Color Range to select the sky in the castle shot and saved the selection as a channel. The Color Range selection unfortunately picked up quite a bit of ancillary bits from within the castle that needed touching up. **Figure 5.30** shows the original sky channel and the adjustments to the channel.

FIGURE 5.30 The Color Range selection saved as a channel and adjusted.

▲ COLOR RANGE SELECTION SAVED AS A CHANNEL

▲ DETAIL OF CHANNEL BEING FILLED IN

▲ DETAIL OF FILLED-IN CHANNEL WITH A 1-PIXEL BLUR APPLIED

TIP I tend to prefer using the Gaussian Blur filter on a saved channel rather than using the Feather command on the active selection. The underlying engine for Feather is the same as for Gaussian Blur, so there's no real difference in the mask. When you work on a 16-bit image, the image, channels and masks are all 16 bit. However, selections always only have 8-bit precision not 16-bit. So, where possible, I prefer to modify selections only when saved as a channel or mask.

You can see that Color Range got some extraneous parts of the castle in the selection that would need to be cleaned up. I zoomed in and used the Pencil tool to paint black inside the castle perimeters. I find it easier to use the Pencil tool because it's less likely to accidentally paint outside the boundaries, as might happen with a Paintbrush tool. Plus, the Pencil tool paints really fast. The final step was to apply a 1-pixel blur using the Gaussian Blur filter.

COMPOSITING THE SKY

After preparing the sky channel, I copied and pasted the entire lighthouse image into the castle shot. I loaded the sky channel as a layer mask and prepared to use Free Transform to size the lighthouse sky for the castle image. To be able to transform a layer with a layer mask, you need to uncheck the layer mask link to the pixel layer. **Figure 5.31** shows the link indicator. To unlink the layer and layer mask, just click the link icon.

FIGURE 5.31 Unlinking the layer from the layer mask.

Once the layer mask was unlinked, I selected the image layer and used Free Transform to resize the sky of the lighthouse image to fit correctly on the castle image. I intentionally distorted the lighthouse sky to give it more perspective, which was slightly ironic since the castle was shot with a 75mm normal lens while the lighthouse was shot with a 28mm wide-angle lens. I positioned the lighthouse sky so the actual lighthouse was just invisible. In doing so, I had a touch of the English Channel showing beyond the castle in the far-left edge. I didn't think seeing the English Channel beyond the castle would be a good idea, so I used the Paintbrush tool to paint black in the layer mask to blend the water out and the original castle clouds back in. **Figure 5.32** shows the two steps.

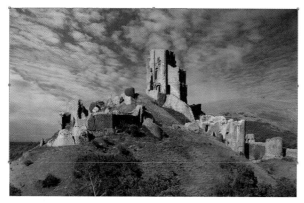

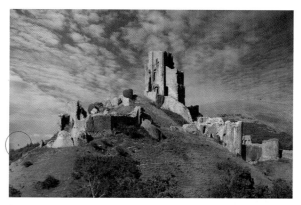

▲ USING FREE TRANSFORM TO RESIZE THE SKY

▲ PAINTING AWAY THE ENGLISH CHANNEL

FIGURE 5.32 Resizing the sky and adjusting the layer mask.

LUMINANCE-BASED MASKS

The composite looked pretty good, but I wanted to adjust the lighthouse sky tone and color. To do so, I needed to create a mask based on the luminance of the sky image. Luminance-based masks are very useful for tone and color correction and are something I use often. To create a luminance-based mask, you can Command+click (Mac) or Ctrl+click (Windows) on the combined RGB channel icon or use the slightly obscure keyboard shortcut of Command+Option+2 (Mac) or Ctrl+Alt+2 (Windows). Once the luminance selection was created, I saved the selection to a channel. I needed to remove the castle area from the channel. While the luminance selection was active, I used the Load Selection command, selected the Sky channel, inverted, and used the Subtract from Selection option as shown in **Figure 5.33**.

The result of the Load Selection command is shown in **Figure 5.34**, as is the original luminance-based channel.

FIGURE 5.33 The Load Selection dialog box and the options selected.

FIGURE 5.34 The luminance–based channel and the Sky Luminosity channel.

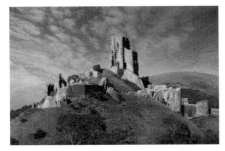

▲ THE LUMINANCE–BASED CHANNEL

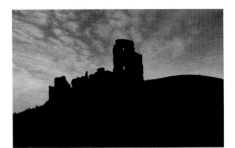

▲ THE SKY LUMINOSITY CHANNEL

FIGURE 5.35 The final Channels and Layers panels showing the adjustment layers.

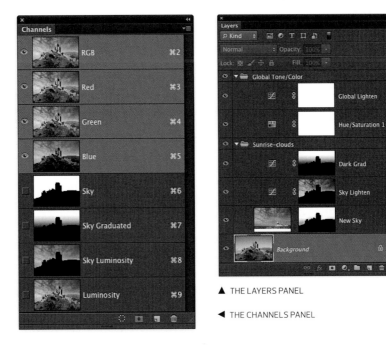

▲ THE LAYERS PANEL

◄ THE CHANNELS PANEL

After loading the Sky Luminosity channel as a selection, I used a Curves adjustment layer to lighten the sky and tweak the color of the clouds to warm them up. I also created an additional channel to use as a gradient-based Curves adjustment layer to darken the top of the whole sky. I added a Hue/Saturation adjustment layer to brighten the green grass and a final Curves adjustment layer to lighten the entire image. **Figure 5.35** shows the final Channels and Layers panel. **Figure 5.36** is the final composited image.

FIGURE 5.36 The final Corfe Castle composite.

COLOR TO BLACK AND WHITE IN PHOTOSHOP

While both Camera Raw and Lightroom have excellent color to black-and-white conversion capabilities, they both share one shortcoming: they're global conversions. All colors are converted to black and white in the same manner. Although that works for many images, you may find some images where a more precise conversion may improve the final results.

Since all digital cameras shoot color images, you have three flavors of black-and-white images built into every digital negative. The trick here is to use the color-channel information as a grayscale layer and use layer masks to modulate how the image's panchromatic response is mapped to the final black-and-white conversion of a color image. It's actually pretty easy—particularly if you record an action that can be applied at the push of a button.

From Lightroom or Camera Raw, open the color image in Photoshop. Once opened, select the Duplicate command in the Photoshop Image menu. This will produce a copy of the original image. With the original image targeted, select the Grayscale command in the Mode flyout submenu of the main Photoshop Image menu. If this

▲ THE COLOR IMAGE COPY

◀ THE COLOR CHANNELS PANEL

▲ THE GRAYSCALE ORIGINAL IMAGE

◀ THE GRAYSCALE CHANNELS PANEL

FIGURE 5.37 Converting the color image to grayscale with a color image copy remaining.

is the first time you've converted color to grayscale, you'll see a warning asking if you want to discard color information. Click Discard. You might want to click the option to not show again if you plan on doing this often.

Once you've taken the original image into grayscale, you'll have the copy of the image remaining in color. I put the color copy on the left and the original that's been converted to grayscale on the right (it doesn't really matter). **Figure 5.37** shows the color copy on the left and the grayscale original on the right.

The default color-to-grayscale conversion in Photoshop is basically at a blend of 30 percent of the Red channel with 60 percent of the Green channel and about 10 percent of the Blue channel. This is, in effect, Photoshop's default panchromatic response and is based on Thomas Knoll's experimentation. The exact percent will vary a bit based on the working color space and gray gamma you've set for grayscale images in your Photoshop Color Settings. I use ProPhoto RGB and set my Gray working space to gamma 1.8 to match the gamma of ProPhoto RGB.

Once you have the original in grayscale and your copy remaining in color, target the Red channel of your color image, Select All (Command+A [Mac] or Ctrl+A [Windows]) and copy the Red channel to the Clipboard. Target the grayscale image and paste. This will paste the Red channel information as a grayscale layer with the Red channel luminance values. **Figure 5.38** shows the steps.

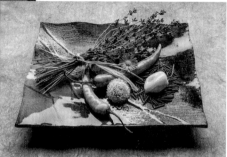

FIGURE 5.38 Copying and pasting the Red channel into the grayscale document and viewing the Red channel as a grayscale layer.

▲ THE COLOR IMAGE CHANNELS PANEL WITH THE RED CHANNEL TARGETED

▲ THE GRAYSCALE IMAGE WITH THE RED CHANNEL VALUES PASTED AS A GRAYSCALE LAYER

▲ THE RESULT OF THE RED CHANNEL PASTED INTO THE GRAYSCALE IMAGE

Continue going through the color image channels and copying and pasting the Green and Blue channel values to new grayscale layers. I tend to work Red, Green, and Blue, but the order doesn't really matter because, in the end, you'll be using layer masks to determine which channel values are blended by which grayscale layers. I make Hide All layer masks for each grayscale layer and work into the layer mask to produce various degrees of opacity to blend the layers into an optimal result.

Figure 5.39 shows the grayscale layer stack with Hide All layer masks for each color-based grayscale layer. The figure also shows the results of modifying each layer's layer mask for the final panchromatic blend.

You might be wondering about keeping the color image open after pasting all the color channels as grayscale layers. Well, let me clue you into a trick: In my experience, Color Range selections don't work too well on grayscale images but do work well on color images. So, I use the color image to make the Color Range selection and then move the selection from the color image to the grayscale image by holding down the Shift key when dragging the selection from the color image to the grayscale image. Since the two images are the same pixel dimensions, the color-based selection can be moved to the grayscale image in exact registration. This allows you to create a color-based selection and use it to paint into the grayscale layer mask. **Figure 5.40** shows the process.

FIGURE 5.39 The result of pasting in each color channel as a grayscale layer with the intial Hide All layer masks and the final painted layer masks.

▲ THE GRAYSCALE LAYERS PANEL WITH EACH LAYER WITH HIDE ALL LAYER MASKS

▲ THE GRAYSCALE LAYERS PANEL WITH EACH LAYER WITH THE FINAL PAINTED LAYER MASK

FIGURE 5.40 Selecting a color using Color Range in the color image and dragging the selection to the grayscale image for painting.

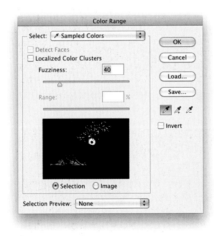

▲ THE COLOR RANGE SELECTION TOOL TARGETING THE BLUE COLORS IN THE FLOWERS

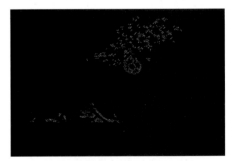

▲ THE ACTIVE COLOR RANGE SELECTION

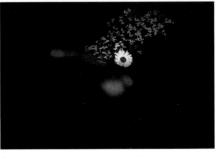

▲ THE RESULT OF SHIFT+DRAGGING THE SELECTION TO THE GRAYSCALE IMAGE'S BLUE LAYER'S LAYER MASK AND PAINTING WITH WHITE TO REVEAL THESE AREAS OF THE BLUE CHANNEL

By using the layer masks on the grayscale layers, I was able to blend different amounts of each of the red, green, and blue layers to arrive at an optimal (to me) color to grayscale conversion. Actually, it doesn't really end there—you can convert the color image to L*a*b mode and copy the Lightness channel to the grayscale to add yet another grayscale option. However, I've never gotten any useful results from doing an RGB-to-CMYK conversion and using the CMYK channels. You're welcome to experiment on your own images, though.

So, was all this effort worth it? You can be the judge: **Figure 5.41** shows the result of stacking up the various color channels as grayscale layers with the layer masks working to blend the final result.

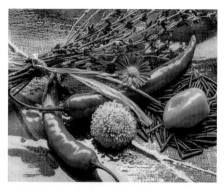

▲ THE BASE COLOR-TO-GRAYSCALE CONVERSION

▲ THE BASE PLUS RED LAYER BLENDED WITH A LAYER MASK

FIGURE 5.41 Comparing the base, red, green, and blue layers blended with layers masks.

▲ THE BASE PLUS RED AND GREEN LAYERS BLENDED WITH LAYER MASKS

▲ THE BASE PLUS RED, GREEN, AND BLUE LAYERS BLENDED WITH LAYER MASKS

PHOTOMERGE FOR PANORAMIC STITCHING

Photoshop's ability to merge multiple images into a stitched panoramic assembly is pretty nifty. While there are third-party applications that specialize in panoramic stitching, I've found Photoshop Photomerge to be very capable for the types of stitches I do. A lot of the success you can get depends on the manner in which the original captures were shot. You can go nuts and get a panoramic tripod head that allows you to pan (and tilt for multi-row stitches) around the "nodal point" of the lens. On the other hand, I've had excellent results stitching handheld shots without the use of even a tripod.

The key to successful stitching is really based more on providing sufficient image overlap that gives the stitching software enough image area to calculate the optimal stitch. When shooting, I try to use the camera in a vertical position so that there's less edge distortion to correct. I also tend to shoot with slightly longer lenses because a wide-angle perspective is more difficult to correct in the stitch. That said, of course, the example I'll be using was shot horizontally, but because it was shot using a 75mm lens on the Phase One 645DF camera with the P65+ camera back, there wasn't a lot of perspective correction required when I processed the images through Photoshop's Photomerge. The three shots are of the Eilean Donan Castle on a small island in Loch Duich near the village of Dornie in the western Highlands of Scotland. **Figure 5.42** shows the three images selected in the Lightroom Library.

The three images were shot using manual exposure settings so the overall exposures didn't vary. Some tone and color correction was used, but the settings were synced across all three images. I selected the Merge to panoramic in Photoshop command

FIGURE 5.42 The three captures of the castle at dusk, selected in Lightroom.

FIGURE 5.43 The Photomerge dialog box.

in the Edit In flyout menu in the main Lightroom Photo menu. (The same command in Bridge is in the Tool menu under the Photoshop flyout menu and simply called Photomerge.) Lightroom hands off the images to Photoshop and the Photomerge dialog box appears, providing various options for how Photomerge will handle the stitching. **Figure 5.43** shows the options I selected in Photomerge.

In my experience, Auto only works sometimes, and when it fails, it fails spectacularly and produces hideous results. I've had very good experience using the Cylindrical layout option, and that's what I used in this example. The other layout options use different projection algorithms that may have uses for some, but I tend to stick with Cylindrical. I also checked the options at the bottom: Blend Images Together, Vignette Removal, and Geometric Distortion Correction. The blend option applies an auto-blend logic to the stitch, while the next options apply lens correction before the blend is processed. **Figure 5.44** shows the resulting blended layer stack with layer masks and the initial stitched result.

The merged results suffer from a bit of distortion I wanted to correct. To do so, I used the Warp command found in the Transform flyout menu in the main Photoshop Edit menu. But before doing the warp correction, I used a little trick I've come up with to be able to treat all three layers with their layer masks as a single layer: I converted the three layers into a single Smart Object. With the three layers selected, I used the

Convert to Smart Object command in the Smart Objects flyout menu in the main Photoshop Layer menu. This embedded all three layers into the Smart Object while preserving the individual layer's editing capability if needed. **Figure 5.45** shows the result of converting the three layers into a single Smart Object layer and the image in the process of being warped to correct for distortions.

The advantage of using the Warp command is that you can restore the corners that Photomerge distorts. You also can correct for slight keystone or other perspective issues. Since the warp is being applied to the Smart Object, the original layers and layer masks remain unwarped inside the Smart Object. Yes, there are some limitations to editing a Smart Object, but there are ways around them. For example in the final image, I needed to fix an area on the far left of the island where the floodlights

FIGURE 5.44 The results of the Photomerge stitch.

▲ THE LAYER STACK OF THE BLENDED AND MASKED LAYERS

▲ THE RESULT OF THE PHOTOMERGE STITCH

▲ THE THREE LAYERS CONVERTED TO A SINGLE SMART OBJECT LAYER

▲ THE SMART OBJECT LAYER BEING WARPED

FIGURE 5.45 Warping the Smart Object layer.

are lighting up some bushes. I simply created a new blank layer and used the Clone Stamp tool set to use Current and Below sampling to eliminate the bright branches of the bushes. **Figure 5.46** shows the cloning step.

The final stitched image was 16,574 × 6905 pixels and would output at 46 × 19 inches at 360 PPI. It's a delicious (and expensive) irony that I got into using a medium-format camera back so I could capture higher-resolution images and yet I still find myself stitching 60MP captures (and now 80MP with the IQ 180 back) into really, really large panoramic images. Too bad my publisher can't let me print this image in the book on an eight-page gatefold! **Figure 5.47** shows the final stitched image.

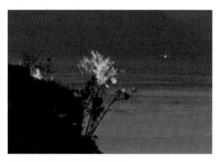

▲ BUSHES LIT BY FLOODLIGHTS

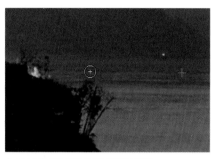

▲ CLONING THE BRIGHT BUSHES AWAY

FIGURE 5.46 Bush removal by cloning.

FIGURE 5.47 The three-shot stitch of Eilean Donan Castle at dusk.

MERGE TO HDR PRO

NOTE This ability to import 32-bit floating-point images is new to Lightroom and Camera Raw; it was introduced in the 4.1 version of Lightroom and the 6.1 version of Camera Raw.

When you find yourself photographing a scene with a contrast range that far exceeds the dynamic range of your sensor, you have to make some decisions: do you try to preserve the highlights or the shadows, or do you shoot multiple captures and merge them to maintain good highlight and shadow detail? In this example, I shot two exposures: one for the interior of the restaurant and one for the outdoor scene. The location is The Mulberry Tree restaurant, about 60 miles southwest of London, England. Instead of taking a bunch of different exposures that are often associated with shooting HDR, I used only the two images to Merge to HDR Pro in Photoshop. Instead of using HDR Pro for the tone mapping, I saved out a 32-bit floating-point image as a TIFF file and imported the file into Lightroom for the final tone mapping. **Figure 5.48** shows the two images selected in Lightroom and the Merge to HDR Pro dialog box. You'll see there are really only two stops of exposure difference between the two captures indicated in the dialog box, but it was enough. It turned my 13.6 EV dynamic range sensor into a 15.6 EV dynamic range sensor.

Camera Raw engineer Eric Chan explained to me when development of the new Process Version 2012 was first being researched that the original algorithms developed were actually designed for tone mapping HDR images, not regular images. So, while the goal was to apply the algorithms to regular-range images, the plan was also to include the ability to process HDR images in Camera Raw and Lightroom. Process Version 2012 was, therefore, already fully capable of dealing with HDR tone-mapping needs. He also indicated that, unlike a lot of HDR software, Lightroom and Camera Raw don't need many separate exposures in order to accomplish an excellent tone

FIGURE 5.48 Merge to HDR Pro.

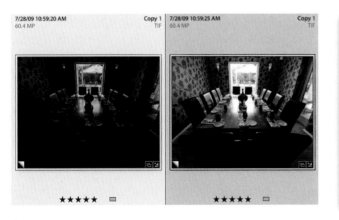

▲ IMAGES SELECTED IN LIGHTROOM

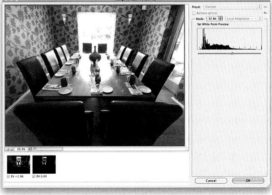

▲ THE MERGE TO HDR PRO DIALOG BOX

mapping. In effect, less is more. So, if your scene's contrast range is only a few stops outside the sensor dynamic range, you need to shoot only two images—maybe three if you aren't sure what the ratio is between scene and sensor ranges. If you do three or more exposures, don't bracket in anything less than one stop and, ideally, two stops to cover the needed contrast range of the scene.

In the Merge to HDR Pro dialog box, the only control you need to worry about is adjusting the Mode to 32 bit. All other options are grayed out. You can move the White Point Preview slider, but it has no effect on the 32-bit image, and the preview is ignored in Camera Raw and Lightroom anyway.

When you save a 32-bit TIFF image from Photoshop, you have some different options than when saving an 8-bit or 16-bit TIFF. **Figure 5.49** shows the 32-bit TIFF Options dialog box.

You have three different Bit Depth options: 16 bit (Half), 24 bit (FP24), and 32 bit (Float). All are usable, but for maximum tone mapping I suggest the full 32-bit floating-point option. The file will be twice the size of the 16 bit (Half) option, but it's a suitable trade-off.

After saving the image, simply import the image into Lightroom or open it in Camera Raw and do your normal tone mapping using the full range of global and local adjustment controls. Upon import, the image preview will look dark. That's

NOTE For use in Lightroom and Camera Raw, the only file format supported is the TIFF file format. So, if you have an HDR file in a different format, such as OpenEXR, Radiance, or even PSD, you'll need to use Photoshop to save them out as TIFF files.

FIGURE 5.49 The 32–bit TIFF Options dialog box.

FIGURE 5.50 The HDR image before and after adjustment in Lightroom.

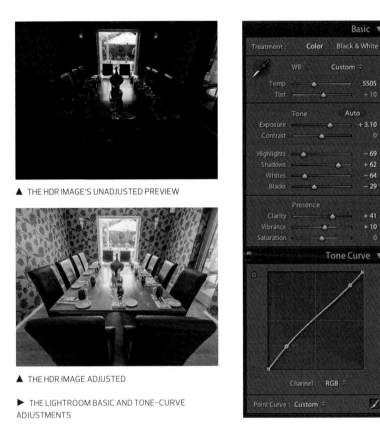

▲ THE HDR IMAGE'S UNADJUSTED PREVIEW

▲ THE HDR IMAGE ADJUSTED

▶ THE LIGHTROOM BASIC AND TONE-CURVE ADJUSTMENTS

okay, because you can easily adjust the overall tone using the Exposure slider, which, when working on HDR images, has an expanded range of +/–10.00 instead of the normal +/–5.00 for non-HDR images. **Figure 5.50** shows the imported preview and the final adjusted image.

The adjusted image doesn't have the typical nasty HDR-type tone mapping because Lightroom (and Camera Raw) controls allow for very natural tone mapping of the HDR image. I could've darkened the outside scene further by using the Adjustment Brush, but I felt that allowing the outside to be brighter looked better.

To run a little test to determine the relative merits of an HDR merge as opposed to just really opening up the tone mapping of the lower exposure, I adjusted the single dark exposure in Lightroom to approximate the look of the HDR result. I viewed the images in the Lightroom Compare mode side by side. At the Fit view, the two images look pretty close, indicating that even with regular 16-bit images, Lightroom tone

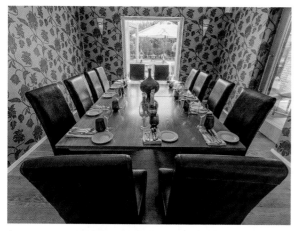

▲ FIT VIEW OF THE ADJUSTED LOW EXPOSURE

▲ FIT VIEW OF THE ADJUSTED HDR

▲ 1:1 VIEW OF THE ADJUSTED LOW EXPOSURE

▲ 1:1 VIEW OF THE ADJUSTED HDR IMAGE

FIGURE 5.51 Comparing the adjusted low exposure and the HDR adjusted image.

mapping is very capable of bringing out a lot of shadow detail while preserving a lot of highlight detail. The true test is to zoom in to 1:1 and compare the two images. In **Figure 5.51**, the adjusted low exposure is on the left, while the HDR image is on the right. Check out the massive differences between the two images when viewed at 1:1. Look at the noise! Clearly popping off a few extra exposures and using Merge to HDR Pro provides superior image quality.

NOTE It's called "Racetrack" because of the sailing stones, a geological phenomenon where the stones somehow move across the surface leaving a track as they move. The moving stones have never been filmed and nobody knows with absolute assurance how they move. The theory is that in the short wet season, the surface mud gets slippery and high-speed winds of up to 90 mph push the stones along, leaving their tracks. All I know for sure is that it's a pretty interesting place to shoot at (and it takes a really long time to drive the 28-mile really rough gravel road to get there).

FOCUS STACKING

As I indicated in Chapter 1, stopping down your lens aperture can come at the price of image sharpness due to lens diffraction. For some situations, focus stacking can eliminate the problem of limited depth of field while maintaining maximum image sharpness. The images I'm using for this example aren't technically "perfect," because I shot them handheld with my Phase One 645DF camera with an 80mm lens. The images were shot at Racetrack Playa, which is a dry lake in the northwestern part of Death Valley National Park.

Figure 5.52 shows the three images I shot at various focal distances. Unfortunately, the Phase One camera doesn't record focus distance in the EXIF metadata, so I can't tell what they were, but as I recall, I focused one frame for the front rock, the next frame just in front of the next two rocks, and the third frame at infinity.

There is no direct command for creating a focus stack. You'll need to use the Open as Layers in Photoshop command in the Edit In flyout menu in the Photo menu in Lightroom or the Load Files into Photoshop Layers command in the Photoshop flyout menu of the Tools menu. Once they're loaded into Photoshop as separate layers, select all the layers and use Auto-Align Layers in the Photoshop Edit menu. **Figure 5.53** shows the layers selected in Photoshop, the Auto-Align Layers dialog box, and the layers after alignment.

One of the problems faced when focus stacking is that, as you change the focus of a lens, the size of the image formed on the sensor also changes. The Auto-Align Layers tool resizes and, in this case, had to rotate the images on the layers to align them because I shot them handheld and didn't have stable framing. For this reason, it's important to frame the crop of the image loose enough that you don't lose critical image content after the alignment.

FIGURE 5.52 The three images selected in Lightroom for focus stacking.

Once the layers are aligned, the next step is to use the Auto-Blend Layers tool in the Edit menu in Photoshop to get a blend of the focus-stacked layers. It's the same basic logic behind Photomerge where the algorithm creates layer masks of different portions of the layers to produce an optimal (sometimes) blend. **Figure 5.54** shows the Auto-Align Layers dialog box and the resulting blended layers.

If you were making a Photomerge, you would select the Panorama Blend Method. Since I'm creating a focus stack, I chose the Stack Images option. In my experience, getting a completely perfect focus stack properly blended isn't likely. I've used third-party tools that have some substantial benefits over the Photoshop method. One excellent application is Helicon Focus (www.heliconsoft.com), but hey, this book is about Lightroom, Camera Raw, *and* Photoshop, so I'll simply show you how to fix the

FIGURE 5.53 Aligning the layers loaded in Photoshop.

▲ IMAGES LOADED AS LAYERS IN PHOTOSHOP

▲ THE AUTO–ALIGN LAYERS DIALOG BOX

▲ LAYERS AFTER THE AUTO–ALIGN IS PROCESSED

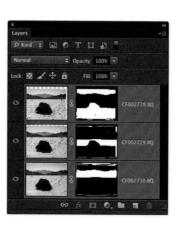

FIGURE 5.54 Using the Auto–Align Layers tool.

▲ THE AUTO–ALIGN LAYERS DIALOG BOX

◀ THE RESULTING BLENDED LAYERS

FIGURE 5.55 The Photoshop focus stack result.

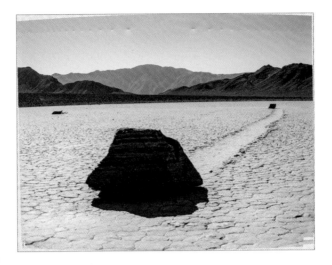

Photoshop results. **Figure 5.55** shows the Photoshop result: decent but with some real obvious issues in the sky—which I don't understand because blending the sky should be easy, but it's the way the algorithm works (or doesn't).

To fix the sky, I needed to work on the image layer as well as the layer masks from the Auto-Blend. Since the blend manipulates not only the masks but also the pixels to achieve the final blend, parts of the image layers get kind of hosed as well. To accomplish the fix, I chose to work on the image with the largest sky, which was the layer where the image was focused at infinity. I disabled the layer mask so I could see all the image pixels (Shift+click on the layer mask disables) and selected an area in the sky where Auto-Blend Layers left some pixel doodoo. I used the Content-Aware Fill command from the Edit menu and let Photoshop fix itself (seems only fitting since it was Photoshop that screwed up). The result was a clean blue sky. **Figure 5.56** shows the selected area and the result of the Content-Aware Fill.

I won't kid you that what came next wasn't a pain in the you know what. Trying to adjust the layer mask results from either a Photomerge or an Auto-Align Layers blend is tedious. You need to figure out which layer is being revealed where, and then fill or paint black and/or white in the layer masks to control the revealed layers manually. In this case, it was relatively simple since all I really needed to do was fix the top of the sky. The final result is shown in **Figure 5.57**. I did do a bit of work on the image back in Lightroom. I added a touch of Clarity, added some Vibrance, and added a Graduated Filter to darken down the top of the sky. That's not cheating, is it? Doing work in Lightroom, Photoshop, and then more work back in Lightroom... whatever it takes to get the image the way I want it is what I'm prepared to do—I'm guessing you are, too, or you wouldn't be reading this book, right?

FIGURE 5.56 Before and after the Content–Aware Fill.

▲ SKY TOP SELECTED

▲ SKY TOP AFTER CONTENT–AWARE FILL

FIGURE 5.57 The final focus stacked and adjusted image

Two kids along a street in San Miguel de Allende, Mexico. The image was captured with a Panasonic DMC–GH2 camera with a 14–140mm lens. The image was flopped to accommodate the gutter, and, yes, I reflopped the signs to be correct.

■ CHAPTER 6

CREATING AN EFFICIENT WORKFLOW

There are likely as many potential workflows are there are types of photographers. One of the wonderful things about using Bridge, Camera Raw, and Photoshop, or using Lightroom plus Photoshop, is the incredible workflow flexibility offered. The price that comes with this flexibility is complexity. There are multiple methods to accomplish almost any task, and it may not be obvious at first glance which method will be optimal in a given situation.

In this chapter, I'll show the different ways of accomplishing the basic workflow tasks and explain the implications of each. That's the tactical level. But to create a workflow, you also need a strategy that tells you how and when to employ those tactics. For example, you may need more than one workflow due to differences in the demands of working in the field versus in the studio.

WORKFLOW PRINCIPLES

There's a big difference between the workflow you need to follow when you're shooting with the client breathing down your neck and the workflow you'd like to follow when you're shooting personal work with no deadlines attached. These two scenarios represent extremes, and there are many points between them on the continuum. I can't build your workflow for you because I don't know your specific needs or your preferences. What I can do is introduce you to the components that address the different workflow tasks, and offer three key principles of workflow efficiency that can guide you.

DO THINGS ONCE

When you apply metadata—such as copyright, rights management, and keywords—to your digital negative, the metadata is automatically carried through to all the TIFFs, JPEGs, or PSDs that you derive from that raw file. So, you need to enter that metadata only once.

Similarly, if you exploit the power of Lightroom or Camera Raw to their fullest, many of your images may need little or no production work in Photoshop. Applying Camera Raw or Lightroom edits to your images is something that often needs to be done only once.

A key strategy that helps you do things once and only once is to start with the general and proceed to the specific. Start with the things that can be done to the greatest number of images, and proceed to make increasingly more detailed adjustments to ever-decreasing numbers of images, reserving the full treatment of careful hand-editing in Camera Raw or Lightroom and rendering to Photoshop for those images that truly deserve the attention.

DO THINGS AUTOMATICALLY

Automation is a vital survival tool for simply dealing with the volume of data a raw workflow entails. One of the great things about computers is that once you've told them how to do something, they can do that thing over and over again. Photoshop actions are obvious automation features, but metadata templates and Camera Raw or Lightroom presets are automations, too.

BE METHODICAL

Once you've found a system that works for you, stick to it. Emergencies will happen and sometimes circumstances will force you to deviate from your established routines, but those should be the exceptions rather than the rule. Being methodical and sticking to your system makes errors less likely and allows you to focus on the important image decisions that only you can make. For better or worse, computers always do exactly what you tell them to, even if that's not exactly what you wanted. Established systems help ensure that you're telling the computer to do what you really want it to do and *only* what you want it to do.

THE FIVE WORKFLOW STAGES

In this section, I'll show you all five stages of a raw-processing workflow, but the major emphasis is on the preproduction stage—the work you do in Lightroom or Bridge—because about 80 percent of the actual work happens in this stage, even if it only takes about 20 percent of the total imaging time. But all five stages are, of course, vital. **Figure 6.1** shows the five workflow stages when using Bridge, Camera Raw, and Photoshop. **Figure 6.2** shows the five workflow stages when using Lightroom and Photoshop.

STAGE 1: IMAGE INGESTION

Transferring your images from the camera to the computer is one of the most critical stages of the workflow, yet it's often one of the least examined and thought-out stages as well. It's supercritical because, at this stage, your images exist only on the camera media.

The following ground rules have worked for me since I started shooting digitally. I've had my share of equipment problems, but thus far, I've yet to lose a single critical image (although I've lost some images that aren't important):

- **Don't use the camera as a card reader.** Most cameras will let you connect them to the computer and download your images, but doing so is a bad idea for at least two reasons: Cameras are typically very slow as card readers, and when a camera is being used as a card reader, you can't shoot with it.

NOTE It's not that Compact Flash (CF), Secure Digital (SD), or micro-drives are dramatically more fragile than other types of storage media—it's just that, at this point, there's only one copy. If you make mistakes during ingestion, you can lose images.

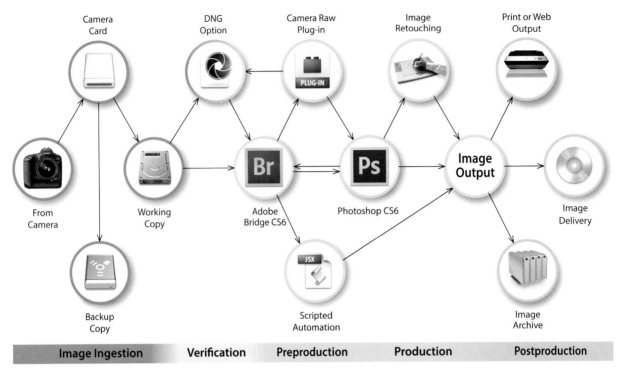

FIGURE 6.1 The Bridge, Camera Raw, and Photoshop five workflow stages.

- **Never open images directly from the camera media.** The media has been formatted with the expectation that the only thing that will write to it is the camera. If something else writes to it, maybe nothing will happen, but then again, maybe something bad will.
- **Don't rely on just one copy of the images.** Always copy them to two separate drives before you start working.
- **Don't reformat the card or erase your images from the camera media until you've verified the copies.**
- **Always format the cards in the camera in which they'll be shot, not in the computer.**

Following these rules may take a little additional time upfront, but not nearly as long as a reshoot (assuming that lost images can even be reshot).

| Image Ingestion | Verification | Preproduction | Production | Postproduction |

FIGURE 6.2 The Lightroom and Photoshop five workflow stages.

TIP One advantage of using Lightroom for ingestion is that you can create Import presets to make sure you know exactly where your digital negatives are going and how they're being handled. Using Photo Downloader from Bridge requires that you set the card download correctly each time you use it and offers no saved presets. This is one of the main reasons I greatly prefer using Lightroom for image ingestion.

STAGE 2: IMAGE VERIFICATION

If you're tempted to skip this second stage, you may not find out that you've lost images until it's too late to do anything about it. Whenever possible (with the full understanding that it isn't *always* possible), don't work on an image until you know that you have two good transferred copies—not counting the camera media. It may sound paranoid, but remember Murphy's Law! If you allow Bridge or Lightroom

TIP If you wind up with a card that's unreadable but contains data you want to recover (it's rare, but it can be caused by doing things like pulling the card out of the reader without first ejecting it in software), do not format it! Doing so will guarantee that any data that was still on the card will be permanently consigned to the bitbucket. Major CF card vendors such as SanDisk and Lexar include data–recovery software with the cards. Before attempting anything else, try the recovery software. If that fails, and if the data is truly irreplaceable, several companies offer data recovery from CF cards, usually at a fairly hefty price; a Google search for "Compact Flash data recovery" will turn up all the major players.

to verify the images before you reformat the camera media, you'll at least have a chance of recovering your images if something goes haywire in the ingestion stage. If you shoot new images over the old ones and the copies are bad, those images are likely gone forever.

If Camera Raw or Lightroom has any problem reading the images, the problems will show up only on the rendered previews from the digital negative. The initial thumbnails are the camera-generated ones, and they don't indicate if the raw file has been read successfully. The high-quality thumbnails do indicate that the raw file has been read successfully, so wait until you see them before you reformat the card. For this reason, when using raw files, always set your Bridge Preferences to generate high-quality thumbnails or set Lightroom to generate Standard or 1:1 Previews. It takes a bit longer, but you get the benefit of image verification for the time invested.

Figure 6.3 shows one of the few corrupted images I've experienced. I'm pretty sure popping out the card while the camera was still writing the file caused the corruption.

If you see a problem at this stage, check the second copy (if you made one) or go back to the camera media. (You haven't reformatted it yet, right?) It's fairly rare for the data to become corrupted in the camera (though it does sometimes happen, particularly in burst-mode shooting or if you remove the card before the buffer has been written), so the first suspect should be the card reader. If you have only one reader available, try copying the problem images one by one. If you have a second reader available, try copying the files using the second reader. If this copy also fails, try running the rescue software provided by the card vendor. If none of these suggestions works, your options are to reshoot, accept the loss and move on, or resort to an expensive data-recovery service.

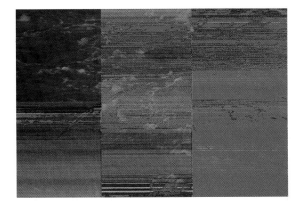

FIGURE 6.3 My favorite corrupted digital negative.

STAGE 3: PREPRODUCTION

The preproduction phase is where most of the work takes place, though it's not where you spend the most time. Preproduction generally means doing the minimum number of things to the maximum number of images so that you get to the point where you can pick the hero images that are truly deserving of your time, while leaving the rejects handy for revisiting.

Rough editing and selecting images

In Lightroom, I use the Quick Develop panel to quickly do a rough edit so that selection editing is easier. Quick Develop can apply relative adjustments (as opposed to the absolute adjustments found in the Develop module and in Lightroom presets). The relative adjustments are important in that they allow you to make quick tone and color adjustments that are added relatively to whatever adjustments already may exist in the image. You also can make quick white balance adjustments either by using a preset or by clicking on the adjustment button. You can rough edit by using Lightroom presets, which can improve your rough-edit efficiency.

TIP If I'm using Bridge and Camera Raw, I'll either apply Camera Raw presets or open a bunch of images into Camera Raw using the filmstrip mode to quickly apply initial image adjustments.

Rating and labeling

Physically selecting thumbnails is certainly one way to distinguish keepers from rejects, but it's tedious. A better method is to use ratings or labels. Ratings and labels become part of the image's metadata that you can use to search and filter. I prefer using ratings to labels, but the choice is entirely yours. I often use the Survey and Compare mode of Lightroom to see larger versions of images. You can do something similar in Bridge by selecting multiple images for viewing in the Preview panel.

There are two basic approaches to selection editing and ratings. In one, you use a simple yes/no approach; in the other, you use an escalating scale to imply greater importance to some images, the heroes:

- **One-star rating for binary sorts:** If you want a flagging mechanism for a binary, yes/no sorting and selecting, Bridge and Lightroom both allow ratings using keystrokes. In Lightroom, the number 1 key adds a star rating. In Bridge, Command+1 (Mac) or Ctrl+1 (Windows) adds a single-star rating.

- **Multi-star ratings:** The techniques for applying multi-star ratings are the same as those for applying a single star. In Lightroom, the number keys between 1 and 5 apply ratings, so simply pressing the 1 key will give you a one-star rating. In Bridge, you use Command+1–5 (Mac) or Ctrl+1–5 (Windows) to apply ratings. In

NOTE Both Lightroom and Bridge can assign flags to images. I don't use them for the simple reason that flags aren't stored as XMP metadata in the images. I also seriously detest the flag as a reject function in Bridge. I think it's dangerous to use the delete key for anything other than an immediate deletion. But, hey, that's just me. You're welcome to use flags if you wish.

TIP If you're collaborating with others in determining the hero shots, the first approach is probably more suitable. The second approach lends itself better to situations where you're the only person making the call.

Lightroom, pressing 0 removes any star ratings; in Bridge, you use Command+0 (Mac) or Ctrl+0 (Windows). Command+. (period) (Mac) or Ctrl+. adds a star to the current rating, and Command+, (comma) (Mac) or Ctrl+, (Windows) reduces it by one star.

There are basically two ways to approach rating your images. Use whichever one works for you:

- **Make an initial one-star pass.** After making that pass, go through the one-star images and apply an additional star to those images that deserve it. Then go through the two-star images and apply a third star to those deserving higher ratings. Many photographers find that four levels (unrated, one, two, or three stars) are enough, but you can go all the way to five if you see the need.

- **Apply all your multi-star ratings in a single pass.** If you take the time and can make the comparisons while selecting, you can choose to use a multi-star approach in a single-selection pass. This can take some practice. Using the Lightroom Compare module to make a selection and compare other images to assess their relative "goodness" can help. If you have a relatively small number of images to select, this approach can be useful.

Consider just how important the selection editing process is. Once you've made these decisions, the rest of the work will generally be done only to the selects. Keep in mind that, right after shooting an image, you might have an emotional attachment to what you thought you were trying to accomplish. Your first reaction to your images may be clouded by what you think to be successes or failures in technique and not the image in its own right. That's why I suggest multi-pass selection editing and revisiting your images after a period of time to confirm your choices or find other hidden gems you missed in the heat of the moment.

TIP The main reason I don't often use labels is that they introduce extraneous color in Bridge and Lightroom. (Hey, what can I say—I'm a visual sort.) The Label mechanism is also less well suited to rating images than the star–based rating system. It's intuitively obvious that a five–star rating is better than a one–star rating, but there's no clear hierarchy between, say, yellow and green. In Lightroom, you can apply any of the first four labels using 6 through 9; in Bridge, use Command+6–9 (Mac) or Ctrl+6–9 (Windows). But there's no concept of promoting or demoting images from one label to another. There is no keystroke for purple; you have to select it from a menu.

Sorting and renaming

By default, Bridge sorts images by filename, so new digital captures will appear in the order in which they were shot because the camera applies consecutive numbering to each image. You can vary the sort order by choosing any of the options on Bridge's Sort drop-down menu or the Sort submenu item under View > Sort. You also can create a custom sort order by dragging the thumbnails, just as you would with chromes on a light table.

In Lightroom, the default sort order is the order in which the images were added. You can change the sort order in the toolbar with one caveat: User Order is available only when you're viewing a single image folder or a collection in the Library. If you're looking at an enclosing folder containing subfolders, you can't change the order.

I like to use well-organized and well-named folders instead of renaming images on ingestion. But if you want to rename your images upon ingestion or later in Bridge or Lightroom, you should come up with a scheme that you can stick with and use it religiously. For example, my good friend and colleague Seth Resnick has put more sheer ingenuity into building his workflow than anyone else I know (he even teaches about workflow through www.d-65.com). Seth uses a sophisticated naming scheme that, to the initiated, at least, conveys a great deal of information at a glance. For example, he might rename a raw file called 4F3S0266.dng to 20120423STKSR3_0001. dng. This decodes as follows: 20120423 defines the date on which the image was shot (April 23, 2012), so the files are automatically sorted by date order. STK indicates that the image was shot for stock, and SR indicates that it was shot by Seth Resnick. The number 3 indicates that it belonged to the third assignment or collection of images of the day, while the 0001 indicates that it was the first image in the collection. Seth's approach works for him because it's informative and easy to replicate—he sets up import presets to do the renaming on import into Lightroom. The key is to find an approach that works for you.

Applying keywords and IPTC metadata

The key to being efficient with keywords and metadata is the same as that for being efficient with applying raw image edits. Look for and select images that need the same treatment, and deal with them all at once. The only metadata that is editable in Bridge or Lightroom (or in Photoshop, for that matter) is the IPTC metadata. For recurring metadata, such as copyright notices, metadata templates provide a convenient way to make the edits. The best time to apply the presets is when first ingesting the images.

FIGURE 6.4 The metadata, keywords, and caption of the seal that attacked me.

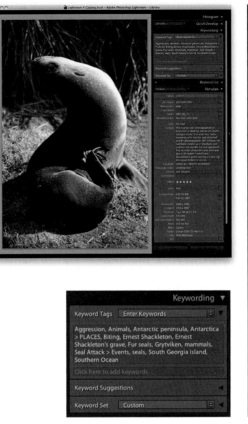

▲ THE KEYWORDING PANEL ▲ THE DEFAULT METADATA PANEL

NOTE The seal in this image was the seal that attacked me in Antarctica. It put a nice hole in both my knee and waterproof pants. According to the expedition leader, I was the first victim of a fur seal attack he's ever experienced—lucky me! Our ship's doctor gave me a huge shot of antibiotics, which actually hurt worse than the seal bite. The worst part about the seal attack was that his teeth put some nice big holes in my pants right at the knee, which then made kneeling a wet proposition.

NOTE In Lightroom, the field is called Caption, while in Bridge the same metadata field is Description. A bit confusing, don't you think?

Alternatively, you can select multiple images and then edit the metadata directly in the Metadata panel in Bridge or Lightroom. Click in the first field you want to edit, type your entry, and press Tab to advance to the next field. Continue until you've entered all the metadata shared by the selected images, and then press Enter or Return, to confirm the entries.

Figure 6.4 shows an image with IPTC, keywords, and captions.

Sometimes called tagging or metalogging, *keywording* is the practice of adding descriptive words that relate to your image for the purpose of cataloging or organizing photographs. This can be as complicated as following an exact *taxonomy* (classification), or it can be as simple as describing the who, what, where, when, why,

and sometimes how of the image. The IPTC Keywords panel of Lightroom or Bridge lets you enter as few or as many keywords as you want. Be sure to separate multiple keywords with a comma. Keywords are case sensitive, so you should capitalize only those words that generally need to be capitalized, like proper nouns. Keywords can consist of single or multiple words or even a short phrase, but resist the temptation to add extraneous words that don't relate directly to the image. Be sure to list word variations and alternative spellings, such as *gray* and *grey*. Use gerunds (verbs that function as nouns) and participles rather than verbs—for example, use *eating* rather than *eat* or *traveling* rather than *travel*. In general, use the plural rather than the singular form of a word, unless the plural spelling is different than merely adding an *s*—for example, use *baby* and *babies* but only *cats* not *cat*.

Some keywords can be conceptual attributes, but use these selectively. When keywords such as *beautiful* or *tranquil* are used to describe a landscape, they soon lose any special meaning. Also, be careful of anthropomorphizing animals—not everybody will get it and you might confuse someone. Above all, be consistent in your approach and keep a dictionary handy if you're a poor speller. There's nothing quite so embarrassing as misspelling a keyword for the world to see. Using a controlled vocabulary is critical; for more information, see the website run by photographer David Riecks (www.controlledvocabulary.com).

Captioning is the process of telling the story surrounding the photograph. Writing a good caption is a natural starting point for the addition of keywords (which will often present themselves while you're composing the caption). Here are some rules of thumb: Use proper grammar and punctuation. Use proper sentence structure. Capitalize the first word in a sentence and proper nouns. Avoid clichés like the plague. And, of course, keep a dictionary handy. If you know exact locations or scientific names of your subjects, use them, but don't guess. Base your descriptions on solid fact, not speculation. Avoid writing a novel; the IPTC Description field isn't large enough and it's not intended for creative writing.

STAGE 4: PRODUCTION

The production phase is when you polish the select images deserving the bulk of your time and attention, hand-tuning the Camera Raw or Lightroom settings and then bringing the images into Photoshop for the kinds of selective corrections that Camera Raw and Lightroom simply aren't designed to do. For additional information about the production stage, refer to Chapters 4 and 5.

TIP Adding keywords and captions is work. If you're doing it only for yourself, keep everything simple and add only as much as you feel necessary. But if you're engaged in licensing stock photography, using excellent keywords and descriptions can mean money in the bank.

STAGE 5: POSTPRODUCTION

Once you're done with the immediate processing and consumption (printing, delivery to clients, and so forth), you might think your job is done. Nope—far from it! You still need to deal with all your original and processed files. The better organized you are at this stage, the greater the likelihood that you'll be able to find your images when you need them in the future (and you probably will need them in the future).

Archiving images

You may have heard of photographers who don't bother to archive their digital negatives once they've processed them. That seems about as stupid as throwing out all your negatives because you've made prints that you like! Given the huge amount of processing that goes into converting a digital raw capture and the fact that the techniques for doing conversions are only likely to get better, it seems extraordinarily shortsighted at best not to archive your raw captures.

The issues then become when, in what form, and on what media you archive them:

- **When to archive:** When you first copy the raw images to the computer, you should almost always copy them to two different drives. One copy becomes your working copy; the other serves immediately as a short-term backup. Once you're done with selecting, sorting, ranking, and renaming, and you've applied initial Camera Raw edits and saved the files in DNG format to bind the metadata, you archive these, too. Yes, it makes for a heavy storage requirement, but storage space is relatively inexpensive, while time is expensive and images are irreplaceable.

- **What to archive:** Archive anything that you or someone else may need to retrieve at some time in the future. It's really that simple. Don't confuse archives and backups. Backups are usually short-term insurance. Archives are long-term storage, designed to remain undisturbed unless and until the data is required. Archiving isn't a substitute for backing up, and backing up isn't a substitute for archiving!

- **What to archive on:** Strictly speaking, there's no such thing as a permanent archival medium for digital storage—any of the even slightly convenient solutions available for recording ones and zeroes will degrade over time. Archives must be maintained and migrated to new media when needed. There are two main problems in archival storage: The obvious problem is the integrity of the storage medium. The less obvious but equally critical problem is the availability of devices that can read the storage medium. There are probably magnetic tapes from 1970s mainframes that have good data on them, but good luck finding a drive that can read those tapes.

Any archiving strategy must include periodic migration of the data onto new media, preferably taking advantage of improvements in technology. I used to use tape storage (and I still have a large collection of DAT and AIT drives to *try* accessing the tapes), but I've switched to online hard-drive storage with duplicated arrays for digital captures. Unless something better comes along, you'll probably need to constantly refresh that data onto the even larger, faster, and cheaper hard drives that will be available in the future with capacities measured in petabytes (1,024 TB) rather than gigabytes or terabytes.

A word of caution about Network Attached Storage (NAS): While often set up with a robust RAID 5 redundant array, NAS drives are actually miniservers often running an embedded Windows OS. Not all offer Apple File Protocol (AFP) for Macs, and you'll need a well-set-up and well-maintained gigabit network to use them reliably. That said, they often offer the best gigabyte-per-buck quotient with reliable and reasonably fast I/O.

Burnable CDs and DVDs, both read-only and rewritable, differ from commercially pressed CDs and DVDs in an important way: In the commercially manufactured disks, the data is stamped on a foil layer made of metal. (It's about the same thickness as the foil in a cigarette pack, but it's metal nonetheless.) Burnable CDs and DVDs use a photosensitive dye layer to record the data—the dye changes color when the laser writes to it. Photographers should be well aware of the fragility of dyes.

So, use whatever storage medium you find convenient, but recognize that it will eventually fail, and plan accordingly.

I wish I could give you a magic-bullet solution to long-term archiving of digital captures, but there's simply no good solution right now. For archiving, I recommend keeping multiple copies of important work on multiple drives in, ideally, multiple locations. Whether you use local internal or external hard drives, RAID 5 NAS, or dedicated servers, the rule is the same: have a lot of copies in case something dies. It's not a question of *if* it'll die, but *when*.

Delivering images

How and in what media you deliver, print, or post images to websites is beyond the scope of this book, other than to explain its role in your overall workflow. I would like to make one strong suggestion after years of working with commercial clients: even if time dictates that you FTP or otherwise transmit your images electronically, you would do well to make the delivery of CD or DVD copies of your prepared images as the final contractual deliverable for jobs.

> **NOTE** One word of caution for those buying terabyte drives: make sure you understand the implications. Many less expensive drives measured in terabytes are actually two or more drives in a striped RAID configuration that show up as single large volumes. If one of those drives fails, the entire volume is toast.

Why? Well, once you burn a CD or DVD, it's read-only media, so if somebody else screws up your image downstream of delivery, you can always point to those unchangeable files on the CD or DVD as proof of the condition of the image when delivered.

It's also becoming far more commonplace for photographers to be asked for copies of the original "raw files" for purposes of verification and provenance of the digital imaging applied to your delivered images. For this purpose, DNG is starting to become an important file format for final delivery in any photographic field that needs proof of what you've done to your images, such as journalism or science. With the advent of far more advanced tools in the raw processing arsenal, it's now possible to deliver tone-adjusted, color-corrected, cropped, and even spot-healed images that anybody with Camera Raw or Lightroom can look at to verify what's been done. All the image settings and other embedded metadata make this a lot safer to do because it's all contained in one package. While still somewhat limited in retouching, many users of Camera Raw or Lightroom need far less of Photoshop than they used to. DNG allows you to put your "stamp" on the image in terms of looks, rendering, and even the literal stamp of your name and contact information.

MY PERSONAL WORKFLOWS

I actually have two separate and different workflows that I follow depending on how or where I'm shooting: I use Lightroom at the front end and back end, and I usually use Photoshop in the middle for hero images. Even though I may use Bridge and Camera Raw on a regular basis, all my digital negatives live in my Lightroom catalog on my main workstation.

FIELD WORKFLOW

When I'm on a photographic trip, I use Lightroom to ingest my images. Before the trip, I create a new blank catalog on one of two external hard drives used to store two copies of the images I shoot. Why a new catalog? Although I have a downsized copy of my main Lightroom catalog on my laptop, I really don't want to mix the old images with new ones and it's simpler to start with a fresh catalog.

I set up a preset for importing that creates standard-size previews, applies a basic IPTC metadata template, and adds initial keywords for the area I'll be shooting. I also make sure to have the import process copy a second set of my images as backup to the second hard drive.

Although I never make any color-critical adjustments when working on the laptop, I do apply some basic tone and color adjustments. Often, I'll use virtual copies as a way to play around with color and black-and-white versions of the image. I often create stacks of images that are similar or in a series. Usually, I also start making some Lightroom collections of various image selections or groups of images for panoramic or HDR assembly later.

While working in the field, any adjustments you make can be saved out as XMP metadata. I think this is a good practice, but I want a field catalog I can later import back into my main catalog at the studio because things like virtual copies, image stacks, and collections aren't stored in metadata, only in the catalog itself.

When I return to the studio, I open my main Lightroom catalog and use the command Import from Another Catalog in the main Lightroom File menu. Importing from a catalog takes advantage of any previews I've already generated and preserves virtual copies, image stacks, and collections. I also have the catalog import move the images from the external drive to my main image storage array.

Importing to Lightroom

The following workflow was what I used for a recent trip to San Miguel de Allende. I created a new blank Lightroom catalog on a 1 TB external FireWire 800 hard drive. I also used a second 1 TB external FireWire 800 as the Lightroom Import backup drive. **Figure 6.5** shows the initial Lightroom Import module from the first SD card with the various panel settings.

The Source panel is showing the No Name SD card (that's what a Panasonic LUMIX camera names an SD when formatted in the camera). The main panel is showing All Photos with all the images checked for import. The Import function is defaulted to Copy since the import is coming from a camera card not a hard drive. Lightroom helpfully refuses to import from a camera card using a Move or Add function, which would be a really bad thing to do.

In the File Handling panel, I have the Don't Import Suspected Duplicates option checked. Although I try very hard to remember to reformat the card in the camera after a verified successful import, I've occasionally forgotten. This function is useful to prevent adding multiple copies of the same image to the catalog.

In the Apply During Import panel, I've set the Develop Settings to None because, at this point, I don't have the need for a preset. I'm embedding my 2012 basic metadata preset that contains the general IPTC metadata shown in **Figure 6.6**. In the Keywords section of the Apply During Import panel, I've got a simple set of two keywords: San Miguel de Allende, Mexico. Since I would be spending the week shooting

◄ IMPORT FUNCTION

▼ FILE HANDLING PANEL

▲ SOURCE PANEL

▲ APPLY DURING IMPORT PANEL

▲ IMPORT PRESET MENU

▲ DESTINATION PANEL

FIGURE 6.6 My 2012 basic IPTC metadata preset.

▲ THE LIBRARY SHOWING THE IMAGES

FIGURE 6.7 The results of a week's shooting in the Lightroom catalog.

▲ THE FOLDERS AND COLLECTIONS PANEL DETAIL

in and around San Miguel de Allende (SMA), I knew it would be safe to embed this level of keyword granularity. Over the course of the week, I added additional keyword refinements, as well as geotagging the entire shoot.

In the Destination panel, I've instructed Lightroom to copy the images into a subfolder of the TB-FW-03 hard drive organized by date with a year, month, and day order. Each day's imports will end up in a subfolder organized by day.

In the Import preset menu, I've saved a preset named SMA-2012 so when I import each camera card, I can maintain all the import settings. The last step is to click the Import button and have Lightroom do its thing. **Figure 6.7** shows the result of the week's shooting in San Miguel de Allende.

Selection editing in the field

Although I don't do any final color-critical image edits with my laptop, I do make some changes and experiment to allow me to see what the shoot results look like and how I might adapt different approaches. Over the course of the week, I really only had a few days of shooting, with just one day of really heavy shooting on the fourth. One series I did want to edit were some shots of two little kids hanging out in a doorway. Since it was a series, I stacked all eight captures and a single virtual copy into a single stack. **Figure 6.8** shows the stack collapsed and expanded.

FIGURE 6.8 Using Stacks to help organize an image series.

▲ THUMBNAIL VIEW WITH THE STACK COLLAPSED

▲ THUMBNAIL VIEW WITH THE STACK EXPANDED

The image I gave five stars has been shifted out of the shooting order to the first place in the image stack. The easy way to do this is to drag the image within the stack or use the context menu and the Move to the Top of the Stack command.

I liked several images, so I used the Survey module to isolate the main eight captures. When the kids saw me shooting them, they hammed it up a bit. Those images are cute, but I didn't really want them looking into the camera. I kept shooting as I walked away. **Figure 6.9** shows the eight images in the Survey mode in the Lightroom Library.

Viewing the images in Survey mode allowed me to see the images larger than the Library thumbnails, but to get to the final decision on the images in the series, I used the Compare mode. I put the image I thought was the best in the Select position—that way I could cycle through the other images in the stack in the Candidate position. This makes it really efficient to do a head-to-head comparison of all the other

FIGURE 6.9 Viewing the images in the Survey mode of the Library.

FIGURE 6.10 Viewing the images in the Compare mode of the Library.

images in a stack to the image you think was the hero selection. **Figure 6.10** shows the Compare mode.

Using virtual copies

One of the really useful aspects of image organization in Lightroom is the ability to use virtual copies for the purpose of spawning off multiple versions of the same image. I use virtual copies a lot when making black-and-white versions of images or when I need to have multiple crops of the same image for different purposes. Yes, some of this can be handled using snapshots in the Develop module, but the only way to switch to different snapshots is by going back into the Develop module to switch the active snapshot, which isn't very efficient.

A virtual copy is simply a duplicate database record of the image, which can contain different Develop settings and even different keywords. Virtual copies only live

FIGURE 6.11 The original color version and the black–and–white virtual copy.

in the Lightroom catalog and can't be stored in the XMP metadata, as can be done with snapshots. This is a big reason why I use a separate catalog in the field and end up importing that field catalog to my main Lightroom catalog upon returning to the studio. **Figure 6.11** shows the hero kid image in color and a virtual copy of the image converted to black and white and given a warm tone.

Using Collections

A Lightroom Collection is a grouping of images that can span across multiple folders or even hard drives. They're a convenience for the purpose of organizing images. Manual Collections allow easy sorting, and an image in a Collection can be reordered as desired—even if the images aren't in the same folder (a limitation in the Lightroom Library when viewing images within subfolders).

While shooting in San Miguel de Allende, I kept finding images that I really liked *after* converting to black and white and adding a warm tone. I started by making virtual copies of the images I liked and placed them into a Collection I named Warm Toned. This is another important aspect of using a Lightroom catalog in the field and then importing that catalog back into the main catalog: Collections are preserved when they're imported from a catalog. **Figure 6.12** shows a series of warm-toned images in a Collection.

Importing the field catalog into the home catalog

After returning from San Miguel de Allende, I mounted the TB-FW-03 FireWire hard drive on my main imaging computer. With my main Lightroom catalog open, I selected the option to Import from Another Catalog in the Lightroom File menu. This brings up the Import from Lightroom Catalog dialog box where you select the catalog to import, as shown in **Figure 6.13**. I selected the SMA-2012.lrcat catalog file that opened the Import from Catalog dialog box, shown in **Figure 6.14**.

FIGURE 6.12 The Warm-Toned Collection from San Miguel de Allende.

FIGURE 6.13 The Import from Lightroom Catalog dialog box with the SMA-2012.lrcat file selected.

In the Import from Catalog dialog box, I selected the option to Copy new photos to a new location and import. This instructed Lightroom to copy all the images to my main hard drive and place them in the correct folder. Import from a catalog preserves virtual copies, image stacks, and Collections that are made in the field catalog and adds them into the main catalog. **Figure 6.15** shows the SMA-2012 catalog imported to the main Lightroom 4 catalog on my main computer.

FIGURE 6.14 The Import from Catalog dialog box showing the SMA–2012 images selected for importing.

FIGURE 6.15 The result of importing the SMA-2012 catalog into my main Lightroom 4 catalog.

STUDIO WORKFLOW

When I'm shooting in the studio, I generally shoot tethered with my laptop. Although I have some cameras that can tether to Lightroom, I generally prefer not to because all you can do in Lightroom is click the shutter. Lightroom doesn't have the ability to control camera functions other than the shutter release. When shooting my Phase One 645DF with IQ180 camera back, I can't shoot tethered to Lightroom anyway, because Lightroom doesn't support tethered shooting to that camera. I use Capture One from Phase One to control the camera and do the tethered operations, and then set Lightroom to use the Auto Import capability for importing from a watched folder.

When shooting tethered in the studio, I don't import the images to my laptop. Instead, I copy the files over my gigabit network to my main imaging computer. I set Capture One's Session Folders into a folder networked from my computer. I set the Lightroom Auto Import Settings options to watch the Capture Folder from Capture One. The Auto Import Settings options also are set to apply a basic metadata template and relevant keywords. Since I'm not using Capture One for image adjustments, I usually create a develop preset on some test images on the main computer and apply that initial preset during the Auto Import.

There are, of course, times when either of my personal workflows is modified as needed on the fly. If you're using a camera that can tether to Lightroom, you can avoid running a separate capture application—although, personally, I find the inability to control the camera functions in Lightroom to be a deal killer. If you're shooting from the camera instead of at the computer, you can adjust the camera settings right at the camera, which helps mitigate the Lightroom limitation.

Setting up and shooting tethered

When I set up and shot the images for the "Lens colorcast correction" section in Chapter 4, I used this tethered workflow. I tethered my Phase One IQ180 camera back mounted on my Sinar 4x5 camera to my laptop in the studio. The camera back was tethered with a FireWire 800 cable. **Figure 6.16** shows Capture One running on the laptop with a first test image already shot.

Since I was shooting with the Sinar 4x5 camera and not the Phase One 645DF camera, I couldn't control the aperture and shutter speed from the laptop. This first test shot included a ColorChecker Passport target so I could use it as a basis for setting the white balance in Lightroom. All the image adjustments would be made in Lightroom, so I didn't bother to use any image adjustments in the Capture One application. I did, however, double-check focuses while zoomed in to be sure the important areas of the image were sharp. Since I had used a lens tilt and shift, I needed to make sure the tilt and shift provided the optimal plane of focus.

FIGURE 6.16 Capture One running on my laptop in the studio.

▲ CAPTURE ONE MAIN WINDOW

▶ CAPTURE PANEL SETTINGS

Auto importing into Lightroom

Working back at my main computer, I checked the option to Enable Auto Import and opened the Auto Import Settings dialog box. **Figure 6.17** shows the Auto Import menu item and the Auto Import Settings dialog box.

In the Auto Import Settings dialog box, I specified the Watched Folder to be a subfolder on my RAID-01 hard drive. In the Destination folder, I specified where Lightroom would move the auto-imported images. I did use a Develop preset to adjust the white balance and some of the other image parameters. I also embedded a basic metadata preset. **Figure 6.18** shows the initial test shot after being auto-imported into Lightroom.

Running back and forth between my laptop in the studio and the main computer in the imaging area is a real exercise, although, once I confirmed that the tether was working, I just stayed in the studio shooting additional shots, secure in the knowledge that all the images would be waiting for me in Lightroom. I did a few shots while adjusting the position of the flowers and the camera position. **Figure 6.19** shows all the images I shot in Capture One and the same images auto-imported into Lightroom. You'll note that, in Lightroom, I've already run the DNG Flat Field plug-in, and the selected image is the image with the colorcast removed. That's why there's one more image in Lightroom.

FIGURE 6.17 Enable Auto Import turned on and the Auto Import Settings dialog box.

▲ THE AUTO IMPORT MENU

▲ THE AUTO IMPORT SETTINGS DIALOG BOX

FIGURE 6.18 The initial test shot auto-imported into Lightroom.

FIGURE 6.19 Shooting tethered in Capture One and images auto-imported into Lightroom.

▲ CAPTURE ONE

▲ LIGHTROOM

FIGURE 6.20 My image organization on my main hard drive array (above).

HOW I ORGANIZE MY IMAGES

My image organization is far from perfect, but the system I've set up and used for the last five years (since adopting Lightroom as my main image organizer) has worked well enough that I don't have a compelling reason to change. **Figure 6.20** shows how my digital images are organized on disk.

At the far left, you'll see the mounted hard drives on my main imaging computer. I'll discuss the reasons for some of those other hard drives later, but let me draw your attention to the highlighted drive named RAID-01. That's the main working hard drive array with 12 TB of storage. On that drive, I have enclosing folders for organizational purposes. All my digital negatives are in a single enclosing folder named ~DigitalCaptures. I add the ~ to force the folder up toward the top.

Inside the main digital captures folder are subfolders broken down to logical groupings of categories such as Events, Studio Shoots, and Travel Shoots. Images are inside of another folder named for the location and the year. If I've been to a place multiple times, those trips are in additional subfolders by year.

Inside the location folder, I have the images organized by the Lightroom import by date. Multiple cards and shots from different cameras all end up in a single day's folder. Hmm, it seems that seal shot is stalking me. **Figure 6.21** shows the same folder structure in Lightroom.

FIGURE 6.21 The folder structure in Lightroom mirrors the hard drive folder structure (right).

MY DIGITAL IMAGING AREA

I mentioned my main computer digital imaging area and thought you might like to take a peek inside. **Figure 6.22** shows my digital imaging room. This image was made from a three-image stitch using my Canon EOS 1Ds Mark III and a 14mm lens. While it looks really big (and a bit distorted) in the shot, it is a nicely functional 10 feet wide and 11 feet deep. It's big enough for two people to work, although these days it's usually just me.

The main computer has three displays—two 30-inch and a 24-inch—which allows me to have Lightroom or Bridge open on the right, Photoshop open in the middle, and the Photoshop panels on the left. The main computer is a 2009 Mac Pro with dual 2.93 GHz quad-core processors, 32 GB of RAM, and dual video cards. I have a Mac RAID card with four SAS 600 GB drives for booting the computer, my users folder, and Photoshop scratch disk.

FIGURE 6.22 My digital imaging room.

MOVING YOUR OS X USERS FOLDER

You'll note that my users folder is on a separate drive from my main boot drive. There's a reason for that: it's more efficient and can be faster. I got this advice from MacGurus (www.macgurus.com), who are the guys who supplied my RAID enclosures. Check their website for an article called Desktop Drive Setup (or go to www.macgurus.com/productpages/guides/MoveUsers.php). Sorry, as far as I know, this is a Mac–only thing.

NOTE When it comes to using the backup function of Lightroom, I tend not to worry about doing that very often. Since Lightroom's backup is only of the catalog and not the images, having multiple Lightroom backups is not mission critical, because I already have three online backups in my backup drives. What's important after an extensive Lightroom session is to save the XMP metadata to the image files. Ultimately, all the image adjustments and keywords are what's important to have, and that will get caught in the backup process.

Under the desk are two six-drive arrays connected via eSATA using RAID 0 for speed. The one on the left is RAID-01; the one on the right is RAID-02, which is essentially a twin of the one on the left. RAID-01 is my main working drive and everything is backed up nightly to RAID-02 using Carbon Copy Cloner by Bombich software (www. bombich.com). Over the years, I've used a variety of backup software and I've settled on CCC, which used to be donation-ware but now costs $39.95—cheap for added peace of mind!

I also have a third array, which isn't visible because of the chair. I've scheduled that drive (named FW-External-BU) to be backed up every night from RAID-02 after the RAID-01–to–RAID-02 backup. I also have an NAS unit next door at my house that gets backed up to on a weekly basis. That's my "off-site" backup, even though it's just next door.

Because this is my main imaging computer, it's a very lean machine. When I'm running Lightroom, Bridge, and Photoshop I don't have any other "stuff" running (like iTunes) that will steal processor clicks from Photoshop or Lightroom. I have a second computer (on the right) for iTunes, e-mail, and surfing the web.

PERFORMANCE TUNING YOUR SYSTEM

Over the years, I've gotten pretty good at tuning my computer systems for optimal Photoshop performance. More recently, I've learned how to also tune for Lightroom. The two programs are similar, but they have some important differences.

PHOTOSHOP PERFORMANCE

For Photoshop, the single biggest performance enhancement is memory—lots and lots of RAM! But RAM is only one of the three major Photoshop bottlenecks; the other two are CPU speed and scratch disk.

CPU

Multiple-processor (or a multi-core processor) machines are faster than single-processor machines, and Photoshop, since version 4 or so, can use multiple processors on many Photoshop operations. The faster the CPU speeds, the faster Photoshop can perform. For maximum RAM usage, be sure you're running the 64-bit version of Photoshop (or Lightroom) on a 64-bit operating system.

RAM

The old saying, "You can never be too thin or too rich or have too much RAM" is basically true. Adding RAM will, in most cases help. You can set your Photoshop document window display option to display "Efficiency" and watch it during the course of normal Photoshop operations. If your Efficiency remains at or near 100 percent, you have enough RAM. On the other hand, if you notice Efficiency dropping below 90 percent for any sustained period, you're a candidate for adding RAM. The RAM requirements vary considerably based upon file size, number of files open at one time, and the particular Photoshop operation running. Some operations are particularly RAM intensive. In some situations, the available RAM can become so fragmented that your system and Photoshop performance can degrade. In that situation, closing down unused applications, quitting, and relaunching Photoshop can restore the fragmented RAM.

Another thing to keep in mind is that, even if you're working on images that aren't in and of themselves huge, if you have a whole bunch of images open all at once, it's the total number of images open that dictates how much RAM Photoshop will have available for processing. You may be tempted to run your Memory Usage settings really high, but that's usually a bad idea unless you have a ton of RAM. **Figure 6.23** shows the way I have my Preferences set for Performance.

The Cache Level settings under History & Cache have an impact on RAM usage. Increasing the Image Cache setting will speed screen redraw—particularly when you're working with larger files with many layers. However, the Image Cache doesn't do too much for small files. The Photoshop CS6 default is set to Cache Level 6, with 8 being the maximum. If you routinely work with larger multilayered files, try increasing the cache level. If you have a video card with a suitable GPU, you'll see improvements in certain operations like the new Photoshop CS6 Lens Blur Gallery or when using Liquify.

FIGURE 6.23 My Photoshop Performance Preferences settings.

Scratch disk

The third Photoshop bottleneck is scratch disk usage. For optimum performance, the primary scratch disk for Photoshop should be a different physical drive than your system's boot drive (assuming that your system is set to page to your boot drive). Having a second fast drive for Photoshop's scratch disk can improve performance.

A solid-state drive (SSD) is an excellent speed for scratch disk use, but be sure you have plenty of free space on the drive. SSD performance starts to drop off if the drive gets filled up. I don't use SSDs on my main computer because I have a RAID 0 pair of really fast SAS drives running on a RAID card. The performance almost matches that of an SSD. In the future, though, I plan to use SSDs on any new computers.

There is simply no longer a hard-and-fast rule about how large the scratch disk should be. It depends upon too many factors, such as file size, RAM allocation, and what your History States setting is. The scratch disk can be split across multiple drives, but I've found that it's optimal to assign a single large volume rather than several smaller volumes. There is an upward limit to the scratch file. According to

NOTE The History States setting does not affect RAM allocation—it only affects the potential for scratch disk size. The higher the History States, the larger the potential scratch disk size you'll require—sometimes by a huge amount.

Photoshop engineer Chris Cox, it's "somewhere around 64 exabytes, but you'll run out of RAM before you get there, so the practical limit is more like 32 TB."

Performance for Photoshop CS6 will be considerably better for the Photoshop power user because even more functions are now speeded up by using the graphics processing unit (GPU) of your video card. However, for optimum performance, all aspects of Photoshop bottlenecks must be addressed. Additionally, Photoshop's performance and stability is still only as good as the health of your system and hardware. Regular maintenance and running a clean system without a load of system hacks and overloading the running applications is the best way to assure maximum Photoshop performance.

LIGHTROOM PERFORMANCE

The same three bottlenecks in Photoshop also impact Lightroom performance but in a different way (and Lightroom doesn't use a scratch disk). Past a certain point, more RAM won't make Lightroom any faster. If you have at least 8 GB of free RAM available for Lightroom, that's sufficient. Adding more won't speed things up. Running Lightroom on a multi-core 64-bit system is important for performance. Lightroom 4 on a Mac is 64-bit, but if you're running Windows, you should be running a 64-bit system and the 64-bit version of Lightroom.

Lightroom is very sensitive to hard drive speeds. Lightroom constantly reads and writes a lot of data back and forth between the application and the drive. Here again, an SSD drive can come in handy, but you'll need a large enough SSD drive to hold not only your catalog.lrcat file but also the Previews.lrdata file. Sadly, at this point, Lightroom doesn't take advantage of the video card GPU. Hopefully, that will change in the future.

For better Lightroom performance, be sure that in the Metadata tab of the Catalog Settings dialog box, you have the Automatically write changes into XMP option unchecked. This option is a performance killer. **Figure 6.24** shows the Catalog Settings dialog box.

You also should routinely optimize your Lightroom catalog. The command is in the main Lightroom File menu (you also can check the option to optimize the catalog when backing it up). Optimizing the catalog helps get rid of the database "cruft," which is the term the Lightroom engineers use to describe redundant or obsolete database records. You should do this on a fairly regular basis. I do it weekly or when doing a Lightroom catalog backup. On my catalog of over 150,000 images, it takes about 15 minutes.

FIGURE 6.24 The Lightroom Catalog Settings dialog box.

In the Develop module, certain functions can take a performance hit. For example, I usually do image adjustments with the Lens Corrections panel turned off. Lightroom must redraw the screen preview each time you move a slider. If the Lens Corrections panel is enabled, the preview drawing is slowed because of the distortion correction that must be applied. Just be sure to turn it back on when you're done making other adjustments. Lots of spot-healing areas or local adjustments also will slow down Lightroom. There's not really much you can do, but be conservative with the number of spots you heal. Don't try to do Photoshop-type retouching in Lightroom—it's far more time-efficient to do it in Photoshop.

INDEX